STAINS
REMAIN

STAINS
REMAIN

stories of
becoming
an artist in
the 1960's

Michael Harvey

Acknowledgements

I would like to thank Elizabeth Baker for all her help, art world knowledge, and acute editorial intelligence. I would also like to thank John Daniels for his tireless reading and suggestions, Barbara Zabel for her continued encouragement, Georgiana Goodwin for her generosity and design expertise, and, of course, my daughter Sophia for her unfailing support and enthusiasm.

Published by the Lyman Allyn Art Museum,
New London, Connecticut

ISBN 978-1-878541-07-9

To Sophia

STAINS REMAIN

```
a b c d e f g h i j k l m n o p q r s t u v w x y z a
b c d e f g h i j k l m n o p q r s t u v w x y z a b
c d e f g h i j k l m n o p q r s t u v w x y z a b c
d e f g h i j k l m n o p q r s t u v w x y z a b c d
e f g h i j k l m n o p q r s t u v w x y z a b c d e
f g h i j k l m n o p q r s t u v w x y z a b c d e f
g h i j k l m n o p q r s t u v w x y z a b c d e f g
h i j k l m n o p q r s t u v w x y z a b c d e f g h
i j k l m n o p q r s t u v w x y z a b c d e f g h i
j k l m n o p q r s t u v w x y z a b c d e f g h i j
k l m n o p q r s t u v w x y z a b c d e f g h i j k
l m n o p q r s t u v w x y z a b c d e f g h i j k l
m n o p q r s t u v w x y z a b c d e f g h i j k l m
n o p q r s t u v w x y z a b c d e f g h i j k l m n
o p q r s t u v w x y z a b c d e f g h i j k l m n o
p q r s t u v w x y z a b c d e f g h i j k l m n o p
q r s t u v w x y z a b c d e f g h i j k l m n o p q
r s t u v w x y z a b c d e f g h i j k l m n o p q r
s t u v w x y z a b c d e f g h i j k l m n o p q r s
t u v w x y z a b c d e f g h i j k l m n o p q r s t
u v w x y z a b c d e f g h i j k l m n o p q r s t u
v w x y z a b c d e f g h i j k l m n o p q r s t u v
w x y z a b c d e f g h i j k l m n o p q r s t u v w
x y z a b c d e f g h i j k l m n o p q r s t u v w x
y z a b c d e f g h i j k l m n o p q r s t u v w x y
z a b c d e f g h i j k l m n o p q r s t u v w x y z
a b c d e f g h i j k l m n o p q r s t u v w x y z a
```

Rotating ABC's white papers 1968 - 1972

FOREWORD

These stories are about becoming an artist in the nineteen sixties; the artists I met and the art they made. These are sketches of the art world: the lives, ideas, affairs, rivalries, friendships. They are about the memes of art and culture passing around the small network of the art world socially, intellectually and sexually. They recount the wakening of a young artist from callow naïve to slightly less naïve in the years 1967–1972. Years of enormous cultural energy and change. Usually portrayed in terms of music, drugs, assassinations and the Vietnam war, it was also a time of much intellectual and artistic fervor, a time of Fellini and Godard, Chomsky or the Deconstructionists, of the Women's Movement and Mao's Cultural Revolution. A period when the makers of Minimalism, Abstract Expressionism, Pop, Land Art and Conceptual Art coexisted in the same small area of lower Manhattan and let their long hair down at Max's Kansas City.

The interconnected stories are both fact and fiction. They are based on real events and where known figures are mentioned the facts are not skewed. No drips, no smears. The fiction is in the color, the chiaroscuro, the background collage - a changed location, a switch in time - made to infuse the scene with the mood of the

moment. Most of the actors were young, obscure or unknown at the time, though many have since become headliners at MOMA, The Tate or Pompidou. Here and there a character, usually composite, comes in the door, invented to highlight a theme or an idea that was prevalent in the zeitgeist. It is Cubism's shifting point of view, Fauve color and Dada absurd.

In the sixties, England, where these stories begin as prologue, was still remaking itself after the devastation of WWII. There was interest in art but little money to support it. Youthful energy found its outlet in music. The war had transformed America too, into a flourishing superpower. New York had become the Paris of the twenties, drawing old masters like Mondrian, Leger and Duchamp. The new home grown masters of Abstract Expressionism and Pop Art had confirmed the new citadel. Downtown Manhattan and SoHo specifically was more than a place, it became a metaphor of the unconventional life, youth and febrile creativity. In 1967, when I first saw it, SoHo was dark and dirty, not for the faint of heart, few street lights, and the streets themselves like a Rauschenberg combine, scruffy and strewn with the most delightful junk. Despite the grime, or maybe because of it, the art scene south of Houston had an irresistible vibrance, energy and freedom. In SoHo there was a great appetite for life.

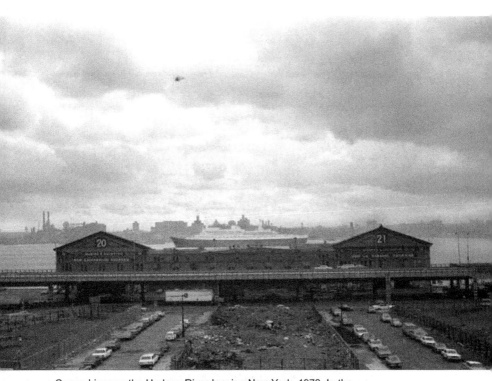

Ocean Liner on the Hudson River leaving New York, 1972. In the
foreground the empty lots of the Washington Market, now called
Tribeca. Pier 20 and 21 belonged to the Lakawanna Railroad.
In the background is New Jersey

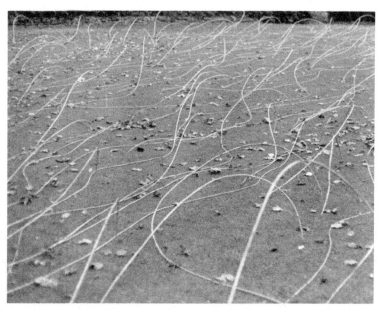

River of Canes, 1967, Oxford University, England

Hedgehog or Fox

Sated by culture and ripe rosy nipples we pushed the nation's pictures aside. Enough milky flesh, pompous monarchs and haloed madonnas. We lit up our smokes. Centuries of talent. Centuries too far. We had spent hours in the National Gallery and now we had to walk it off, get some air some light, some room to stretch and talk above a whisper. From the terrace we looked out on the genius of an ordinary day: the aimless crowds, the surge and cease of the London buses, the heavy aromatic diesel of clacking cabs. Stepping down we joined the pigeons and took a turn about Trafalgar Square among the springtime tourists. Polyglot groups in precautionary raincoats, they milled about Nelson's Column, clutching their *A to Zs*. Grinning shutterbugs clicking away, more taken with snapshots of the day than masterpieces of yesterday. Birds fluttered about their laughing heads. Bronzed Empire lions sat supercilious looking on.

We crossed Charing Cross.

"Smell the respect, did you?" John laughed. "Reverential polish at the feet of greatness."

"Over-awed." I shook my head. "Is that a word? I mean there's only so much awe you can feel."

"Your eyes glaze over?" he said.

"Toward the end. That beauty near the Velazquez's Venus woke me up."

"What a body," he said.

"In the blue dress?"

"Oh, her." He looked surprised. "Yes, yes, she was something."

"Stunning," I said.

We'd gone to soak up art and culture and I'd come away with the ideal woman imprinted on my mind. Her casual stance, at ease with the world, her absorption with the pictures. I could see her clearly, the look of thought on her delicate face. In the brief glance in our direction I was captivated. Why her? Every day I see beautiful women. Why her - as inexplicable as the genius of Velazquez and his mirrored venus. She was perfection and she turned away.

"The pictures," said John.

The art, the paintings, most of them, anyway, were quickly fading from memory.

"I liked ..." I said. "Now I think of it, two extremes. Complete opposites. I was very drawn to Uccello's "Battle of San Romano"; all that obsession with perspective."

"A bit cardboardy, though," he said.

"Yes. The Bellini, too."

"Icy. Don't you think?"

"Absolutely. But there's something intriguing about that Classical coldness, that haughty, broom up the arse, severity."

"It's the God thing," he said. "Conceal the artist's hand."

"Masterful stuff, though ... you gotta admit. Intellectual But then... what I really loved was the Rembrandt."

"Which one?"

"The wading woman."

"Holding up her dress?"

"I mean, did you look at that thing? How can so much flying paint evoke her hesitancy, the delicacy of her movement through the water, her apprehension? Up close it's like a Jackson Pollock the way he throws the paint around."

"So, Bellini's cool-mint verses the fetid breath of Rembrandt."

"Humanity is what it is. I'm drawn to both."

"So, which are you, hedgehog or fox?"

"What?" From his look this was not a frivolous question.

"The fox knows many things. The hedgehog knows one big thing." John's eyes followed a young woman in a mini skirt crossing the street carrying a stool of Scandinavian design. Heal's was having a sale. I watched her too. Another long-legged beauty, very attractive but nothing compared to my new ideal. "So," he repeated.

"are you a hedgehog or a fox?"

Not knowing what he meant, still watching one woman, thinking of another, I couldn't say. We walked up St. Martins Lane toward Seven Dials, our conversation moving against the traffic of the sixties. A tumultuous time, Martin Luther King just assassinated. Turmoil in Prague, the Tet offensive, Mao's *Little Red Book*, marches against the war, dodging the draft, Johnson throwing in the towel, the Black Panthers, Kubrick's 2001. Yet, somehow, Carnaby Street fashions, Twiggy and John and Yoko still managed to make headlines. And now on Marx's anniversary they were throwing cobblestones over barricades in the streets of Paris. Trotskyites bashing Maoists with their baccalaureates. Or was it the other way round?

John, a poet, a little older and far better educated, was my intellectual guide – the only person I knew who had actually read the books he talked about. His question was about more than paintings, momentary likes and dislikes, he was asking me to declare myself, show where I stood on this whole mess of culture.

"It's from *The Hedgehog and the Fox* by Isaiah Berlin," he said. "About our nature and our beliefs. Those who believe in many things are foxes, those who have one core belief are hedgehogs. Foxes pursue all kinds of ideas, philosophies, religions, styles. Unconnected things, contradictory things, and ..." John stopped outside the Salisbury pub, knocking his pipe against the wall. "Our natures often contradict our beliefs. You want to know if you're real or just faking it?" He glanced at the ornately etched glass in the pub doors. "Feel like a beer?"

Was I faking it? I bought Berlin's book on the way home to find out. It wasn't long, an essay really, on the character beneath the character. The one we barely acknowledge. The trouble starts,

Berlin points out, when principle contradicts practice. Tolstoy, his example, with his deep belief in the innate spiritual essence of mankind, was a hedgehog, but by nature, the writer in him, was a fox. The conflict, Berlin felt, left Tolstoy with a good deal of contradiction in his ideas and torment in his soul. I lay awake thinking about this. Born of Irish parents, brought up in England, I felt I was not wholly one or the other to begin with; neither fish nor fowl. Now was I hedgehog or fox? Like everyone else I wanted to believe there was something special about me and took the dilemma of my thoughts to be original. I drifted off with my bestiary.

Shouts from the street woke me. Loud voices and laughter, the noisy clamor of trucks, the clatter of handcarts across the pavement. The cane merchant next door had a shipment of bamboo from the East; bundles of long poles, best butter yellow, trundled through his doors. It made me happy. Work starts early on this side of town, the calloused side. *The Hedgehog and the Fox* fell to the floor as I got up and went into the bathroom, a washroom really, just a shallow sink and a pull-chain toilet stamped, in royal blue, with the monogram 'Thomas Crapper, by appointment to the Queen'. Down on the street a male voice shouted, "'allo lovely!" His friends laughed and whistled. As I bent to splash water on my face, I was overtaken by the sensation of riding a bicycle – breathless, pedaling up hill in a fury. Was it an overnight dream? A dream with nothing surreal or dreamlike about it. I looked my morning face in the face. Bicycles? I didn't have a bicycle. And hedgehogs. What's that about? I had to admit, when it came to self-knowledge, I couldn't pick myself out of a line-up.

I dressed, pulling on my daily uniform of old work shirt worn and worked and faded blue jeans, remembering the bike I had as an adolescent. Derailleur gears, ten speed; I rode it everywhere.

Outside on the street below someone asked,

"You see the telly last night?"

We had a history teacher who said the Middle Ages ended on Monday morning, August 22nd, 1485 at Bosworth Field.*

"Nah. Wot were on?"

Bosworth Field was only twelve miles from our school so we went to see for ourselves. We rode our bikes and we stood on the hill where King Richard III stood.

"That's King Henry's lot down there." Pete Thrush pointed at the tiny railroad station in the valley.

"Yeah, they musta come by train," said Terry Unthank.

"Stupid prat," said Nobby Sykes. "You can't get a whole army on a train. Horses, everything."

"I was being ironic," said Terry Unthank. He knew the rest of us wouldn't know that word. He was top of our class.

"Yeah, they woulda had to change at Crewe," I said.

"There weren't no trains then," said Pete Thrush, suddenly confused. "Were there?"

"I was joking," I said.

"Yeah," said Terry Unthank. "He was being ironic."

"Bonanza!" Came up from the street, followed by a chorus of the theme music.

"Nah! I took this new bird out to the pictures," came from below.

"Ooowha!"

* When they discovered King Richard's grave in 2012, it was only a few hundred yards from my school

6

The insistent ringing phone brought me back to my loft, a floor in a small manufacturing building on the east side of London. The high rents of the fashionable West End had sent me and a couple of other artists east to the industrial side of town. Renting a loft was new in London. It was something we'd seen in New York; it said you were serious about being modern. We were young, all of us, a year or two out of art school. All trying to figure out what to do and who we were. The floor above me was vacant, the floors below were sculptors making Minimalist boxes out of poisonous resins and spraying them with cellulose paint. The fumes I got, the art I didn't. It was my friend Jim on the phone. "Come over," he says, excited and insistent.

Artists can't wait to show you what they've done.

But first to breakfast at the Starlight Cafe before Rita's meals congealed. The greasy spoon cafe with the twinkling cocktail name, fading along with the stars on its sign, was the only neighborhood place to eat – small and grubby, everything fried plus a mug of thick tea. Rita was the stringy care-worn owner, her parchment skin mapped with dark veins, her faint hair caught up in a knotted headscarf - a relic from the Festival of Britain. The ever-present Woodbine fag dodging magically across her lips, the eye above it flickering against the smoke.

"If you don't like it," she advises the picky customer. "Sod off!"

Her regulars, mostly old and poorly dressed, re-lived the war each day nursing cups of tea and their memories of deprivation and fear. World War II was little more than twenty years in the past; there were still bombsites around the country and rationing only ended as the sixties began. Survivors of the war were different from those of us who came after it. For them war defined their lives, took away loved ones, cut close to the brink of existence, created unexpected camaraderie. For us it was old news. They were

a close-knit brotherhood that eyed youth with silent suspicion. Then back to the Blitz.

"We had some laughs, though, didn't we, Reeta? S'truth!"

"Had to, dint you. Bloody 'ouse bombed out from unner you."

At his Notting Hill flat I passed Jim's wife coming down the front steps. Disapproved of me, she did, thought me subversive, did she know I was a fox? We exchanged smiling insincerities. Indoors, Jim and I squeezed into his tiny back bedroom studio between the ironing board and his wife's old Raleigh three speed bicycle (more bicycles?). His large abstract painting took up the whole of one wall. We stood fidgeting, shuffling our feet in the patches of sunlight puddled on the linoleum floor. What to say, what to say? We lit cigarettes to add gravitas and gain time. The new painting didn't look that different from his last one. They all looked pretty much the same to me. Big, abstract, a slight change of colour here and there. Jim was in a world of his own. He blew smoke through the drowsy motes; enthralled by his own creation he started the one eye closed business, leaning his head to one side.

"The grey moves back, d'yer see?"

He held his hands in front of him framing areas of his picture, blocking out other parts.

"It's pushing the yellow forward." His hands sidled back and forth like passing trains. "The grey turns blue. See?"

I hated this crap. Was this hedgehogism? I must be insensitive, but I simply didn't care if the grey turned blue. Am I too literal, too foxy for this? What's it all about is what I want to know. Without thinking I set my hand on the seat of the bicycle. It was warm from the sun.

We'd been through art school together, Jim and I, where the one eyed, two-hand business was the alternative to forming a rock group. I might have gone with a band if I could carry a tune. We learned our trade, art school was all about craft, no one asked why we were doing it. Art history was the long, beguiling guide but none of us thought it was talking to us.

The warmth of the bicycle seat under my hand gave it a phallic feel and the sudden thought of Jim's wife, her disapproving arse snuggled into it, surprised me. I put my hands in my pockets and frowned at the blue and white scarf hanging on the back of the studio door. Chelsea football colours. Jim was a fan. How did these things go together? How did yelling yourself hoarse at grown men kicking a ball about sit with sensitive shifts of colour? Was what you like the same as who you are?

"Why did you do this?" I asked.

"Whaddya mean?"

"I mean why coloured rectangles not something else? Like a face."

"Portraits?" Jim dropped his hands in disgust. "The fuck?"

"I'm just curious. Why do we do what we do?"

"It's a painting! What more do you want?"

What more do I want? I want to know why we are doing it, is what I want. Where is the art? In the painting? In the mind that views it? In the artist's hand? Should the artist be removed, invisible? Should you be looking through the clearest crystal. But then isn't it the artist who you want to see? Not the apple but how they viewed it, what they did with it, how they brought it to you? I found myself constantly drawn to these questions but ill equipped to answer. Was this the foxtrot? Was it true, the long history of art

from cave to soup cans was all the excuse you needed? You just did it. Let it all hang out? Abstracts. Why not portraits? The wife in the rude? The answer was simple, might as well ask why Dylan switched to electric guitar. It's the sixties! man. Sit in, drop out. "Roll Over Beethoven." Was it too self indulgent of Rembrandt to insert himself into his art? Self promotion in the sixties was reactionary and selfish – counter revolutionary.

I convinced Jim he should get out of the back bedroom and take the empty floor in our loft building. He went off, happy, to his football game. I began to walk, wondering: was it all air guitar – style without substance? The streets of Notting Hill were peaceful. Waiting to cross the street an excited Welsh voice came behind me.

"I'll tell you, boyo, this Roland Barthes has it all figured out, see. Sem-i-yotics it is."

"Loada bollocks!" His friend had a north midlands accent I couldn't pinpoint. "Semi-idiotics."

Newness was here. The sixties moving so fast it was hard to keep up. Words like transcendental, bricoleur or structuralism appeared every day. Marx or Levi-Strauss were in the daily paper. Godard or Chomsky worn next to the skin, Fellini came with every change of underwear. A new must see movie, must grasp theory appeared while you were still chewing the last, great books sat by every bed unread. You couldn't be caught with your Mcluhan down.

Youth was a must, long hair, blue jeans, bellbottoms. Though contrary to common belief there was little evidence of 'Swinging London' at its core. The youth movement was split into factions of class, education and taste: Mods, Rockers, Skin Heads, Hippies, and arty long-hairs, like myself, who were mostly condensed

around the colleges, or areas like Chelsea, Kensington or here in Notting Hill. To the average pay-packet walking the streets of central London it could easily be the fifties with shorter skirts and better music. Modern was so much about style. Did everything about you say something about you? Style as substance? I wrote in my head as I walked:

Dear Mr. Chomsky,

May I call you Noam? You are so damn bright, please explain to me the significance of where I am and what the fuck I am doing.

I turned into the Portobello road where the fabled flea market was moving into high gear. Up ahead the two young men went into the antique uniforms store. It had been a youthful fashion, though an eccentric one, to wear old uniforms long before Sergeant Pepper. Through stalls of antiques and second-hand junk. Past the Electric Cinema. And there she was quite suddenly crossing the road to an old jewelry stall, my National Gallery Venus. Was it really her? My pulse quickened. I circled the stall to see her face. Hard to tell, she was bent over the display, her blonde hair falling over her face. Turn this way, look in the mirror. Then she stood up holding a necklace. I couldn't tell. How could I be unsure, didn't I still see her in my mind? The blue dress. This was different, that was it, the light. It's her ... but then a man joined her, she showed him the necklace. It's not her. Not with a jerk like that! Besides, my Venus was a brunette.

And so, over to my friend Livia's place. Livia's an artist, a sculptor who had spent the previous year on her hands and knees meticulously painting the surface of the moon for Kubrick's 2001. She was in her kitchen boiling water for tea, hanging out with a couple of friends. Big Brother's 'Cheap Thrills' was the soundtrack. A new paper The Rolling Stone with John Lennon on the cover was being passed around.

Friends, and friends of friends, came and went; some I knew some I didn't, it was a casual place to hang. A slender curly haired guy I had never seen before, sat following the conversation without speaking. Batty was telling us about the same two cars that crashed into each other, at the same corner, two years apart. It started stories of coincidence.

"I was sitting in Washington Square once," the curly haired guy spoke up, speaking softly in an American accent. He appeared to be totally stoned. "This old guy sat down beside me and started to talk. I wasn't real interested at first. You know. Idle park bench chatter: she's pretty, look at the size of that dog, this fellow looks like Charles de Gaulle. But as he talked I realized he had a very different way of seeing things. Unique really. He was funny and fascinating. The next day I went to a talk by Marcel Duchamp. I was excited for it but knew I'd be too shy to ask the questions I wanted to ask. I'm sitting there, in the audience, and who should walk out on stage but my old guy from the park. I mean, the size of New York, what are the odds?"

"This is Walter," said Ann who'd brought him over. "He's American. A sculptor."

We looked at Walter, sizing him up. To us, sculptors were brawny physical types with hardened plaster under their fingernails, stone chips in their hair. Walter was delicate, exotic, and kind of inscrutable like Bartleby the Scrivener. About ten years older than me, in his early thirties, wearing granny glasses, he was more how you might imagine a poet or a philosopher. He was shy at first, but the talk of coincidence, Rolling Stone and the music opened him up. He began tapping his hands to the beat. He'd been the drummer for the Primitives, he said, a band with John Cale and Lou Reed that eventually became The Velvet Underground.

"Did you ask your questions?" said Livia.

"No. It was too formal," he said.

"You didn't recognize him in the park?" said Batty.

"He was just an old guy. I wasn't expecting Duchamp."

"I bet he would have liked the coincidence," I said.

"I thought of that ... afterwards."

"How was the talk?"

"Okay. See, that was it. I learned far more sitting on the bench."

I watched his bobbing curls as I tried to pin him down as a hedgehog or a fox ... shy, introvert would have to do for now. Someone had loaned him a flat so he was staying a while in London. We met a number of times, after that, walking and talking about art. He liked to talk. Most artists I knew intuitively grasped at the culture through their chosen medium. He had been a history major at Berkeley, and his thinking worked in the opposite direction: he didn't look for the culture through his material, he sought the materials through his sense of the culture.

His hands often drummed as he talked of the influence of geography on history; the importance of the Pacific Ocean to California, and the imprint of Asian thought. He talked of the infinity of the huge desert skies, and of the energy of density – the compactness of stainless steal mesmerized him. He was a Minimalist with a rich sense of Dada theater. A contradiction that made his art, his 'Spike Beds' and 'Cages' and 'High Energy Bars' the more intriguing. He told me he planned to fill a room full of dirt. A decade later his 'Lightning Field' in the western desert of New Mexico would make him famous. Clasping his hands, knitting the

fingers seamlessly together, he would invoke the precision of the machine. He was awed by technology, its very exactness carried an edge of danger – the unforgiving ruthlessness of perfection. A hedgehog with spikes!

An eye opener; heavy baggage to carry back through check-point Charley into the grim reality of the Eastern block and Rita's thick brown tea. Walter De Maria was not just playing air guitar, there was something there, a thoughtful, philosophic outlook. It confirmed my belief that there was more to art than the one eyed, two handed tango. But exactly what, for me, was still a mystery. I ruminated in my loft. Minimalism as a movement had already been around long enough to be corrupted. Look at the candy coloured pastiches the sculptors were making downstairs. Sugar coating their austere boxes to make them more palatable. The original Minimalists were after precision, the completeness of mathmatics, pairing away to an aesthetic of perfection. Gnawed to the bone. It was something to admire, like the ascetic in search of enlightenment, like Jim's search for the perfect note, but was it me? Beside them I was an urchin in disarray, neither purist nor refiner. My foxy nature was to add not take away. Never a perfectionist, flaws came naturally to me; perfection was too close to the divine. My inclinations ran more toward the fetid breath of Falstaff the fuck-up. drawn to the mysteries of chaos.

Duchamp on a park bench, eh? What had he done exactly? He'd taken a urinal, a porcelain pissoir, and put it where it was useless – in a gallery. A magic trick: the gallery made it into art. Inside the door it's art, outside the door it's a pissior. Nothing physically changed, the gallery is context, the artworld is the frame.Whatever's in the frame can be art: a chair, your shoes, the time of day, melancholy, a fever, but outside the door it is just the flu. It was a philosophical riff on the nature of art. I was drawn to it of course,

anything provocative. Though I liked de Kooning's attitude too: "I think I'm painting a picture of two women but it could turn out to be a landscape." Nice, uh? His willingness to be surprised, his mind churning as he worked, all hot and bothered, and all the churning right there in the picture. Whereas Duchamp's cool-hand Luke was no where to be seen, off someplace puffing on his philosophical pipe.

"Georgie Best. Golden feet, mate! Pure gold."

The narrow street bounced the sound right into my face. Workers talked football on the pavement below. I often felt like part of the team. We'd rented the space without thought to the neighborhood. It was bleak. In London the generation gap was geographic too, east and west. The West End had been rejuvenated by youth – all things sixties – rock 'n' roll – The Beatles, Stones, Hendrix was the soundtrack to its renaissance. It wasn't happening in the East End. The feeling was Dickensian, old and musty. The streets around the loft were dingy, full of small businesses: cabinetmakers, carpet, bamboo importers. It was stuck in the thirties or forties: cigarette-smoking men in cloth caps, women in headscarves and aprons. I'd grown up in streets like that where men lived in their overalls and women's arms were red to the elbow from scrubbing laundry. This part of London was benighted as any communist block city, its soundtrack was the hacking cough.

Jim, whom I had started to think of as Hedge, moved his studio upstairs and overnight the place was immaculate: well organized rows of paints, jars of clean brushes, neat stacks of stretched canvas. His new surroundings, the big space, the neighborhood, the commute, seemed to have no affect on him. He didn't miss a beat, within hours he was back into the hedghogery of the one-eyed, two-handed tango: subtle change here, a minor nuance there. The sculptors downstairs were the same, spending months sand-

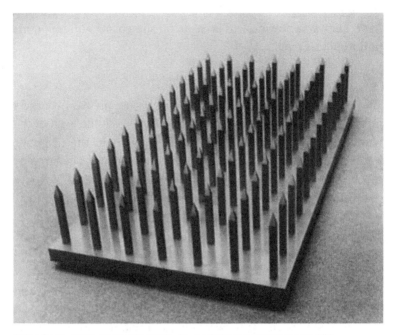

Spike Beds, 1968. Walter De Maria. Dwan Gallery announcement, NY

Walter De Maria in his long black coat out walking
in London 1968. Author's sketch

ing and polishing their boxes equating labour with value; elbow grease intensified their gratification, elevated their pride in completeness. I was surrounded by hedgehogs. Their lapidary patience admirable but, I thought, misdirected. To me the whole appeal of a manufacturing loft was the radical change from an apartment ... you could do things here you could never do in a back bedroom.

At the end of the working day remnants of the local trades were tossed or stacked or dumped outside on the surrounding streets: off-cuts from the cabinetmakers, carpet scraps, bundles of bamboo. I was infoxicated, trotting from pile to pile of plastic, leather, rope, cardboard boxes and tubes by the thousands. I made sculpture by piling or hanging, or leaning, or rolling – all the verbs suggested by the material itself. Out of the bric-a-brac came lessons about gravity, pliability, rigidity, about precision or scattered indifference. Exhilaration fed fecundity. I was making half a dozen sculptures a day. And as quickly as they could be made they could be undone. For if the idea was to stack or throw or lean, say, it could just as easily be bamboo poles, or ladders or umbrellas that did the leaning. It quickly became obvious, too, that there was no precious object here, and no point in keeping it. A photograph was enough.

Downstairs, Frank sprayed another box the color of strawberry cream. Upstairs, Hedge contemplated his austere abstracts. When they came into my studio they looked at my piles of cardboard or rolled up carpets as so much junk and shook their heads; I couldn't possibly be serious. We were all at sea with ourselves and as we rowed we sang MacArthur Park: "Someone Left The Cake Out in the Rain."

Jim bought a parrot.

"What's with the bird?"

"Great, innit."

He made a small aviary in his studio out of chicken wire and stood with his nose to it making daft noises. The macaw sat on its perch ducking its head, eyeing us with suspicion. With more room than his back bedroom, Jim had put up half a dozen paintings side by side along the wall. I could see the differences now. Small shifts in design, subtle modulations of colour – they were about hitting the perfect note, as in Walter Pater's "all art aspires to the condition of music." How young he was to be so settled.

I told Frank about De Maria's Land Art, about his views on the desert and the oceans. We were in his studio, downstairs, standing among his candy coloured cubes of shiny plastic. The news didn't sit well with Frank – Infidels at the gate trying his beliefs. He moved among his sculptures thoughtfully touching them, brooding. Land Art?

"Uts boolshait!" he decided vehemently. "Ut's jus po'tic landscape aat, is what it is! William fooking Werdswerth, nowt else."

Frank didn't know himself from a doorknob and never would.

On the night Andy Warhol was shot I lay on my bed listening to the lackadaisical drawl of John Peel on the radio. He was playing the Velvet Underground and Nico in tribute. Two days later the assassination of Bobby Kennedy pushed Warhol out of the news. Another tragic event come and gone. Warhol became a victim of his own shallow world of fleeting images.

Mid-summer and no closer to seeing my face in the crowd. I had no trouble with being a fox. There was certainly no core belief, no center of gravity pulling everything into its orbit. But how did this constant sniffing curiosity manifest itself as an identity? Wasn't I everywhere, scattered, wind blown mysterious content? I

went back to the National Gallery as I often did, to take another look. At art, I told myself, but part of it was the memory of Venus, the hope that hadn't died. I had somehow convinced myself that she was the answer. The solution to all things. Of course I'd seen her many times; crossing the street as a blonde, on the escalator as a brunette, in the park as a redhead. The best thing about being young in a great city is the other young people. Thousands of them, from all over the world, passing through, every day, looking for each other, looking for themselves. They are in the squares, at the zoo, the flea markets, in the bars, and the museums.

I didn't get far at the National. Still in the Renaissance, standing in front of the Arnolfini Wedding portrait when:

"Those shoes look painful. You can see why she took them off."

She was standing beside me with such a casual air of self confidence that I thought I must know her. But one look at the dark Mediterranean beauty: the olive skin, the deep brown eyes and black, black hair assured me I'd never seen her before. She didn't turn away, or smile or even look at me, but took my arm, as if we were old friends, and gave it a squeeze.

Her name was Amanda, which she pronounced with a great rush of air on the first syllable, Hah!– Manda. Her English was perfect except for the sexy accent – which made it even better. She was from Buenos Aires, she told me, hugging close as we strolled through the galleries barely noticing the paintings. A philosophy student at the Sorbonne who danced striptease to pay her tuition. This was a new kind of woman to me. Self confident, smart, adventurous. I knew few men, if any, who had that kind of spirit. The Women's Movement had not arrived yet but Amanda was already there, and beyond, a liberation movement of her own. We left the National and strolled through St. James's park. She was my age

but already a worldly sophisticate who brought out my provincial innocence. My lack of cool amused her. Enough at least that she showed no interest in leaving. At the end of the evening when we took the long taxi ride across the city back to the loft, she was perfectly at ease with the dim-lit, unknown streets of the industrial east end. In the cab I discovered how truly uninhibited she was.

Unlike the Venus of my fantasy Amanda was probably not the perfect woman for my life, or I for hers, but we were perfect for the moment. A week of passion never became love but in it Amanda became Rembrandt's Wading Woman, with all the sour odors of humanity. The perfection of fantasy came down to earth. It amused my poet friend, John, when I told him. He quoted at me: "My mistress, when she walks, treads on the ground."

And what better place than on the ground with Ha-Manda. Sadly she went back to Paris after a week and I never saw her again. Years later, many years later, I heard she'd done her Ph.d at Oxford, and married an English Lord. He then overdosed on heroin. I like to think of her as Lady Ha-Manda.

De Maria exhaled some of the Moroccan product talking about jazz and drumming and his composer friends Lamont Young and Terry Riley. The flat where he was staying was plush compared to my raw space: Art Deco furniture, carpets, Hockney drawings on the walls. He didn't seem to notice any of it. He'd asked me over there to hear the tapes of his drumming mixed with the sounds of the Pacific and Atlantic oceans. Artists always want to show you what they've done.

"The ocean and the desert are the most esthetically pleasing places in the world," he said, threading the reel-to-reel tape machine. "The great thing about desert sites is they're hard to get to. It makes you appreciate them more. In a museum you look at a work of art

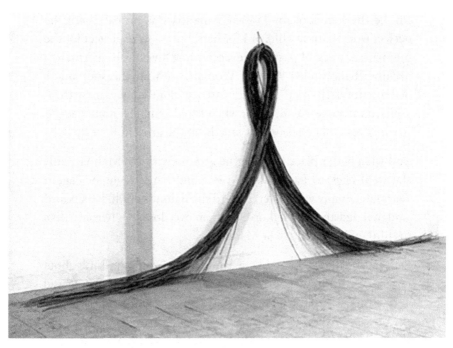

Loop, 1968, 20 foot long ratan canes.

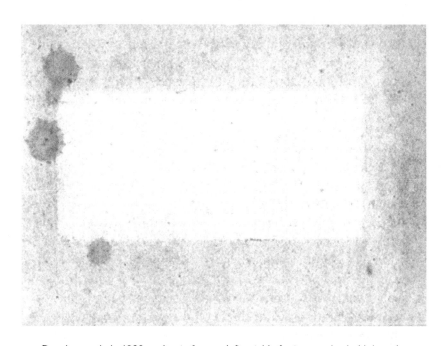

Drawing made in 1968, a sheet of paper left outside for two weeks, held down by a brick.

for ten seconds, then you're distracted by the next one. The desert's so inaccessible, takes so long to get to, you take the time, you soak it in, you can't just rush away."

We smoked and sat listening to waves crash for an hour or so. Music had the condition of oceans.

"You know what killed jazz?" said De Maria, rewinding the tapes. "Those live recordings at nightclubs. At the end of the session you'd hear one guy clapping." He clapped his hands for a moment or two. "Hear that?" It teetered between appreciation and sarcasm. "Hear that lonely hand clap in the back of an empty club. That killed jazz."

It was not lost on me that I had never seen any of De Maria's work, not even photographs. The bed of steel spikes, lines drawn in the desert, an earth filled room were descriptions – words. Frank's critique: "Wordsworth!" was more apt than he knew. As objects they were tied to specific locations not something you could pull out of your pocket and show. Yet I could visualize them clearly, would seeing them be better – or worse? The remoteness of the desert might concentrate the mind, but made it unlikely that many would see the work. The tourists snapping pigeons in Trafalgar square rarely take the time, or the few steps, needed to view a history of masterpieces right behind them. Would the desert remain empty and desolate with lonely hand clapping? Knowing it was there was enough. How much, I wondered, was that spirit of isolation something De Maria longed for?

Late summer already, The Beatles released "Hey Jude". The Soviet tanks entered Prague. The papers ran photographs of grim young soldiers staring down crowds from the turrets. Police beat up protesters at the Chicago convention – the whole world is watching. Upstairs, Hedge had bought more birds. Mina birds, parakeets,

canaries, his little aviary was bursting.

"Brings life to the place, dunnit," he grinned.

It do. What was it though, substitution? Was his art so monkish, so controlled and deliberate that he needed a little chaos in his life?

"Hey!"

And life has a way of meddling.

"Wha?"

"Quick. Gimme a hand!" Just days later Jim was pounding at my door in panic. "Give us a hand."

I ran after him, bounding up the stairs; was the place on fire?

"Wassup?"

"They're out!"

The door to his aviary had opened overnight. It was like the Hitchcock movie "The Birds" in there. They were everywhere and the slightest movement panicked them into frenzied flight. Already his paintings, those delicate blooms of flawless colour, were Jackson Pollocked with angry acid. The birds were crapping over everything including us. We ran about chasing and shooing the birds back into the their cage. Hedge was inconsolable. In the days that followed he worked in sullen silence cleaning his pictures. Even then faint stains could be seen floating like spectral memories within colours. I watched with sympathy questioning an esthetic that could be ruined by such small imperfections. There was a price to pay for hedgehogery. Wasn't the bird of life always flying by?

My own art had turned away from material objects. I liked the idea of ideas. I read Chomsky's ideas about the innate nature of language, how we had the ability to make an infinite number of sentences. I read anthropologists, Bertrand Russell's History of Philosophy, Montaigne's essays, Dr. Johnson. I couldn't get enough of ideas. Making little books you could pull out of your pocket anywhere any time became my ideal. The desert was in my head, right out of Lawrence of Arabia, along with Atlantis, King Solomon's mines and all the other comforting and disturbing bits and pieces of life and art, seen and unseen, all the vagaries and emotions collected day by day.

I didn't aspire to poetry or perfection. The world is what it is. My clumsy feet in the foxtrot of chaos kicking over the best-made plans only reveal something new to sniff at. There was no ideal beauty for me. Amanda was better anyway. I experimented with small drawings. Everything was a work in progress.

It rained. I stood by the front door watching more bamboo being delivered next door through the downpour. Then Frank came in. I hadn't seen him in a while. I hadn't smelt the paint fumes either.

"How's it going?"

"A'reet. Yous?" Frank shook the rain from his hair. "Comin' doan in b'kets!"

"Where've you been? Haven't seen you in a while."

"I was aal awer the countree. Tak a luke."

Wet as he was Frank opened the soggy briefcase he carried and pulled out a handful of photographs. Artists can't wait to show you what they've done.

They were landscapes, shots of crop fields, gorse covered mountains, riverbanks, orchards, rocky shores with pounding waves. A nature lover's England. And in every photograph, conspicuous in some, discreet, slightly hidden, in others, was one of his colorful boxes.

"Aye," he said, proudly watching me look through them. "Am gettin' inta Land Art now."

Had he become a fox?

Outside Rita's Starlight Lounge one morning I ran into Michael Sandal, the sculptor, he'd been a mentor of mine in art school. He offered me some part-time teaching at the art school in the midlands, where he taught. I'd have to take a train each week. That'd be fun. I took the A train that night, standing with the rest of the audience at the Finsbury Park Astoria in an ovation for Duke Ellington and his orchestra. The legendary maestro and his aging musicians, near the end of the road, could still bring down the house. I thought of De Maria's words – jazz was not entirely dead. The A Train was still running.

Going through my address book that Fall, thumbing back and forth, I kept passing a number with no name attached. It had been there for months and I had no clue who it was. It was not my handwriting. Intrigued, I called. The phone rang several times before a friendly voice answered in a strong Yorkshire accent. He was pleasant but it was no one I recognized. I explained about the number in my book, and how it was driving me crazy that I couldn't place it. He was amused.

"Well, my name's David Hockney, if that helps."

As soon as he said it the drawings I'd seen when visiting De Maria, to hear the tapes, came to mind. Hockney confirmed it was his

apartment. Obviously De Maria had written the number in my book. I thanked him.

"That's all right," Hockney laughed. "I'm glad we sorted it out. I thought maybe you got it off a lavatory wall."

Isaiah Berlin's list of historical Hedgehogs and Foxes

Hedgehogs: Plato, Lucretius, Dante, Pascal, Hegel, Dostoevsky, Nietzsche, Ibsen, Proust
Foxes: Herodotus, Aristotle, Erasmus, Shakespeare, Montaigne, Molière, Goethe, Pushkin, Balzac, Joyce

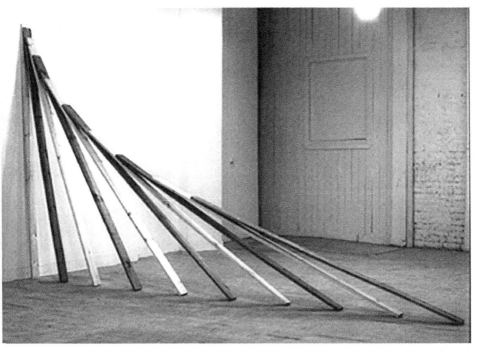

Sweep, 1968, alternating pine and cedar boards, 6" x 2" x 10'

the practice comma art comma method comma or system
of inserting points or open single quote periods closed
single quote to aid the sense comma in writing or
printing semicolon division into sentences comma
clauses comma etc period by means of points or periods
period other punctuation marks comma e period g period
exclamation marks comma question marks comma refer
to the tone or structure of what precedes them period
a sentence can contain any of these symbols comma
its termination marked by a period period

Punctuation, White papers, 1968 – 1971

You've gotta believe it to see it

As soon as her face flashed by, flickering, scattering reflections, I took off, mind in my loins, racing the length of the platform. Where is she? There she was, gorgeous and alone. I climbed aboard gasping for breath, pretending I didn't see her. Good, someone left a newspaper. Look out the window. Did she notice? Casually I picked out a seat across the aisle and settled in with discarded local news. She knew. We both knew. She busied herself staring out the window through her own image. Nothing out there but an empty station on a grey day. Same on my side. I caught my breath behind the paper. She straightened her magazine, toyed with her hair. Out came the little make-up mirror, her perfume scenting the air; she checked the eyeliner, the lipstick, her creamy skin. Pleased with herself, she was full of confidence in her beauty. I folded the paper.

I was always running after women. Never satisfied, never enough. Shallow? Yes, I was shallow. Absolutely. Pure id. A callow youth full of unquiet urges. And so was the beauty in the mirror. The sixties were supposed to be the age of free love, of mindless carnal lust. We were happy to oblige.

"Hi, there. Hi"

The train lurched into motion dropping the paper to the floor and throwing a flustered latecomer about the aisle. She was talking to me.

"Hi. Whoa!" flailing arms "Goddamnit!" falling bags. I recognized her from a staff meeting earlier in the day - my first stint of the part-time teaching job an hour or so north of London. She'd been outspoken, loquacious. She threw her bags into the seat opposite me. "You were at the meeting, right? Going to town?"

"Hi. Yeah." She's not going to sit? No, don't sit.

She sat, following her bags into the seat, sticking out her hand.

"I'm Barbara Reise, head of the Art History Department." Her accent was American mid-west, her build was industry sturdy. I put my hand into her manly grip and she pumped it, affectionately stroking my arm with her free hand. "You're new, huh?"

The sudden intimacy threw me, left me wordless. The native reserve, I was unaware I had, came rushing out to throw up walls and dig trenches. She was in my face, a torrent of friendliness; loquacious swarms of warmth overwhelmed me setting me back on my British Rail seat. I stammered, gaping at the passing coal yard; would she never let go of my hand? Compared to the likes of miss Peaches The Art History Department was not glamorous. Quite plain, in fact, emphasizing the dowdy with matronly clothes, fusty with the mothballs of academia. She was the distracted professor oblivious to the whims of fashion. The hand kept pumping as her eyes slipped across the aisle to meet Peaches and Cream who sat staring back, gobsmacked.

"Almost knocked me down, racing like a madman! What's the hurry?"

My lust deflated. The Art History Department, insensitive to the subtext of the mise-en-scene, had flushed away my wild weekend orgy. I could taste the disappointment.

"I'm sorry." I couldn't say I didn't notice her, which was true. "I thought I saw a friend."

The train ride was a commute I would be making weekly. Would The Art History Department? I glanced over at Miss Creamy Delicious. Would she? She pretended to read her magazine, a smirk on her face.

I had taught at other art schools and this was much the same: students emerging from adolescence, abilities often mis-matched to their self-confidence. Some unsure about art as a career, others way too self assured. The staff was a grown up reflection of the kids. The younger of us still swaggering with our inflated egos, the elders given up, drawn to their vegetable gardens, more interested in tatters than the Tate. How long did I have? Inattentive at school, not so much bored as distracted, I was in art school before I found there were things I really wanted to know, films and art I wanted to see, books I didn't have to read but wanted to. I had a lot of catching up to do.

Settling back into the rhythm of the rails, I faced Art History Department, as the train gained speed. Barbara fidgeted, looking for her ticket, pulling at her lumpy cardigan, opening and closing her bags for tissues to clean her over-sized tortoiseshell glasses, and talking non-stop. She concluded by knocking the contents of her purse to the floor.

"So tell me," she said, after we had crawled about the shuddering floor retrieving keys and pens and loose shillings and threepenny bits. "You're an artist?"

"I'm trying ... yep."

The equivocation was not modesty just reality. London in the sixties didn't offer many options for an artist. Either you had entrance into the few snobbish galleries around Bond Street, or you were just another also ran. She understood.

"You're still young," she said.

I was. She was in her early thirties. A stream of consciousness without cessation. I half listened, sneaking peeks at miss glamorpuss, quietly seething over my loss. It was quickly apparent though that Barbara was no fool. Smart and articulate, she was deeply involved in the world of contemporary art, a world I wished to be part of. She wrote criticism for a major art magazine and, as part of her job, brought known artists to the college to give talks. She knew a lot more than I did. A couple more stations and her knowledge and smarts outpaced miss silky haired lovely. Was I growing up?

"Did you see Barnett Newman's new foreword to Kropotkin's Memoirs?"

"Huh? Krop pot ...? No."

Newman the Abstract Expressionist painter was deeply political, she said, laying out his views on anarchy and individual autonomy. This was deep dish. "Uh hu," I nodded expressions of interest to mask my ignorance. "Of course." If my libido was over-heated my curiosity was equally promiscuous. The fox in me. There was more to life than carnal knowledge. I was engrossed. As she talked her fidgeting faded; the physical Barbara disappeared as the realm of ideas enveloped her, she was calm and focused. Then she paused, another tissue, another glance across the aisle at miss Delicious, and she became undone. Her vulnerabilities spilled like

her purse; she began fixing her lifeless hair, smiling too much, and talking at twice the speed.

Of course, at that age, I was ignorant of dysmorphia, or any other kind of obsessive self-loathing. Sensitivity to other people's demons and anguish was an aspect of maturity I hadn't attained yet, I still functioned at the level of "stop bloody whinging." Introspection and the examined life were still waiting off camera. I glanced across at the preening beauty. Her smug vanity dismayed me. It was my fault I'd started it, compulsively drawn to the nectar, and knew I would be again and again.

Barbara and I parted with manly hugs at London's Euston station. A small group of young Chinese revolutionaries ran by waving Mao's little red book. Even the news vendors paused to watch, then went on shouting: "Police attack marchers in Derry" – Northern Ireland. Concerned, I had a sister Kate with family in Belfast, I bought a paper and took the tube to my loft on the east side. I realized then that I'd forgotten to see what happened to the silky-haired beauty. It was fortuitous meeting Barbara. I didn't know anyone so familiar with the latest shifts in current art. She was someone to talk to. I could learn a lot from this woman.

"Eh up."

"Hey."

The liquescent figure of my downstairs neighbor, Frank, the Tyneside Geordie, wandered into my studio. No knock, no hesitation. We were still that young. He roamed around looking at stuff before poking through the things on my worktable.

"Where's that little 'ammer?"

"You borrowed it."

"Oh." He stood watching me work. The part-time teaching was not enough to cover the bills. My other job was making props for television.

"So, what's this fer?"

"The Tom Jones show," I said.

It was a life-size wishing well, like something you'd see in a child's fairy-tale book or a Disney cartoon. I was carving it out of big blocks of Styrofoam.

"Am a Joe Cocker man, me." Frank mindlessly toyed with whatever he found nosing around on the table. "*Ulysses!*" He snorted. "Tha's a bugga."

Frank picked up the book, shaking it free of styrofoam dust, and measuring its thickness between his fingers. His nostrils flared as he grimaced.

"It's got the stink of think on it."

"You ever read it?" I asked.

"Yu kiddin'? I'd rather jump oot the fookin' winda!"

It had that kind of reputation. He held it like infectious flotsam making no attempt to open it. But then Frank wasn't the kind of guy you'd see with a book, any kind of book.

"What you readin' it for?" He said. "Showin' off?"

"Yeah," I said. It had that reputation too. "I just started ... everyone says it's the peak modernism. I thought I'd try."

Secretly I was convinced that *Ulysses* held all the treasure of

Twentieth Century creativity. Once I'd cracked the impregnable fortress it would show me the way. I'd be initiated, a made man.

"Fuck it." Frank dropped the book back on the table. "Life's 'ard enough we-out that. Why force y'sell to fail?"

The stink of think! Was that my problem? Always with the questions ... can't leave well enough alone.

I'd first met the *Ulysses* 'bugga' through my parents, immigrants from Ireland with soft brogues, who constantly took us back and forth to the auld sod. My dad, though uneducated himself, had a great reverence for genius, the Olympus of all creativity. But rather than read their works he would make small clay sculptures or buy little statues to form a totemic bond with the greats. Around our house Shakespeare sat on the mantel watching the tele, Socrates stared out the window at the W.W.II bomb shelter in the back yard, Leonardo frowned at the stopped clock on the stairs, and Beethoven stomped over the rockery. As a religious man I suspect his only reason for attempting *Ulysses* was that it took place in his home town. One Sunday afternoon while doing my homework. My father jumped up from sofa behind me, throwing down the book in disgust.

"That's the filthiest buke I ever read!"

I waited until he left the room.

Barbara never appeared until the train shook itself into acton. Then, like our first encounter, she'd come slamming into the compartment, ricocheting down the aisle, ferocious for life as ever. As soon as she spotted me, she'd start in before hitting the seat.

"You ever heard," She caught her coffee as the train violently

spasmed. "You ever hear of the Ship of Theseus?"

She sat down, unwrapping her egg sandwich breakfast, licking yolk off her fingers.

"Can't say I have." I kept a close eye on her food, a goalie ready for the penalty.

"Theseus" She bit a great hole in the sandwich and chewed as she spoke. "... A Greek hero ... had a ship ... 30 oars ... they kept it ... hundreds of years after his victories." She crumpled the wrapper as we passed through Watford Junction. "As the ship disintegrated with age ... they replaced planks, the masts, everything. Exactly as before, bit by bit, until, over many centuries, the whole ship was rebuilt. So, here's the question ... is it the same ship?"

"Hmmmmmm."

It was safe now, the wadded wrapper rolling across the table between us. "But if you do a play," I suggested. "*Hamlet*, say, and replace the actor all time, it's still Hamlet, isn't it?"

"But you're just changing the actor not the role."

"Right, right. So at what point does it become not his ship, is the question. I mean, if Theseus came back he'd think it was his ship, right?"

"Right! It's a paradox. A new old ship. Right? The same thing that's not the same thing."

Duchamp would've loved this shit. A lot of recent art used ready-made materials, which could easily be replaced. I'd done it myself.

"So, you're asking where is the actual ship itself?"

"Exactly. Suppose you made a sculpture out of a stack of bricks.

Can you replace a broken brick? Or even all of them?"

"And still have the sculpture? Is the art in the idea or the object?" I said. "Is this art or is it philosophy?"

"Can you separate them?" Behind the heavy tortoiseshell glasses she batted her eyelashes.

More stink of think!

Philosophy was in everything, wasn't it? The pants you put on, or didn't. How we define the world. Since Cubism, when art became self aware, many shifts and isms had vied to remove the crafting hand from art: collages, found objects, thrown paint. The most recent being Minimalism where the physical sculpture was usually made by someone other than the artist; a machine, a fabricator. If the hand of the maker didn't matter then the core was the conception. Thought rather than its physical manifestation, the very language itself, was the essence of the art. How to get at it without the concomitant object?

"What are you working on?" She asked.

I had become intrigued by the relations between things, I told her, how nothing seemed to exist in isolation. I was fascinated by how objects, emotions, thought, influenced one another, the importance of context and language. The butterfly in asia causing the hurricane in the Gulf of Mexico. I was amazed at how the mind stored and associated things, some long forgotten, consciously and subconsciously like the madeleine in Proust. Like the montage effect in movies where disassociated images, cut back and forth, created a whole new interpretation by the audience. How custom or prejudice created things not seen. Inside one social group, outside another.

"Always something influencing..." She said. "Unnoticed ..."

"The dog that didn't bark," I grinned. "You're never alone."

"How're you doing that?"

"That's the hard part."

I told of my attempts to use words, language and numbers, to make reproducible little books rather than single objects. In the idealistic zeitgeist of youth and the sixties, making object d'art for the very rich and privileged few seemed like heresy.

"You're not alone either," she said.

It was fresh ground being pursued by a number of young artists, in different forms, in different countries. It would soon become known as Conceptual Art. It was a new direction which allowed for many things. Artists photographed, spoke or danced, others philosophized, some worked with language or numbers. And yet for artist the persistent question remained – what to express and how to express it?

Staring at the passing fields of yellow mustard rapeseed from the train window, I thought about the "buke" – the way my dad pronounced it. I didn't find any dirty bits that first look, only a bunch of characters who were just like my very Irish aunts and uncles. I admired it enormously but the genius was overwhelming. If this is what it took to make art I was in trouble, struggling just to scratch the surface. I had to learn. Seared deep into my psyche was the knowledge that my father abhorred his job and hated going to work every day. It killed him way before his time. Long before deciding to be an artist, or anything else, I was determined not to live like that. But maybe I was more like him than I thought. Would I end up making little statues of *Ulysses*?

Barbara was writing in her notebook. True to herself she wrote loudly and in full colour – cursing and objecting, as she underlined, switching coloured pens. She laughed, crossed out and capitalized as she ravaged the page. When she paused I asked her if she had ever read *Ulysses*. She didn't look up from her writing.

"Hasn't everyone?" she said.

No. No they hadn't. I was only part way through. I turned the page. At five to three the Superior, the Very Reverend John Comnee S. J. sets out on his walk through Dublin. It is the section of *Ulysses* known as the Wandering Rocks. All of the many incidents in Wandering Rocks take place simultaneously between three and four o'clock in the afternoon, with some part of each incident linking into another. It was cubist simultaneity, synecdoche, the self-similarity idea, the recapitulation theory, Vico's recycling, history repeating itself. Ah ha! I was beginning to get it, I should steal some of this for my own art.

Over the months Barbara had introduced me to a number of young American artists who were passing through London, coming from Rome or Dusseldorf or Paris, where they had shown their work. Sol LeWitt was the last one, a very pleasant man, but after traveling for days too exhausted to socialize. We'd meet again in New York. This time she invited me to meet the sculptor Carl Andre suggesting we meet at her flat in a Camden Town muse.

Coming out of her door, as I climbed the narrow stairs to her flat, was a delicate young woman with blonde wispy hair so pale it was almost white. She lowered her eyes, whispered a shy hello and ducked away.

"Come up, Kinch," Barbara bellowed as if I was still out on the street. "Come up, you fearful Jesuit."

So, she had read *Ulysses*; the opening page at least. She was still cranking at full volume, rumbling the walls of her tiny flat, as I entered. The attic room had dramatically sloping ceilings which forced everyone to lean and duck if they cared to move about. Barbara, well inclined to the left, greeted me with a glass in one hand, a bottle in the other. There was something different about her, I couldn't say what.

"This is Carl Andre," She waved the bottle unsteadily. She was already a little tipsy.

"Ah, yes, indeed," he confirmed from his corner. He didn't try to stand. I ducked in and offered my hand. He wiped his hand on his beard, and took it. He didn't really greet me so much as acknowledge me. His peremptory tone addressed a general audience.

In his early thirties, I guessed, of average build with an oversized head made bigger still by a mass of dark straggling hair that flowed over his shoulders. His facial hair sprouted to a shaggy beard that covered his chest. He was old Walt Whitman hairy, Karl Marx hairy. He introduced his girlfriend with a casual wave of his hand toward the empty doorway.

"Take a glass of wine." He was in command, casually dismissive without rudeness, gesturing to the bottle Barbara was holding.

She handed me a glass. "Carl just brought this from Germany."

The blue coveralls he wore were from Germany too, with matching jacket, the standard working man's outfit. His shoes were heavily laced American work boots.

"It says Quali-tät-swein on the label," he said. "I take that to mean quality wine ... though it could mean quality pig for all I know."

Barbara giggled, a proud eager hostess, and went ducking into

42

a corner for another bottle. In the last year or two Andre had emerged as a major force in the Minimalist movement. He enjoyed the attention, grew expansive, holding forth, an orator's hand held out to press the moment. He didn't speak conversationally, he intoned a kind of Dr. Johnson authority, telling you exactly what's what.

Marianna, the ghost-like girlfriend, apparitioned back into the room and stood silently watching. Catching my glance she rolled her eyes.

Barbara brought out photos of Andre's exhibition in Germany, and we clustered round. He used bricks, metal plates or concrete blocks. Rectangular industrial products that he set out in the form of grids or side by side in lines.

"The important thing is to keep each part whole and unchanged." She splashed more wine into our glasses and looked at him for approval. "Isn't it, Carl?"

She seemed giddy, an awkward, all elbows coquette. I'd never seen her like this; her usual boisterous certainty turned deferential. And where were her glasses? Oh ... of course, now I saw it – lipstick, mascara, she was all dressed up. Yes, she was in love with this guy. He was her guru. Her genius stomping over the rockery. And the bricks! No wonder so many of her deliberations on the train were built with bricks. She had been absorbing the ideas of the art world through these New York artists, and digesting them through endless discussions. I had been the unwitting recipient of an education.

"Each part being equal, no part greater than any other," Andre said. "The part reflects the whole,"

"Ah ha!"

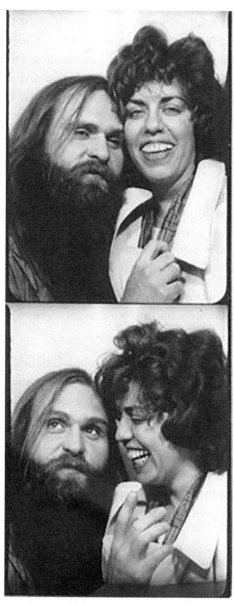

Carl Andre and Barbara Reise, 1968, London

Pleased with myself, suddenly able to contribute, I tried to expound upon what I'd been reading in Ulysses. Show off my newfound insights on part to the whole. How Joyce had jigsawed together ideas, symbols, reference – layered thoughts interweaving into a multiplicity of expression. How the Wandering Rocks section of the book was a reflection of Ulysses as a whole. It didn't fly. They looked at me quizzically, surprised, as if the spear-carrier had interrupted Caesar's speech. Perhaps I didn't carry the gravitas, or display enough Johnsonian authority.

"Ne'er." Barbara disapproved, glancing at Carl for reassurance. "It's ... it's"

"Equality of parts," he said. "Unobtrusive, non-phallic, coexisting. From each according to his ability." He shoved his hands into his overalls. "To each according to his need."

"You mean it's political?"

"Everything is political."

"But the meaning?" I said.

"There is no meaning," he said. "It just is."

This guy was a major hedgehog. His girlfriend vaporized.

It was obvious how the square related to the grid. How the brick sat side by side with like brick. Was everything else to be extrapolated? Was this the Minimalist exploration of elemental essence, or the dour face impotence? We sat and we drank and he grew voluble. He talked of railroads, of vectors, the Tet offensive, Dialectical Materialism, and the poetry of Ezra Pound. He was a poet too, and widely read and provocative: a very interesting man.

And a man so different from his art – his life expansive, his art re-

ductive. I was ambivalent, maybe he was a fox not a hedgehog. Did I think more of the art because I was impressed by the man? No question the work was original and just as he said – reflective of the manufacturing culture. Which meant it was also mechanical, uniform and repetitive. The mechanical and the repetition were intrinsic to the idea but it did become, after all – repetitive. Not the individual work but the making. Constructivism, espousing the glories of industry, reveled in the end product, never dwelling on the numbing monotony of the making - the machine. Inventing the assembly line was creative, working on it, soul destroying. This all too logical formula of grids and lines predetermining the outcome was too rigid for me. It gave the artist little to do. I was young, I wasn't ready for unemployment. I wanted optimism and play.

Eventually we made it out to eat at The Standard Indian restaurant on Westbourne Grove. The young waiter handed out menus while Dhanapati the manager fussed over our order.

"If I may be suggesting, we are having a very fragrant Lamb Pasander, this evening."

"Is that spicy?" Andre turned to his girlfriend. "You can't eat anything too spicy, right?"

"I want something hot," said Barbara. "Like a vindaloo. That's hot right?"

"That is very hot indeed, madam," Dhanapati smiled. "Are you being quite sure?"

"Hotter the better."

Carl was a drinker. Barbara, not so much, and she was pretty spiffed trying to keep up. For all his bombast there was something

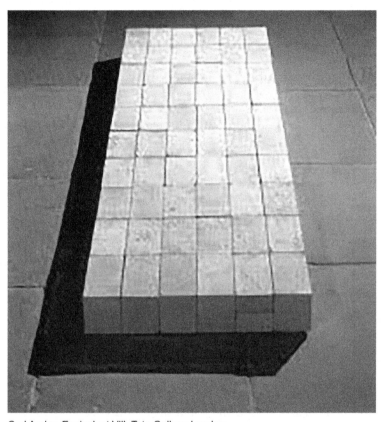

Carl Andre, Equivalent VIII, Tate Gallery, London

appealing about Carl Andre, perhaps better than all of us he saw through the image he presented. He gave us the bricks we built the facade.

"Do you know," he Dr. Johnsoned again, gathering us up with his eyes, "What polyandry is?"

"Your sister?" I blurted out.

We laughed. Silly drunken laughter; Barbara so hard she was howling into her curry.

"It's not that funny." Andre would brook no heckling. "Polyandry is ..."

"Oh, no!"

Marianna the spectral girlfriend spoke above a whisper for the first time. She was watching Barbara digging around in the vindaloo with her fingers.

"I got it." Barbara cackled.

She fished a contact lens from the curry. It sat steaming and sticky with turmeric and cumin at the tip of her finger. Marianna's quick hand shot out across the table and grabbed Barbara's hand before she could make a Cyclops of herself.

"So," said Barbara. "What did you think of Carl?"

The train pulled out of Euston Station heading north through the London suburbs. She had little memory of the evening and none at all of the Indian restaurant. What bothered me about Carl was not his art but his method. How could an artist of his complexity be satisfied with such constraints? His self-imposed rules left little

room to move: little room to fail and retreat, little time to doubt and contradict, no chance to concede the pedestal of perfection. Blake's road of excess leading to the palace of wisdom was the road not taken. Or was I missing something? It seemed a pyrrhic victory at best. With his options so limited I couldn't help wondering, without sarcasm, what he did all day. I preferred Picasso's kind of industry, the prolific output, the willingness to make a fool of himself, despite the enormous ego, then turn around and laugh at his own foolishness. There's something sterile about always being right. There just is.

"A fascinating man," I said, and meant it. In this and many later meetings I learned a lot from Andre, mostly about poetry and words. On the train rides Barbara had done a great job of filtering the ideas coming out of New York, I had learned a lot more from her.

For a long time after I finished *Ulysses* I was still dazed by its effect. I mulled over its significance while aware that I'd probably missed most of the fine detail embedded in the rich layers of the book. Joyce was the Sherlock Holmes of seeing, noticing, speculating on the turn of phrase, the speck of mud on the glove, the angle of wear on the heel, the sigh in the song. The living organism of a city came to life, moment to moment, the interdependence of everything in the mind and to the senses. The smallest detail growing rich in the imagination of his characters. The real interwoven with abstract thought and philosophy. The city breathes vitality. Isn't that what art should do?

Then early in that summer of sit-ins, bed-ins and moon landing my life took a sharp turn. Out of the blue I got a phone call. Two women from New York were in London and wanted to visit my studio.

Was this Barbara's doing? I didn't know. I had never had an official studio visit before, and I wasn't sure how to handle it. Of course other people came by all the time, artists and friends, but these were professionals; people who knew a thing or two. When they arrived I was surprised by how young they were, and accomplished – Betsy Baker was already the editor of a major art magazine and Diane Waldman a curator at the Guggenheim Museum. They were traveling around Europe looking at the work of young artists. That they were smart and knowledgable was obvious, and like me, they were trying to figure it all out. We talked for a long time that day and, as they were leaving, they suggested I might find a better reception for my work in New York. When they returned to America they recommended me for a teaching job. So I was headed to New York, but first a diversion – California.

```
a  b  c  d  e  f  g  h  i  j  k  l  m     o  p  q  r  s  t  u  v  w  x  y  z
a  b  c  d     f  g  h  i  j  k  l  m  n  o  p  q  r  s  t  u  v  w  x  y  z
a  b  c  d  e  f     h  i  j  k  l  m  n  o  p  q  r  s  t  u  v  w  x  y  z
   b  c  d  e  f  g  h  i  j  k  l  m  n  o  p  q  r  s  t  u  v  w  x  y  z
a  b  c  d  e  f  g  h  i  j  k  l  m  n  o  p  q  r  s     u  v  w  x  y  z
a  b  c  d  e  f  g  h     j  k  l  m  n  o  p  q  r  s  t  u  v  w  x  y  z
a  b  c  d  e  f  g  h  i  j  k  l  m  n  o  p  q  r  s  t  u     w  x  y  z
a  b  c  d     f  g  h  i  j  k  l  m  n  o  p  q  r  s  t  u  v  w  x  y  z
```

negative, white papers, 1968 - 1971

51

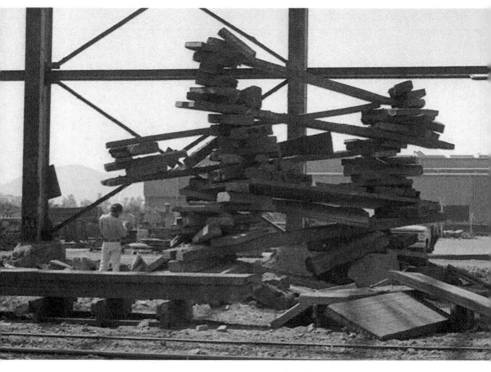

Stacked, 1969, Richard Serra's sculpture at Kaiser Steel, Fontana,
CA. Mount Baldy in the background. Photograph: Michael Harvey

Desert Steel

As the plane took off for America, climbing into the skies over London I thumbed through the Evening Standard. A tiny squib of an ad. caught my eye – Sun Tours. Holiday on the Costa Brava. How I could I forget? My first summer in London, a few years earlier, I had needed a job. Sun Tours was hiring with few requirements: a passport and a clean driving license. Tours was run, out of a closet office, by a couple in their mid-thirties. A prim, matronly blonde and a silent cherubic man. Miss Prim, clearly in charge, gave me the once over while he checked my license. The whole thing was settled in minutes and she left the closet. Right away the silent cherub began a sputtering suppression of lascivious giggles.

"We don't pay much," he could barely contain himself, "but you are going get laid this summer. More fuckin' than you ever dreamed of. Sex, mate. Loads of sex."

"That's the job?"

"A benefit. Biiig benefit."

The actual job was to drive a mini-bus from London, via Paris, to a small seaside village on the Costa Brava just north of Barcelona. The drive there was to be made with one stopover for a night in Paris. The trip back had to made non-stop, a sixteen hundred mile drive without a break. You could see why they were easy on the requirements.

I picked up my first passengers that Saturday morning at Charing Cross Station in the center of London. A dozen benighted young men and women in their twenties, already old, with thinning hair, paunches, poor complexions and bad posture. They were England before the sixties – rationing, bad plumbing, poor heat, and hard times. Words like chilblains and bunions clung to them, words you rarely hear any more like – wens and warts, corsets and scullery, were part of their lives, part of a fading past. Young people with low self-esteem after a risk free Continental holiday. All that glorious Spanish sunshine with lovely beaches, and tea, and fish and chips – and none of that foreign muck.

Twenty hours south of Paris the sun came up as we passed over the Perpignan mountains. They slept in the back, I almost slept at the wheel. Around seven they staggered, half dead, from the mini bus to begin their vacation. The tiny one-street village had been transformed into a British High street set down by the ocean in sunshine. There were tea rooms and snack bars, fake English pubs and discos and fish and chip shops. A Spanish hostess, the only one I ever saw, led me to a room where I could sleep.

I woke to the sound of a Scottish voice shouting. A voice full of merriment. It was in my room, sort of. The room was a typical Mediterranean cube with stucco walls and a single window facing the street. It was deeply shadowed by the afternoon sun but I had no difficulty making out the form by my window: the most

beautiful naked ass. She was leaning out talking to a friend in the street below, the bath towel meant to cover her risen up as she leaned, presenting me with my bedside greeting.

"Hello," she turned to me. "Did I wake you?"

Her head was turbaned in a second white towel. She was lovely.

"It's okay."

"My name's Irene." She stressed the last e.

"Where are we?"

"This is where the help stays. All the girls have been in already to take a wee look at you." She grinned.

The help was mostly British students with a few 'adults' thrown in, men who had never grown out of 'party' mode. Sun Tours encouraged the help to mix with the clients, loosen them up, get them to spend. The water-ski instructors made a game out of fucking as many women as they could until it became too easy. Then they held competitions with the tennis instructors to see who could sleep with the ugliest vacationer.

"The gals dunnay sleep wi' the clients. That's just the lads," Irene was firm.

It was Monday and I didn't make the return trip until Saturday. During the week I spotted her in bars and discos having a good time. But at siesta she would always show up in my room to talk.

The return trip to London was to be nonstop. A thirty-six hour drive that would land the passengers in London late Sunday night in time for the poor bastards to get up for work Monday morning. It was a different group than I'd brought down. They got to stay two weeks and get as red as lobsters before we dumped them back

on English soil looking green and ill.

When I checked in at the office the cherubic owner was amazed I'd made the trip without amphetamines.

"They're over counter in Spain," he said. "Stock up."

Saturday I was back at Charing Cross for my next group. They were the same age and class, but different from the first – outgoing, confident and better looking. They were what the first group would have called brassy; Mods of television and transistor radio England, in cheap trendy clothes and stinging aftershave, the women in heavy mascara and mini-skirts. If the first lot were mousey this lot was flashy. The flirtations started before we made the outskirts of London and were hot and heavy by nightfall in Paris.

I don't know how long I slept when we got to Spain, but when I woke Irene was there. For the rest of the Summer she kept me tantalized, infuriated and bemused. Each time I had to leave she was angry, when I returned she was passionate. I loved her fiery spirit. She was like a volatile Sophia Loren or Monica Vitti in some Italian movie, abruptly careening from mood to mood. Always looking for the fun.

Back and forth all summer taught me one thing - I didn't want to be like these holiday people, beaten down and given in. If becoming an artist seemed impossible before, it was imperative now. I had to learn. Back in London Irene and I hung out together for few months but she grew restless. My enthusiasm for art, for filmmakers like Eisenstein or Godard, just plain bored her. She wouldn't sit through Waiting for Godot or Marat Sade. And the books I read were no fun at all. Irene was a party girl ever after the good time, peddling hashish to float the life-style. We gradually lost touch.

The plane made a broad turn on approach to LAX. I gazed at the sprawl of Los Angeles sunning itself below. My first sight of California. The weary businessman, next to me, had busied himself with paperwork the whole flight barely acknowledging my existence. As the plane began its descent, without looking up he casually said:

"L.A......Eighty miles wide and half an inch deep."

With a neon blue sky like the postcards. It was just what they said it would be, and it felt unreal. After the chill grey streets of London's East End, where hunched introspection was the natural inclination, these canyons of L.A. were bursting with light. A brightness so startling that simple, ordinary things jumped out in high definition. How could climate not affect your outlook? Hard to brood on hidden depths in a place where every surface simply shimmered. I felt like I'd emerged from a Sun Tour bus full of those Dickensian chilblains into a resort of beautiful tan people with perfect teeth.

"Out in the desert" was not a phrase I'd heard a lot in England. It wasn't something that came up in conversation, unless you'd just seen *Lawrence of Arabia*. From Jane it sounded so natural. She worked at the L.A. County Museum and she said I should meet a young sculptor who was working "out in the desert." How romantic. I pictured warm winds and shifting sands. The map showed Fontana, where I was told to go, out on the San Bernardino Freeway. About an hour away. Another paradox of Los Angeles - everywhere was an hour away from anywhere else.

The image of rolling dunes hung with me until the old beater I'd borrowed for the trip was rattling along the freeway; cruising

from that crisp Hollywood light into a miasma of grit and heated gas fumes. People in West Hollywood didn't go to Fontana. All anyone could tell me was that it was the home of Kaiser Steel and the birthplace of the Hell's Angels.

In 1947, motorcycle gangs with names like The Boozefighters and The Pissed Off Bastards of Bloomington, had trashed the small town of Hollister, CA. A Brando movie, *The Wild One*, had made it mythic, and one of the Pissed Off Bastards, split off to start his own gang in Fontana *The Hells Angels*. Bikers were an ambivalent part of the counterculture, romantic rebels, highwaymen tearing up the freeways. In truth, beyond a bunch of scary looking dudes in greasy jeans, tattoos and chains, most of us had no idea what The Hell's Angels were really like. It took The Altamont Speedway concert, a few months later, where they beat a guy to death, to show us.

On San Bernardino reality began to sink in: no swirling sand dunes here, only swirling plastic bags, a burning sun, and grime. With a busted A.C. and all the windows open, the toasted air blew grit and candy wrappers through the car. The landscape was flat and dusty on either side of the Freeway. Dead bugs and industrial crud built up on the windshield, sweat on my shirt, Crosby, Stills, and Nash on the radio. They'd already played "The Road To Marrakech" three times since I left Laurel Canyon.

Nearing my exit the landscape was a gritty industrial wasteland of run-down buildings, Kaiser Steel signs, chain link fences, rail lines and mountains of slag. Off in the distance, Mount Baldy to the north, the San Bernardino mountains to the east, shimmered through tangible air. The empty streets around the Steel plant were named for trees: cherry, poplar, redwood but the only trees I saw were dust covered palms. So this was the desert.

Kaiser Steel was everything industrial and hard, everything that makes you feel small and vulnerable – miles of sprawling train tracks, overhead cranes, rusting sheds, slag heaps, out-sized trucks, shovels, front-end loaders. Men in hard hats went about their business moving steel through heat that baked the day. Given a hard hat of my own I was driven out to an older part of the plant, and set down by a big pile of scrap. It was quiet. Hot and incredibly quiet.

"Hey."

A young guy, about thirty, medium build with bushy brown hair peeling out from under his white hard hat appeared holding out his hand in greeting.

"Richard Serra," he said with an easy grin.

I was pleased to see he had European teeth, not the movie star smile I'd come to expect in past few days. He had the look of a worker cleaned up after a hard day, freshly showered and shaved and spruced up, his work shirt sparkling clean, his blue jeans freshly laundered, only his torn and beat-up work boots gave away what he did. He was raw as the iron he worked with and made me feel kind of prissy standing next to the heap of scrap.

"So, come look."

He wasn't much for small talk. No offers of sodas or coffee, no questions about the traffic. He never asked where I was from, never mentioned where he was staying. It was all about the work. The big heap was his sculpture. He was building a pile. A mound of scrap – rocks, metal, concrete, wood beams - that was at least twenty feet high. We walked around it picking our way through fallen pieces that littered the ground.

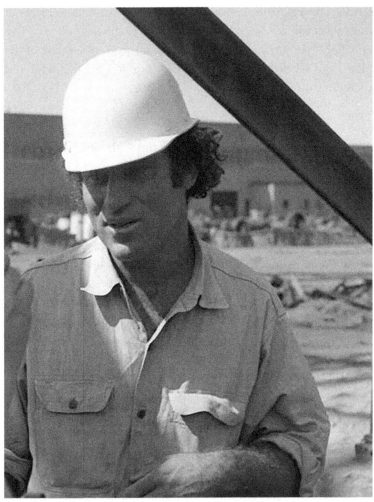

Richard Serra at Fontana Steel, 1969. Photograph: Michael Harvey

"Yeah, yeah."

He was in conversation with himself. It gave him pleasure to stop and look up at the forces of compression and gravity that held the pile together. Giant beams lay at precarious angles pinned in place by counter weights and opposing bulk. Words like ballast, load, mass, density, torque, tension came to mind – it was the physics of sculpture. Small rocks and other detritus made spindly staircases to nowhere that supported other beams. He had set force against force so that parts of the heap, precariously out flung, hung in danger of imminent collapse. They barely clung to their anchors. Improbability defined. The pile had an almost goofy whimsical quality. A loony acrobatic balancing act teetering out here in the desert – though not his intention to be sure. It was clear from the moment we met he was not a whimsical guy.

"It wants to bust apart," he said. "You can feel the pressure, the strain."

He pointed to crucial spots in awe of the tension they contained. It was a heap of vulnerabilities. That it held at all was unfeasible, and yet it stood. It lived in that moment of anticipation when something is expected to come crashing down.

He called it "Stacked."

"Yeah, with the overhead crane."

I looked up. As big as his pile was it was dwarfed by the overhead crane.

"Whoa!"

It was so enormous I hadn't seen it overhead. Made out of I-beams it formed a skeletal ribcage that seemed big enough to encase the Titanic. The ribs so open, so widely spaced you lost sight of being

underneath anything at all. The crane itself crawls along the length of its spine delicately sorting, picking and stacking like a miser counting change.

The operator, a company man, with a mountain man beard out in the desert (or maybe one of the bikers), strolled over to say hello. He seemed to get a kick out of his assignment, helping this crazy kid build a pile of scrap. Richard picking out the pieces and directing their placement gave him a fun kind of challenge. How many times, I wondered, had the heap collapsed as they built it. The two men seemed to get along through a mutual respect for the work, through respect for the power of steel. Richard obviously felt at ease with these guys who worked with their hands and their brawn.

"Yeah. My dad's a pipe fitter," he said, "in the San Francisco shipyard."

Like all shipyards, San Francisco's is immense. Once considered the largest in the world. Everything about shipyards dwarfs humankind. Gigantic cranes, steel plates of unimagined size, even ordinary hand tools are enormous.

"Yeah. He's Spanish, yeah. When we were kids he'd sit us around the kitchen table after dinner and make us draw. Loved that, yeah." He set a beaten boot on a small piece of metal. "I worked in steel mills to get through college. I've been around this stuff all my life." He turned over the chunk of steel with his boot. "Know what a Puddling is?"

"Nah uh."

"Heating the metal 'til it turns liquid. I've been doing plumbing in New York so I got into molten lead. I'd heat it to a liquid. Take a ladle full and throw it against the wall – right where it meets the

floor." He swung his arm to show his throwing action, "Wham! Soon as it hits, it solidifies like this." He brought his hands together at right angles. I had this long, L-shaped splash of metal. Like a three-D Pollock. Here to there." He pointed to a rusted I-beam ten feet away. "And when it cooled I could rip it away, the whole piece – intact. It was like Detroit. I'd throw another. Pull it away. Throw another, pull it away. A production line, man, just like Detroit."

We hung out kicking rocks, taking in slag heaps, talking of art and steel and other sculptors, like Smithson and Andre, with a fondness for heavy industry. They were another facet of the sixties. Not Pop or celebrity driven, nor glimmering surfaces, or tie-dye shirts and dreamy flower-power. The original Romantic poets were against the Industrial Revolution, these guys loved it. Since World War II, America had been on such a high, such rush of production and expansion. These guys were the Romantics of heavy industry, oil rag in their pocket, they rejected the high gloss, the technicolor surface, they loved the hard steel and furnace, the production line and manufacture, the grit of industry. The sheer scale of Stacked made you take it seriously. The immense physicality reminded me of the famous Howlett photograph of Isambard Kingdom Brunel in front of the shipyard chains. It was a different kind of patriotism. These guys didn't wave flags, they savored a visceral connection to these vast open spaces, rich in geological time and minerals, still rough hewn and full of potential. Steel and the landscape, railroad men making time.

I took photographs. The shimmering heat of the afternoon and dry dusty valley slid away to the distant mountains. I kept meaning to ask if the pile ever collapsed as they built it, but somehow I'd missed the chance. It would be fitting to the tenuous and precarious nature of the over stacked stack. But I only remembered when I was on the freeway headed back to West Nirvana.

At the house in the Hollywood Hills industrial grime was like the flag on the moon, a million miles away. Idyllic days spent on the patio gave me time to consider myself in relation to these enormous sculptures, these monumental works of Land Art, these epics in Cinemascope and culture. They were not my nature. I was a jumpy fox who needed to run from scent to scent. I was the small independent movie, more *Brief Encounter* than *Lawrence of Arabia*.

Abruptly the mood of the house changed when the jaunty newsmen, snapping inanities about each others styled hair, turned deadly serious. Savage murders in a house on Cielo Drive drew us in around the television. Cielo Drive was close by, close enough to get our attention.

They were not ordinary murders either – domestic troubles, bungled robberies, or gangland slayings. Sharon Tate, a young actress, and several friends had been brutally butchered in a lavish, upscale home. Blood everywhere. The whole thing seemed incomprehensible. The next day, Aug 10th, news of more senseless, bloody murders close by – Leno La Bianca and his wife had been savagely, almost ritualistically, slain. This time there were messages scrawled in blood - "Death to Pigs" and "Helter Skelter". There was something chilling in that phrase – Death to Pigs - we all recognized it as a counter-culture proclamation, something used by the young. Was this love and peace gone awry? A macabre twist in the cult of youth?

A day or two more and our mood changed again. Televised pictures of thousands of kids, our age, gathering up-state New York at a place called Woodstock. We watched in envy. Three days of music and mud. Janis, Joe Cocker, The Dead, Creedence Clearwater, Crosby, Stills, Nash and Young, The Band, and Jimi. It was good again to be young in sixty-nine.

I had no inkling meeting Richard out in the desert that in a year we would be next door neighbors in New York. The Washington Market, now Tribeca, was almost as forlorn as the San Bernardino wastelands. But there were bars like Barnibus Rex, Magoo's and eventually Puffy's. One night, many years later I stopped by Magoo's to buy cigarettes. It was near closing and the bar was empty save for a couple over in the corner. The woman had blonde hair.

I was at the vending machine when she appeared beside me.

"Do you not recognize me?"

Her hair was not so silky, her skin a little worn, she was older, as was I, but how could I forget Irene Maxwell. I had not seen her in a dozen years and here we were all grown up in dingy Magoo's. Here was Theseus' boat – our planks had changed but in common memory we were still the same. Even her Scot's burr had changed little. We embraced and kissed and talked and embraced again. She was still the feisty, exuberant young woman I'd known years before. How impossible to fill in those years in a few minutes of excited talk. And her possessive date had already grown impatient and was tugging at her sleeve. We arranged to meet for lunch the following week.

It was not more than a few days after we met that I was out doing an errand on Chambers Street, a block or so, south of where I lived. A news seller had the *New York Post*, the afternoon paper, on display and the headline was: Dress Designer Murdered. There was no mistaking her picture. Irene and a girlfriend, Stacey, had been heading for night in Puffy's bar, right around the corner, when two teenage boys who had followed them from the subway tried to rob them. Irene, spirited as always, told them to fuck off. One of the boys stabbed her.

Later, the boy's father, a Brooklyn minister, turned him in.

And even then there was another layer to a memory that started long ago in Spain. Twenty years on I was at a backyard barbeque, when artist, Martha Townsend, told us of the night that she and Eric Fischl and friends had set out for Puffy's bar. A block away they had come across Irene dying on the pavement. The ambulance was summoned and Irene was rushed to the hospital. The others followed only to be told there was no hope. The blade had pierced her heart.

white papers, 1968 – 71, a book of 71 white cards with a seperate idea on each
to be read in no particular order.

Mia Fitch Agee, photograph by Walker Evans, 1939
Metropolitan Museum of Art, N.Y.

What do artists do on Tuesdays?

Reaching New York, to take up the teaching job, I stayed in the West Village, at Mia's house. I had met Mia and her family in London years before. By the time I arrived Deedee, the eldest, was married to the sculptor Bill Bollinger. Andrea and John, were away at school. Mia said I could stay until I found a place of my own. My room was in the basement, at the front, with an eye-level view of feet passing back a forth on the sidewalk. An old federal brownstone the house, and particularly my room, was rumored to be the place where Burr hid out after his duel with Hamilton. I have no idea if that's true or not.

Mia lived simply on the ground floor. The upper stories were rented by a family with three girls. I rarely saw them, except for Charlotte, the youngest and loudest. At age seven, Charlotte was a wise-ass, lithe of limb and agile. She made it her business to have her presence known throughout the house. I had not un-

packed my bag before she presented herself, vigorously kicking at my door.

"Why are you here?" She demanded.

She was a pretty, dark-eyed girl, with a very mobile face. She informed me, with rubbery expressions of delight, that she lived upstairs, where her father was, at that very moment, standing on his head. At my questioning look, she grimaced eye-squeezing disdain and yukked: "Yoga!"

The School of Visual Arts, where I was to teach was familiar, just like the art schools I'd seen all over europe: rooms full of easels and the universal smell of oil paint. The art was not too different either, student work is student work. There was one big difference, though, the school was not yet accredited, so instead of a sedate, controlled academic atmosphere, it was a very loose and open place – a sort of Dodge City before they tamed the west; right in line with the sixties: long hair, rock 'n' roll, Vietnam vets. Acid was the drug of choice which often gave the classes a weird, unpredictable slant. Showing up for class was a hit or miss affair.

Back in my room, after class, I'd barely get through the door before Charlotte would come crashing in demanding attention. If I was alert enough to lock the door she'd kick and holler until finally one of us gave in. If it was me she'd start a monologue, a stream of consciousness while swinging from the furniture. If I held out I'd hear her clomping away up the narrow stairs to the kitchen, and moments later hear Mia's shout: "Charlotte, go away!"

Much as I loved living at Mia's house I had to find a place of my own. I went looking for a loft. They didn't advertise lofts; you had to go banging on doors, asking people on the street, people who

couldn't understand why you would want a loft. Other artists were living in the industrial district south of Houston Street that was lately being called SoHo. I wanted to live there too. The flavor of worn stoops, peeling bodegas, fire escapes, and loading docks was more appealing to me than the fabled New York skyline. There was a gritty, depleted look to the area at the end of the sixties, as if any fresh color had all aged into uniform grayness. Dead businesses, were dumped at the curb: desks, chairs, machines, file cabinets, tossed aside like empty soda cans. The musty smell hanging over it all was a century of sweatshop musk, a thousand small manufacturers gluing, drilling, stitching, stuffing, printing, all blending to one indefinable tang.

A swivel-eyed rag merchant in a greasy once white shirt and yarmulke showed me a third floor loft on Greene Street. It was big and dark, a single bulb against the gloom, the huge windows so etched with dirt that little light would come in even if they were cleaned. The dull gray walls were giving up their plaster, the high pressed tin ceiling showing rust, and the floor covered with bales of rags. It was perfect.

"Any rats?"

"Same everywhere.

He was bored I was entranced. Graffiti scratched into the wall caught my eye, a cartoon head with a big nose looking over a wall, known in England as Chad.

"Hah!" I pointed.

"Kilroy." He nodded, unamused.

There was writing scrawled around the goofy head: "Judge Crater was here."

"Kilroy?" I was intrigued. "Who's Judge Crater?"

"The fuck should I know?"

He sucked his teeth. Out of patience with my questions, and graffiti, he started for the stairs giving me a take it or leave it price beyond my means. I saw eight more lofts that day, full of ball bearings, scrap, plastic flowers, buttons, reeking hides. They were all too expensive – the local merchants had caught on that something new was happening in SoHo.

The kitchen of Mia's house was a neutral zone, I rarely entered Mia's apartment, she never looked into my room. The kitchen was a wooden extension, a long narrow box like the galley of an old sailing ship, sticking out from the brownstone into the back yard. There was a table at the far end but barely room to get to it, or pull out a chair. It was built for a smaller generation, we were grown ups squashed into kindergarten desks. Mia liked to sit at the table, drink tea and read. I didn't realize it at the time, but it must have given me a sense of security in the new city, like living with your mom. Though close in age to my own mother they were opposites. My mother was an earthy Irish farm girl, up at five to milk the

cows and churn the butter, little educated, and always on her feet - a source of inexhaustible energy. I have no memories of her sitting down and certainly never reading.

Mia's house was full of books, serious books, literary books, many of them underlined and annotated with neatly penciled asides. Her name was Mia Agee, but the name Agee meant nothing to me, and no one in the family ever spoke of a writer. I spent weeks going over the shelves before I made the connection between the James Agee in the books and where I was staying. The house was not a museum, no pictures of him, no displays, no reference, it was a simple, unpretentious home. Tucked away on an inconspicuous shelf I found *Now Let Us Praise Famous Men* and between Walker Evan's photographs and Agee's prose I was transfixed, amazed at where I found myself.

Mia was an immigrant, like me, but from another world entirely, well read and sophisticated, a child of privilege. Born in Austria, and raised in the rarified atmosphere of Viennese intellectual circles; even trained as a concert pianist in her youth. A society of such delicate high-strung sensibilities epitomized by the story of Wittgenstein's brother playing Schumann on one of the family's seven grand pianos while the future philosopher lounged in the next room.

"No ... no. I cannot play," screamed the distraught young pianist. "I can feel your skepticism seeping under the door."

I asked if she'd ever heard of Judge Crater. "Yes," she said immediately, then pausing in thought. "But I don't remember why."

She was frequently as mystified as me about things American even though she'd lived here for thirty years. We sat in the kitchen between the old world and the new, and talked of books and music

and politics and, of course, the endless war in Vietnam. One evening, talking of when we first met in London, she casually mentioned spending time with Charlie Chaplin on the set of Countess from Hong Kong. How did she know Charlie Chaplin? Mia lowered her head, looking over her half-moon spectacles. "Oh, you know." She brushed it off.

Out again, along the streets, loft to loft. Beyond the expected "Esther loves Ralph" or the puzzling "Beulah tits" there was little other graffiti yet all but two of the lofts had some version of Judge Crater and the Kilroy cartoon. The phenomenon had been widespread, yet no one could tell me anything more than – "It's bin there forever." I was fascinated. Who was Judge Crater? My whim grew to obsession. The librarian smiled when I asked.

"The missingest man in New York," she said and led me to a file of microfilm. Pre-war New York had scores of publications, daily papers: *Herald, Tribune, Sun, Post, Mirror, News* as well as magazines, periodicals and trade papers like *Belting & Transmission, Carpet & Upholstery, India Rubber World*, and my favorite - *Dominant Band & Orchestra*. And in the fall of 1930 they were all focused on one thing: the disappearance of Judge Crater.

Belgrade Lakes, Maine, July 1930

Judge Joseph Force Crater was distracted; he looked out over the sun-soaked lake watching a small canoe in the distance. Was it a midlife crisis this weariness, this sense of futility? His appointment to New York State's supreme court was good, very good. The sweetener to Tammany Hall, a whole year's salary, was bad. Everywhere he turned someone had a hand out.

Still they came, unwanted thoughts: should he take the money or resist? Moral turpitude played no part, he'd already passed that point, he couldn't afford to give them leverage. Troubles. Troubles. The phone rang inside the cabin. His tailor. He hung up and walked back outside. The thought of Sally Lou his salty young mistress suddenly pushing at his groin.

His wife, Stella, made a nervous cough coming out onto the patio.

"Was that the phone, dear?"

"Yes." He didn't turn, his eyes on the distant canoe.

"New York. I have to go down to straighten those fellows out."

"But you just came back."

"I know. I know. It's the price you pay."

Stella nodded her disappointment at the flagstones.

Almost every block on my walk to school had some young, middle class kid panhandling. Another sixties curiosity. It would be cheaper to take the bus.

BUS STOP in red lettering, No Standing in black.

No standing? Huh? In England standing in bus queues accounts for a good part of your life. There was no one standing at the stop. There were people nearby standing in doorways, hovering by store windows. Apprehensive, I loitered nearby, waiting. Sure enough when the bus arrived people rushed from all directions. Amazed, I hurried after them. They didn't explain this in the movies.

It was several days before I realized that No Standing referred to autos, I'd never heard that term. It was the little things that slipped right by me. All the tiny nuances of everyday life that we take for granted: body language, social readings, idiosyncrasies of sigh and frown; subtle inflections all zipping by unnoticed giving each day an air of mystery, or maybe fog. You'll never understand us, a new friend confided, without having gone to high school here.

The art school, with its casual attitude, was a great place for young artists to teach. Roaming the classrooms I met a lot of my contemporaries. I found Sol LeWitt sitting in a classroom alone, reading the paper. I asked what happened to his students. He shrugged – no idea. I saw too what an odd role reversal there was at the school. It was the staff who were the lively iconoclasts and risk-takers, while the students were suburban kids who preferred more traditional forms of art. My classes were amused by my accent way beyond anything I had to say. They did impressions of me and they quickly grasped my naivete – I might know something about art but they knew America, they'd seen the movie being made. They knew the actor stood on a box, the actress forgot her lines, the director slept with the ingénue. I had only seen what was in the theater. They had lived the sugar high, the acid trip, the endless highlight reel of television. The following year the school fired the sixties crowd and hired a more sober bunch to insure it became accredited.

I looked at a loft in the East Village. The place was fine, Judge

Crater was there too, but the streets round about were still full of hippies in velvet pants, beads and patchouli oil. It wasn't serious. To a serious artist dress was important, a discreet study in unimportance. Even if you could afford something fancy you stuck with denim, men and women both – blue jeans, work shirt and work boots. Hair – long or afro. Beards – pirate style, no grooming or fancy shaving. Code variations allowed for pea coats, army surplus jackets, leather coats, etc. You didn't want anything that made you stand out more than your art. If you did wear something different it became a trademark like Andre's workers uniform, or Beuys' hat or Warhol's wig. You were not a hippy or a Beat. You were a serious artist and any kind of flamboyant dress was going to make you seem frivolous. For women the dress code doubled as feminist attire. You didn't see high heels, stockings, or chic hair styling or make-up, unless it was ironic or on a drag queen.

Bill Bollinger, Deedee's husband, showed his sculpture at the Bykert gallery with artists like Brice Marden, Peter Gourfain, and David Novros. Between the school, Bill, and gallery openings, I was meeting a lot of young artists. The New York Art World was so different from London. You didn't have to take a forty minute subway ride to see another artist, it was a condensed community downtown, South of Houston. And not at all precious, or exclusive, it was very

Bill Bollinger, Untitled, 1966. Two Wheelbarrows with Water.
Kunstmuseum, St. Gallen

open and friendly. Within a few months of arriving I knew more artists than I had ever met in England.

By moving to New York I'd become a "Brit." Hadn't I'd always been a Brit? But now I was the "BRIT!" responsible for the break-up of the Beatles, the weirdness of cricket and why Shakespeare was hard to follow. But the cultural handout, the birth brochure of Stonehenge and Knights-in-armor, is as real to most Brits as Robin Hood. For most of us there was drafty homes, men fixing the road, drinking tea; the yobo throwing up outside a pub; the teenage girl in curlers smoking a fag, and pushing a pram. Down-market Britain.

We learned of the other Britain at school, we felt the flesh-eating

ants covering Burton as he searched for the source of the Nile; we charged our camels "hut-hut" with El Lawrence into the rear end of Aqaba; we shivered, "Bradshaw! Sit up straight, boy." We shivered 'brass monkeys' with Mallory on the icy slopes of Everest, in a tweed jacket and a stout pair of brogues. Audacious Brits, solid chaps and I was not one of them. I had no taste for bugs and bites nor heat or ice. I didn't want to go where no man had gone before, I wanted to go where everyone wanted to go – to the movies

And to most of the world America was the movies, the USIA, whose job it was to spread American culture and propaganda saw to that: the Westerns, the love stories, the gangsters – we loved them. Marilyn had taught us how to be sexy, Bogart showed us how to be tough, Brando how to be torn and confused. The long, fin-tailed cars were as dream-like and unending as the magical landscape of Monument Valley. To an audience still on the mend from World War II, America was a fantasy flickering on screen, and words like mobster or gunslinger rolled off our lips as easy as bangers and mash. Americans loved their movies, to be sure, the great looking glass of the culture, but they could also look out the window for a reality check – not everyone drove Cadillacs, there was poverty and injustice – not everyone was singing in the rain. We didn't know that.

"Do you like Buster Keaton's movies?" Mia said.

"I've never seen one," I said.

"Oh, what a treat you have coming." There was a merriment in her eyes I'd rarely seen before. "The Elgin Cinema is having a Keaton festival."

I went the first day, out of curiosity and her insistence, and I was hooked. For the next two weeks I did little else but watch his films.

Mia would never go with me (the only movie we did see together was *M.A.S.H.* at a drive-in movie upstate – we loved it), but she couldn't wait to talk about what I'd seen. She was rarely funny herself but had a delicious response to the humor of others. Chaplin and Keaton were her favorites.

"We were at the studio once," She let down her guard, but still wouldn't mention his name, "when Chaplin was making *Limelight*. They were no longer young, Chaplin and Keaton, they were playing two old time Vaudevillians. The scene was so simple. All Keaton was supposed to do was walk on, cross the stage, and settle at the piano while Chaplin waited. Five seconds tops, that's all, simple, rrr-ight?" Her accent surged with her merriment. "But Keaton took fife minutes. He came on, he dropped his music, fell down, he got up, he lost his shoe. The stool was too low, he couldn't open the piano, on and on. Everyone was laughink so hard, the cameraman, the crew, everyone watching, everyone howling. He was brilliant. So incredible funny. Of course, Chaplin cut it out."

Searching neighborhoods, facets and asides of the city's demanding personality – contradictions block by block, who it was, assertive in its abrasive charm, showed who you were. Crater graffiti was so prevalent it began to provide continuity. The mystery of his absence consumed wood polishers and dye makers, fascinated soda-jerks, secretaries and rag pickers from the East Side to the West Side, who had scrawled mementos on walls, reveling in the puzzle of the missingest man. Had he disappeared on purpose? Or was he purposely disappeared? Was the corporeal Crater even important? Had he shown up he'd be long forgotten. It was only the mystery that lived; speculation made him a thing of the mind. He was everywhere and nowhere, his absence was his presence.

The industrial streets were changing, the people downtown in-

creasingly young. We met in bars, luncheonettes, going out for bread, coming back with a street found table, standing at the corner, hanging out on metal loading docks, sitting on stoops and talking. For the past couple of years numbers of young artists had begun to use the term Conceptual to describe what they did. It was a rational extension of Minimalism that had taken the artist's hand out of the equation; Conceptual art sought to remove the object as well. Exist in the mind like Judge Crater. Some said we were making the Emperor's new clothes, and maybe we were – you had to believe it to see it.

Consider the mind as the gallery, the museum. Any thought could be your art – as a thought, as firing synapses, conscious or even subconscious – memory, time, desire, epiphany, habit, confusion, meaning, absence as well as well presence – the potential was enormous; physical manifestation not required. Ian, a long thin fellow with pale skin and blonde hair swept back off a bony face, said his art was talking, just talking, about anything. He walked in doubt, perpetually torn by his thoughts – Kierkegaard of the stoop. Adrian, more attuned to popular culture, might break out a dance in the bank line (pre ATM) while she sang Aretha Franklin's R.E.S.P.E.C.T. Bob, an introspective man, disdained the showy frivolities of the art world. He liked the poetry of John Donne. Leaning on the dock he would talk of art made of xenon gas, or sending art via telepathy. Lawrence a soft-spoken mixture of street and intellectual, leaned another way, pushed his hands deep into the pockets of his leather jacket and suggested a stone had been thrown. Keith, the thoughtful Louisiana charmer who usually worked with light, brushed back his long dark hair talking of sound pieces with overlapping airwaves. Bill was into absurdist humor. His wry videos of his dog, Man Ray, were fresh and laugh out loud funny. These artists all seemed so bright and imaginative, that no matter which way you turned there was something new

and surprising – the vitality of youth. Someone put a foot up on a hydrant and mentioned systems.

"You know, the way Sol or Philip uses them."

I'd never heard of Philip Glass.

"He's a composer," said Keith. "Has a studio in my building on Mulberry."

The meaning of leaning: loading dock discourse demanded appropriate methods of leaning, standing, pacing and sitting to reflect a gratifying ideological weight.

So what was discussed?

Is context everything?

Are all words poetry?

Is gesture performance?

Must content equal form? Form equal content?

Is documentation art itself or just evidence?

What is art in the Age of Mechanical Reproduction1?

How can you own the art in art?

Was this art or just bad philosophy?

Once I knew for sure where I was staying Agee's presence, or lack of it, became palpable. The books became his the books, these were his annotations, a literary aristocrat whose elegant style was admired by the likes of poet W.H. Auden. Going to the movies, in the land of the movies, I couldn't but wonder what he would think. If movies were America, here was someone who knew America.

Mia rarely spoke of him. But it was clear that she had been undone by the loss. Her brilliant, charismatic husband had collapsed with a heart attack at forty-five, and she was cast into lasting sadness by his death. Melancholy thinned her hair, turned it white, made her old before her time. She had been young and vibrant when they married. Early photographs by Walker Evans show a dark-eyed beauty with luxuriant wavy black hair. She leans back looking off to the distance. Now the sorrow never seemed to leave her.

In my room I would think of her. One day I could hear her playing her beloved Mozart at the old upright piano upstairs. But she could get no peace.

"Stop banging, Charlotte. I'm playink," Mia called out.

"You stop. It's horrible!" Charlotte went on banging.

Grand Central Station, Monday morning, August 4th 1930

Crater woke to unexpected joy, a fresh taste in his mouth, an inexplicable lightness of being. Stepping from his over-night sleeper

on the train, dressed to the nines, he walked jauntily through the Plaza, an eye-catching dandy, tall and lean, in pin-striped spats and a panama hat, sharp even for the fashionable city. As he turned out of the station into Park Avenue and a searing heat wave, the hit from the latest Rodgers and Hart review rolled off his lips:

It's very fancy
On old Delancey
Street, you know.
The subway charms us so

And strolling south he made his way to his Fifth Avenue apartment where the heat had gained the day. He pulled down the shades against the glare of sunlight. Even so persistent shafts broke through laying golden lines across the polished furniture. And still he hummed:

When balmy breezes blow
To and fro.

He gave the heat weary maid a few days off, and took a cold shower. That evening as the heat relented he dined at Owney Madden's Club Abbey, a mob joint on 46th and 8th taking in Jean Malin's drag show. The following day, Tuesday, he was another man, different again, seduced by the allure of absence, his thoughts were

melancholy and detached. Gaiety had turned meaningless. An abyss. For Sally Lou he found no affection, no stirring of the loins. Nothing.

Mia looked alarmed when I walked into the kitchen. She opened the paper and smoothed the page against the tabletop.

"Did you hear that explosion this morning?" she said.

"No, I was at school all day. What happened?"

"Here." She turned the New York Post so I could see. "The Weather Underground. They blew up a house around the corner."

"Around here?"

"Eleventh Street. I heard it." she nodded. "Close enough."

Mia still rasped her Germanic r's when excited – words bursting through her accent, bare legs rushing through brambles. The bomb led to talk of war, and war to a memory of her youth. She told me of a picturesque Austrian market square where she saw Hitler.

"I was visiting Salzburg. I was young, maybe seventeen." She shuddered adjusting the scarf at her neck. "He stopped there to give a speech in the market square. It's very close to Berchtesgaden, you know, his country place across the German border. Like everyone I went to see him. I already hated him and his brown shirts. I don't know why I went. He was already a joke for many of us; they said his breath could turn milk sour. But I went. He made me cry. I was sooo angry with myself. I hated that man, I hated everything he stood for, but he was so good at ... how to say ... twisting words, sentiment, making lies, wrrringing emotion. Even as I stood there in the crrrowd, hating him, I hated myself more for

being so moved by his lies. Tears, tears coming down my cheeks. It was awful. The whole crowd was in tears."

It didn't seem that long after the Weather Underground explosion before the National Guard shot and killed four students at Kent State University on May fourth. The country was so polarized most Americans actually sided with the Guard. "They shoulda killed more of 'em," was a common sentiment. Days later construction workers attacked War protesters on Wall Street while Market Traders stood and cheered.

I rarely cooked in the kitchen, I ate out a lot. There were so many choices downtown: Chinatown, obviously, *The Pink Tea Cup* in the west village, *Sloppy Joe's* in the Fulton Fish Market, *Odessa* in the East village, *Katz's* delicatessen on E. Houston, *Puglia* on Hester Street. But, oddly, there were no Indian restaurants then, even though lower Manhattan, fourteenth to the Battery, was a cacophony of Melting Pots, markets, and myriad sharp-elbows looking for room. I walked street to street banging on doors. In Chinatown feudal scales of bok choy alongside a wooden crates of live chickens brought tears to an angry man – "You piece shit, stupid birds, you piece shit!"

Bagels from *Katz's* passing a Greek synagogue:

"She hit him. Didn't have no choice."

A shiny new Cadillac outside the Buddhist temple, the Canal Street market of "what is that thing?"

"Use it for anything."

Radio row through blocks of fabric bolts, scriveners supplies to cheese boxes piled on the dock.

"I took her in my arms. Commere, gimme a kiss. It was a night. A

Coney Island night."

Old streets of layered history: *Bandits' Roost*, Tong wars, *Five Points*, the gangs of New York,

"He'll do ten years for that," he laughed. "I thought holy shit!"

... and Little Italy, well ...

tell me what street
Compares with Mott Street
In July?
Sweet pushcarts gently gliding by.

Stream of consciousness thought treading on thought infectious notions slopping bucket to bucket the pull of the moon on the tide.

I found the perfect loft in the old Washington Produce Market. The predominant smell was cheese. There was no graffiti on my floor, though months later I discovered Crater on the floor below among the stacked barrels of feta cheese and Greek olives.

Mia was often stuck looking for the English word and increasingly she forgot the German word. She was in that immigrant waste-land – never wholly American, nevermore in the country of her birth. I empathized. I was not completely Irish like my parents, or wholly English like my upbringing, and now I was only partially American. I did not feel a whole anything.

"More tea?"

Down in my basement room I continued my search for enlighten-ment and the art I was making – a small box of cards with enig-matic statements on each that referenced language, anthropol-ogy, geography, numbers, music, etc. – anything I could think of, pursuing my fascination with the way things related, and altered

Notebook pages from 1970

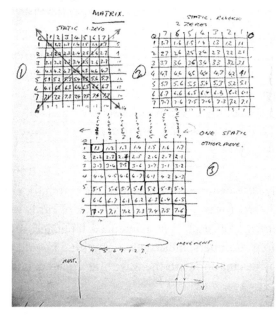

one another, and the synergy of the whole. And I was striving to understand things I had no real ability or affinity for. I read about mathematics, military strategy, or the theory of relativity, with little hope of grasping it, yet with the feeling that what did sink in would give me greater insight into the time and culture that I lived in. And, of course, I struggled with the concomitant question as to whether this is what I should be doing at all. I was a fervent believer in Joyce's line: "The supreme question about a work of art is out of how deep a life does it spring." And I was painfully aware that I was just skimming the surface. But I had drunk the Kool-Aid and wanted my life to be deep. It was certainly better, I consoled myself with the meager profit, than spending time on things I already understood, and gained nothing from. I wandered about my life with a sneaky suspicion that maybe all of it, the numbers, the language, the history, really were all somehow, interconnected.

"Charlotte! For god's sake stop kicking the door!"

"I wanna play."

"I'm trying to read. Go home and play. You're driving me crazy."

I wrote despairing, Beckett like, pleas and rants in notebooks:

I am an artist, what do artists do on Tuesdays? Artists make art. What is art? It's what artists do. It went on for pages, the kind of thing you do when you're young. I gave myself headaches.

Sunday was a bitter winter day. The deserted street had the feel of leafless trees in a frozen wasteland. We kept our heads down, muffled in heavy coats and scarves and watch caps pulled down over our ears. The wind blew hard against us, rattling signs, swirling trash, as we trekked across Bleeker street as far as the Bowery. We were happy to get indoors.

We had faced the cold and wind to hear to music. We flapped our arms and stamped our feet in the lobby of the old building – a forbidding fortress, empty and dirty with a sour industrial smell. It had a texture of grainy grayness with nothing friendly about it, no worn wooden stairs or open wood beams in the ceiling, nothing but cold steel and glass and concrete. We climbed the cement stairs to an upper floor, our hot breath ahead of us. And, of course, at the turn of the landing:

Wednesday morning, August 6th

Up-beat and dapper Judge Crater arrived at his courthouse office on Foley Square and sent his assistant, Joseph Mara, to cash a five thousand dollar check. On his return Mara found Crater had two briefcases packed and ready. He carefully counted the cash and put it in one case - the one he carried. The two men took the briefcases to Crater's apartment. He then gave Mara the day off.

Early evening he met Sally Lou and Bill Klein, a lawyer friend, at Billy Haas's Chop House on west 45th. "He was in great humor," said Klein later. "It was a little after nine when we left the restaurant, and he insisted I see Sally Lou home." Klein and Sally Lou got into a cab and, pulling away, they saw Judge Crater walking east on forty-fifth toward the Belascoe Theater.

Judge Joseph Force Crater was never seen again.

Brilliant sunlight filled the yard outside, shafts of intense white light cut the kitchen into slices of Rembrandt darkness. Mia and I were at the table drinking tea busy hating Richard Nixon. Mia's faint hair wafted in the breeze from the old fan turning on its Art Nouveau brass base, the off-kilter blade sputtering, humming a familiar tune.

"I like that old song," Mia caught it. "*Tell me what street, compares to Mott street.*"

"New York." I nodded.

"How'd you like it so far?" She said.

"I love the pace," I said. "I was always so impatient in England."

"Ah, speed." she smiled. "It's America. That's what it is." Animated, she leaned forward into the light. "Speed and success. They're the only consistent values in this country, everything else is merchandize ... nothing sacred. Satire tells you about a culture but you've got to have a constant, something stable you can work off. Look at Europe, the French. They had an Avant Garde because they have a consistent pompous academy that sets rules. Break the mold in this country and next week you're on TV; the week after that you are the academy. It's constant flux – the next big thing. The next fad. I didn't see that for years. You can't grasp America as one thing, from one point of view. It's constantly remaking itself like New York. There's nothing fixed about it, it's a ... what's it called? Those things?" She screwed up one eye, looking through something that she twisted in her hands.

"Kaleidoscope?" I said

"Ya. It's a collage of constantly changing parts," she said. "Charlotte, for chrissakes!"

I hadn't noticed Charlotte spidering up the wall behind me, suspended by doing the splits between the wall and kitchen counter.

"Charlotte! Get down," I said. "Go home."

"Dad's meditating. I have to be quiet."

"Deal with it. Go home!"

"I hate you!" She rubberized one of her stretchy faces, and slunk away.

"Emmy Kockenlocker," Mia sighed.

She set her cigarette holder against the ashtray and touched her thinning hair, self-conscious of her looks even among friends. We listen to the whirr of the fan on the counter. Neither one of us had witnessed the indelible shape-shifting influences that formed America; the soundtrack of jazz riffs, the absorption of mish-mashed immigrant cultures. As a foreigner I knew nothing of the vigor and invention that simmered beneath the Depression, any-more than I understood the refinement of the Viennese.

"Who's Emmy Kockenlocker?" I asked.

"A wise-assed kid in a Preston Sturges movie." She laughed. "Very funny. Now, he's someone who understood America."

Agee thought Sturges the most American director – all that zany cartoon speed, success, individualism, and contempt for stuffy academia. His movies are a unique blend of comic, intel-lectual and riotous blasphemy toward pomposity. The vitality of American life thrives on contradiction. It's not rational to hold two contradictory thoughts at the same time – it's essential.

The big shell of a room echoed with an edgy grating. It was a whole floor with industrial windows on two sides. Sheets of clear plastic covered the glass diffusing the light into a wintry haze. As the wind shifted outside the plastic bulged and sucked like gasping lungs, wheezing as they inflated, snapping as they caved against the panes.

We clustered in one corner, no more than twenty of us, all young

with abundant hair, still dressed in heavy overcoats and puffy down jackets. There was no heat so we left them on. The musicians had set up their stands, their instruments, keyboards, amplifiers, and soundboards but were nowhere apparent. I looked about recognizing a few people I'd met before. Keith, who'd first told me about the composer. Mary Heilmann and Jackie Winsor stood talking with Tina Girouard. Casually four guys peeled off from the muffled crowd and took their places at their stands. They kept on their coats and scarves and woolen caps. Only their fingers were exposed through the holes cut in their gloves.

The rest of us settled on the cold floor. I had no idea what to expect. Immediately sound saturated the room, music so different and startling.

For a while the cold of the cavernous icebox was forgotten as we were gathered up in its hypnotic rhythms. It built on repetition and systems of ebb and flow. One could pick out numbered sequences, the accumulations, the reversals. At points totally random to the composition the plastic on the windows would join in, suddenly booming out like full-blown sails; then whomping back with force.

The passing joint helped the mood but it couldn't do much for our numbing asses. One by one we got to our feet, stretching and cracking legs that had begun to freeze in position. The musicians, anchored to their instruments, must have envied us our freedom. The keyboard player was the most animated, swaying in the style of the mad composer.

"That's Philip," Jackie whispered.

The rest of the ensemble glanced at him repeatedly, watching for cues. He looked so focused, enthralled. Playing the keyboard

synthesizer, from time to time, he would lean far back and then lung forward throwing his mop of hair at the keyboard. In transports of rapture, I assumed, but apparently it was the signal, for a change that would come a number of bars after.

The music lasted an hour or so; the sound building and flattening, plateau on plateau, racing then dawdling, swirling, it gradually formed into a blizzard all around us. Overwhelming it finally came as an avalanche rushing down upon us and stopped.

The silence was stunning. Absence as presence.

Absence as mystery. Stella finally reported Judge Crater missing on September Third. She'd tried to find him herself but ran into a gauntlet of obfuscation and misdirection from his friends and associates trying to avoid the law. The Agency said the ticket was picked up that evening. When the police went over his apartment they found luggage but no briefcases, no files, stocks or cash. Stella, distraught and fearful, remained at Belgrade Lakes into the snow and ice of January 1931.

When she returned to the Fifth Avenue apartment she found in a drawer that the police had already searched and found empty, the checks, stocks and money, along with note listing his financial assets and signing off – "I am very weary, Joe."

Too much tea. I got up and to went the bathroom off the hall. A typical New York bathroom, small with a scalding hot pipe running floor to ceiling, the floor tessellated with little octagonal Italian tiles. Drying my hands I avoided the scalding hot pipe, my eye falling on the photograph curled around it. It wasn't the first time I'd seen it and more than once I'd been tempted to look at it. Giving in to my curiosity I pulled it free: a photograph, little bigger than a snapshot. I didn't recognize the person in the picture. On

the back, in neat small script it said: To Jim, love Walker. Walker Evans his collaborator on *Now Let Us Praise Famous Men*. The only open acknowledgement of the pair in whole house.

I took the photograph back to the kitchen where I unfurled it on the table to show Mia. She looked down at it through the half-moon glasses without reaction.

"It's being ruined by the hot pipe," I said.

She gave me that look over the glasses, nodded and slid the photo to one side. It rolled itself up and lay. I felt foolish for having interfered.

Absence as void.

The next day the photograph was back curled around the hot pipe.

Robert Rauschenberg performing in Pelican with the Judson Dance Group.
Photograph:Peter Moore

Name dropping

"I hated the name Milton growing up. Hated it. It's not a man's name. I knew it'd be the first thing I'd change the day I left home."

The table went quiet. We knew from the tone of his voice this was something real, something important to him.

"When I walked up to the window at the Greyhound bus station the guy said, name?"

"Rauschenberg."

"Spell that."

"He was writing out the ticket. I spelt it for him."

"First name?"

"I hesitated a second then blurted out – Bob! ... There's a man's name, Robert. I expected him to stick his hand through the window and grab me. He didn't even look up; just wrote out the ticket and slid it under the grill. I looked at it, there it was – just like that I was Robert Rauschenberg."

Rauschenberg laughed. He was Bob not Milton. He was rust, broken buckets and bedspreads, Dante and old tires, rockets and cockerels, Venus and goats. Head thrown back, he laughed out loud his voice bubbling, even after the punch line was thrown, as if the story went on gurgling inside him. He liked his audience captive, sitting around the long scrubbed-top kitchen table in his loft: the usual gang of studio assistants, friends, casual drop-ins, and hangers on who fed on his hospitality. The scene went on night after night whenever he was in town, up from his place in Captiva, Florida. It was cold that night and the rest of us around the table had the New York winter pallor. He had a movie star tan.

This was all new to me, I'd been in New York for about a year but I had never met anyone that successful before. Just about every artist I knew was young, under thirty, and still struggling for any kind of recognition. Rauschenberg was big time, cover of *Time Magazine*, everything. Warhol called him "Our Picasso." While the others at the table were having fun, horsing around, getting high, I wanted to talk shop. So fucking serious. He must have thought I was trying to interview him. I'd been a fan of his work since I was a student, its generosity, its freedom, its laughter, provocation and frailty. I'd mentioned it to Dorothea Rockburne and that most generous of artists had introduced me. I never knew him well, it was his charm that he treated everyone as a friend. If you'd met him you'd have been invited too. He was like that, totally gregarious.

"When I was married to Susan we went to Paris to paint. We were young and it was still the thing to do." He filled his glass from the bottle of Jack Daniels in front of him. "We'd paint in our room, you know, and of course we'd drop splotches of paint on the floor, which was covered with a heavily patterned carpet. Every time we dropped a blob we'd immediately search out the repeating pattern

in the carpet and add spots in the same color. It looked great. The carpet got very colorful."

The war chased the art world out of Europe. Mondrian, Leger, Duchamp and others became New Yorkers, Piet became Pete doing the Broadway Boogie-Woogie. No longer mythic names from exotic places they were now local guys seen crossing Broadway, buying pants in Klein's department store, or at the corner deli. The homegrown Abstract Expressionists could take it from there. R.R. had seen that shift from Europe to the states, had been at the core of art becoming American.

On other nights he'd talk about Jasper Johns, another icon of American art, of their days down on Pearl Street.

"I'll tell you about Jap... Jap'd ask you for a cigarette. You'd say: 'I've only got one left.' He'd say: 'That's okay, I'll take it.'"

A pair of skinny kids sitting at a make-shift table in a barren cinderblock loft, nineteen-fifties, Beat candles in wine bottles dripping wax everywhere. R.R. liked to tell his stories, it was introspection out loud, a way of looking at himself. like his art. Put it there and see what happens.

"He heated the paint in pots," said Bob.

R.R. was enthralled by the luscious encaustic paint Johns used on his pictures. Imagine the spike-haired young Johns hunkered over his flag paintings – if ever there was a symbolic shift in the geography of the art world. Hot wax, the very process was like alchemy. Encaustic is a mixture of oil paint and wax, which has to be kept hot so it is fluid until it has been applied. Rauschenberg would look into the pot bubbling on the hot plate, vibrant color come alive and breathing.

"I'd beg Jasper to let me try a brushstroke, just one."

The paint was so sensual – heavy, viscous, eager to cling to the brush it begins to coagulate as soon as touches the cool canvas, retaining the shape, the very touch of the stroke, even the dribbles, running before they congeal into expressions of flight. Jasper finally relented and let him have a go.

"You had to be quick. I loaded the brush with red paint, turned to the flag painting, and landed the blob of red in the middle of a white stripe."

We all laughed. The way he told it he'd made a terrible blunder, amazed at his own stupidity, but you could sense, under the apologetic laughter, a sneaky glee, a delight in his own bad boy behavior.

Walking home in the cold with Janet, one of Bob's helpers, through the ill-lit streets of SoHo, she told me who was who around the table.

"The big blonde guy, the all-American athlete? That's Matson Jones, Bob's boyfriend. He was straight before they got together," she said. Bob didn't like flamboyant gays, she said. "It's like that Milton thing – it's not a man's name." It seemed odd to me but she insisted. We stopped at the corner of Canal as a chill wind gusted up Church Street.

"It's about being manly men," she said. "That's why Bob and Jasper didn't care for Andy for years, they thought Warhol was just too swish!"

We parted and I went south to my new loft in the even more desolate area of the old Washington Market just blocks from Wall street, where the streets were all cobblestone; a ghost town where the only sound was the cast iron shutters banging in the wind.

Too swish. Manly men. 'Abstract and chronicle of the time.' Hard to blame them, maturing through such homophobic times, Joe McCarthy had Congress by the balls, crusading against Commies and queers. American men had won the war, and the country was still enamored of its rugged boys with crew cuts, no-nonsense, can-do guys. They wouldn't want the art of sissy European aesthetes, they wanted tough guys like Jackson Pollock throwing paint, picking fights, like de Kooning snagging broads, getting drunk. Men's men. Even now, at the end of the sixties, with men on the moon, the silent majority was still sneering at the long-haired hippies.

I thought about Matson Jones, had he really been straight? I'd never thought of it as a matter of choice. I could see being curious, anyone could be curious. I could see being bi but didn't you need the impulse, didn't you need to feel drawn? Was I drawn, I wondered. I liked gay men. They were often less inhibited than straight men, unconventional by definition. I'd never felt that impulse, though, that arousal, it seemed silly to fake it. Up ahead the unfinished towers of the World Trade Center shone in the night sky. Out on the empty lots where they'd been demolishing the Market the bums had their campfire blazing against the cold winter air.

My new home was a raw loft in the dairy block of the old Washington Market, one of the cheese buildings. The space was still in its industrial state - dirty, smelly, no kitchen or fancy bathroom, a broken sink and holes in the floor. Just great. The problem was heat. Mia's house was always so warm. The big front windows looked out on the Hudson River, from Hoboken in the north down beyond the Statue of Liberty in the harbor. The view was fantastic. The wind off the river was freezing. There is only so much plastic you can use to seal up the windows, block out the

cold, at some point you have to have heat. The joy of those big lofts is the space, the bane is the heat. The old radiator by the window was barely enough to melt the ice in the toilet. Already, after only a couple of months, I had a gas bill big enough and late enough for a cut off notice and still the place was freezing with another month before the spring.

"The best way to steal gas," my neighbor Bendiks advised, "Is with the Hoover."

We stood in the lingering salt air of Feta cheese that had been stored here over the years looking at the gas meter. Bearded Bendiks Kosta a passionate champion of abstract painting, a Latvian American full of tearful outrage at the Vietnam War; blustering Bendiks, perpetually giving up cigarettes. He pulled on the collar of his vintage overcoat, a thrift-shop tweed too tight for his muscular body, and traced a square tipped finger across the gauge.

"See, the gas flows this way ... turns these dials."

There was no hint of larceny or collusion in his voice he might well have been explaining how to make toast.

"There's two ways you beat it. Undo the meter and turn it around in the middle of the month so it runs backwards. Or, attach a vacuum cleaner once a month and suck the dial backward. It's what I do."

One earflap of his shaggy fur hat sticking out like a broken wing, he turned to me, eyeing the electric blanket I was wrapped in.

"That plugged in?"

"Sure."

With a fifty-foot extension cord it was the way I kept warm.

Wrapped in my electric Viking cape I moved about the loft leaving a trail of hot breath on the frigid air.

"You need a space heater," said Bendiks. "Get a used one at Lee Sams."

I went on pacing the chilly loft in my electric cloak distracted by the existential questions of youth and art. Debating myself like a plugged in Hamlet on the barricade, the wind ballooning the plastic at the windows, until I could take it no longer. I got a used space heater on the Bowery and wheeled it across lower Manhattan on a shopping cart.

Going over to Bendiks' to borrow his tools, I found a letter, downstairs, in my mail. There was no note, just a check, enough to cover my utility bill. It was signed Robert Rauschenberg. I was stunned. I hadn't said anything, had I? I remembered only a fleeting reference to money and paying bills. He obviously paid close attention. I wrote him a note of thanks.

Outside on the loading dock one of the remaining dairy companies had put out a stack of cheese overnight. When expiration dates came due they had to throw it out, it was the law, but the cheese was still good. I picked through the stack and took a wheel of Brie for Bendiks. With the main market gone the neighborhood was mostly deserted, the streets eerily quiet. Quiet enough to hear someone singing, "*See the pyramids along the Nile*" before I saw the singer. He was at the corner of West Broadway standing in the cold singing in a raspy voice, hands in the pockets of his baggy trousers; no coat or sweater or shirt, just a tee-shirt, surrounded by clumps of graying New York snow. A tough old guy watching the cranes work on the Trade Center, singing, oblivious to the cold.

When I got to Bendiks' top floor loft and pushed open the metal fire door, Stravinsky's "Rites of Spring" was blasting on the stereo. He was up on a beam with a handsaw hacking at the wood. Like the man in a cartoon cutting off the branch he sits on, Bendiks' perch was ridiculous. An antiquated hoist system made of thick oak beams and an enormous cast-iron wheel dominated one end of his loft. It looked like a medieval torture contraption astride an open shaft that ran floor to floor clear through to the basement. It had become an obsession for Bendiks, something else to get passionate about. How to get rid of it? The wheel alone was six feet tall.

I stood at the window looking down at the singer in the street. He hadn't moved from his corner.

"That's Treflich," Bendiks joined me. "He owns that pet shop across the street. Tarzan Treflich, African safaris, tracking and hunting. He catches exotic animals for the zoos."

"And he likes singing hits from the fifties," I said.

"Just that one. Sings that same line over and over. I wish he'd learn the goddamn song!"

I could faintly hear 'See the pyramids along the Nile,' through the closed window

"This thing is driving me crazy," Bendiks glared at the hoist. "When I first moved in I loved it. Now I can't stand it. That fucking wheel weighs a ton."

The juxtaposition of the beautiful cast-iron wheel and haunting pyramids seemed perfect for a Rauschenberg combine.

"Oh, no, no," Rauschenberg said when I told him about the big wheel. "Back when I was making the combines friends who came to visit always brought me something they'd found in the street:

a fender, a chair, an old Coke sign. I never used any of it. They weren't right. People thought any old thing would do ... it had to be the right thing."

We were at the kitchen table again, his entourage busy cooking on the big range behind us as we talked. He was thoughtful through myriad stories, pictures of existence, the way his art was built of countless things.

"When I showed my all-white paintings," he said, "some guy came up to me at the opening and said: 'This is not painting, this is philosophy.' So I said, 'Oh? What would you have said if I had told you this is philosophy?'"

We talked of Minimalism – were we marching the last steps of Modernism, right at the off ramp, leaving little in the box?

"Save the box itself," he laughed.

It seemed the last inevitable step was an art of pure ideas without objects – not even the box. And, of course, we talked of his erased de Kooning.

And then about making choices, the freedom to choose; permission you give yourself, how often opportunity sees you before you see it, how often your own stance blocks your view. There was safety in theory that wouldn't do in practice.

"Oh, I can tell you about that," he said, his voice going gleeful with malice, the chortling bad boy setting the school on fire. "Years ago when Merce (Cunningham) took his dance company on tour in Europe, I went with them to do the sets. I only agreed because Merce gave me complete freedom to do what I wanted. I had to set up something on stage was all, anything I liked, and the dancers would improvise around it, interact with it as they performed."

"When we arrived in a new city I would go off around town searching for props, mostly thrown out stuff I could make a set from, you know: old tires, abandoned carts, broken bedsteads, typical street finds. After weeks of this, one town after another, I was tired and I had nothing to wear, no clean clothes. So instead of going round scavenging material I spent the day at the Laundromat. That evening, for the performance, I put an ironing board on stage and brought out my basket of laundry and began to iron. I was the set. The dancers came out and danced around me, improvising as usual, but the audience was more fascinated with my ironing than they were with the dance. Look at that American underwear. That's no way to iron a shirt. He's doing it all wrong. He's going to burn those trousers. Merce was furious, said I ruined his dance, and forbade any repeats."

The most provocative thing he could do was be himself. Old friends and touchy feelings. It didn't take much to see there was unfinished business between Bob and Jasper too. In the sculpture garden of the old MOMA one evening I was startled when introduced to Jasper Johns. In middle age this portly man looked nothing like my image of the skinny kid with spikey hair I'd known from catalogue photographs – an impish look, a kind of spit in you eye American Rimbaud. The brief introduction swept aside, I'd barely reconciled my surprise when everyone turned toward the commotion across the courtyard. A small group was approaching led by Rauschenberg in his fringed suede jacket. He was crouched and hooting, gyrating all over the place in a weird, loopy gait, like some excited orangutan. It was all for Johns' benefit and Jasper didn't look too impressed. He didn't laugh like everyone else. He wore a cool sardonic mask till Rauschenberg finally straightened up in front of him.

"Well," he said. "I can't top that."

The conflict between theory and practice bothered me. It was easy to imagine all the wondrous accidents or unforeseen obstacles that could occur in the making that wouldn't occur in the planning. Was I becoming too rigid, too tied to theory and formula? I needed to be more open, more receptive to the chaos of being. Lay off the dogma.

Happy hour at Fanelli's bar in SoHo was always a loud mix of local ragmen, tradesmen, artists and firemen from the hook and ladder next door. The place was old and cramped, a brown-stained atmosphere of pressed tin and dark framed photos of old time prizefighters posed in action or stiff mug shots. The place smelled of booze, tobacco, and the eye-watering disinfectant they used to hide the tang of urine coming from the constantly flapping door to the lavatory. Ancient, ninety at least, diminutive and comically vain Mike Fanelli, the owner with boot-blacked hair, stood at the end of the bar, proud that customers mistook him for the son not the father of the toothless geezer behind the bar.

I was by the coffee station reading Jack Anderson's column accusing Nixon's White House of harboring homosexuals. This stuff was everywhere, even in the pretty liberal (pre Murdoch) New York Post; couldn't they get over it? I was there to meet my date, my on again, off again, girlfriend, Bailey, when Bendiks walked in with a woman. She was dressed like most women we knew in jeans and work-boots and a heavy flannel shirt. The Downtown vogue. The guys all dressed the same way, now the women were doing it too. Her name was Mary. Bendiks had mentioned her so often I assumed she was his girlfriend. We sat and drank and when Bailey showed up, in her blue jeans and Frye boots and work shirt, we gave up on our movie plans to sit and talk.

The women were intense. The feminist movement, women's liberation, was at fever pitch, one wrong word and you were in the

Sign outside Fanelli cafe in Soho

doghouse. Hell, everybody was intense. The Black Panthers were on the warpath, the gays were Stonewalling, protests against the war were daily events. You were nothing if you weren't intense. Mary was a strong, Rosie the Riveter, woman with her sleeves rolled over muscular biceps. She followed the conversation with contradictory sighs and hoots whenever she had nothing to say. I found her looking at me several times as we talked as if there was something more she wanted to add.

Old Mike Fanelli, oblivious to the changing times, still the young gigolo of the 1920's, shuffled over to our table arching his eyebrows to serenade Bailey with dated breath. In deference to his age she

smiled and listened. Bendiks went for more drinks, and Mary put a hand on my leg and leaned in close:

"Can I ask you something?"

Her confidential tone curled my toes. What now?

"Sure."

"Is Bendiks gay?" She whispered.

Again! What's going on? Bendiks was just Bendiks. I'd never given a thought to his sexual preference.

"I dunno. You'd be a better judge of that."

She pursed her lips and squeezed out a muted trumpet call.

"I can't get him to fuck me." She announced louder than intended.

A contradiction of the times: demanding respect while craving affection. Bailey's head snapped round, gave me a look, her eyes widening. Mary stared at her glass on the table. Oblivious, old Mike Fanelli kept up his soft-shoe patter.

I had no idea what to say. How do you account for someone else's choices? Bailey read the confusion on my face and left Mike mid sentence.

"Anyone hungry?" she said. "You feel like eating?"

"Remington's? China town? ... How about Saint Adrian's?"

Sweeping the floor, pushing the big broom over the rough unfinished boards suffused with a history of stains: barrel rings from the stored cheese, ink spills by luckless clerks, paint splashes, smeared footprints, embedded paper clips and thumb tacks, I found myself singing *See the Pyramids along the Nile*. From some-

where, long forgotten, my mother, was pinning washing to the clothesline singing - *See the market place in old Algiers* - lines I didn't know I knew rolled effortlessly off my tongue - *Send me photographs and souvenirs.* I wrote the words on a sheet of yellow paper and put it in my pocket - a present for Treflich.

Days later I saw him standing outside his pet shop, suspenders over his wife-beater. He wasn't singing, just standing there, hands in his pockets, musing over the empty street, watching the last of the black snow disappear from the sidewalk. Close up I could see his arms were scarred, his neck and face as deeply cracked as some old master painting. His gruff, unsmiling look was not inviting. I handed him the paper without a word and walked on. As I crossed West Broadway I glanced back. He was looking at the sheet before wadding it into a ball that he casually tossed toward the gutter.

Did he already know the words, or just not care? He obviously resented my interference. I felt bad. I loved that he sang, it was like his very own mating call. I banged at Bendiks' door and over his shoulder, when he opened it, I saw a young guy get up from the table and head for the bathroom. Bendiks didn't mention him, nor did I, besides the immediate distraction was the hoist, the medieval torture machine - it was gone. Someone had cut through the beams, patched the floor, and left the immense wheel leaning against the wall.

Bendiks, smiling, followed my look, explaining with a single word:

"Mary."

After the opening of his show at the Castelli gallery, Rauschenberg threw a big party at his loft on Lafayette. As usual his generosity made it inclusive, no one turned away. Walking in a quick glance

110

around the crowded room showed me the royalty of contemporary art: painters, choreographers, composers, writers, dancers, and how few people I really knew. The immediate stand out was Barnett Newman, the painter, near that long kitchen table. He was hard to miss, very erect and elegant in a dark suit; his head held high sporting a bushy mustache and a monocle – a monocle! Immediately I thought of Kropotkin and the anarchists I had heard of from Barbara Reise on the train a couple of years before. Newman looked like an nineteenth century diplomat. You could see your face in his highly polished black oxford shoes. The contradiction between his art and his appearance always baffled me. It was easy to align, say, the Spartan lifestyle of Samuel Beckett with his work, but I couldn't match this loquacious, stylish political radical with his zipper paintings. Smiling, even beaming, he took an avuncular interest in the younger artists, overlooking their relationships, deciding who was too sad and who was really in love. His wife Annalee, short with thick wavy hair and enormous dark eyes, never left his side. She kept a close watch on his drinking with an occasional "Now, Barney," touch to his arm.

The booze the older generation drank was not like our parties. Here that scrubbed kitchen table was full of liquor bottles: bourbon, scotch, rye, vodka, gin, you name it. Our parties were simple gallon jugs of cheap wine and the cheese from the street.

Jostling through the crowded room I found myself squeezing by John Cage deep conversation with the French writer Alain Robbe-Grillet. I found Bailey and told her about Barney Newman's polished shoes. They'd put on music now and people had begun to dance. Real dancers, maybe the ones who'd surrounded R.R. while he did his ironing. The music got louder, the room began to bounce and the dancers went at it like a performance. No moochers here. Young athletic muscles trained to writhe in sensual rhythms.

We watched in admiration then overwhelmed moved up front to join the amateurs by the potted plants.

We danced next to the broad shouldered sculptor, John Chamberlain, with the Zapata mustache and heavy hands. He was big, over six feet, and used to throwing sculptures of crushed auto parts about. I felt sure he crumpled them in his own hands like so much paper. He was sort of dancing with Helen, the glamorous wife of the painter Brice Marden. Maybe they'd started by flirting and teasing but John was drunk, that was easy to see, and his moves had turned aggressively sexual. Helen was getting scared; each time she tried to pull away he got more physical, more grabby, she wasn't having fun.

Still dancing I put a hand on his arm and said something to him, something sixties like: "C'mon, man. Lighten up." I didn't expect what happened next. I was very skinny, a featherweight compared to his sculpture, with a mop of curly hair. Without letting go of Helen he reached out and grabbed my hair and tried to yank me off my feet. I had not done much fighting in my life, but this did not seem like a manly way to do it – being dragged about by the hair. I fought back as best I could, and it looked like Helen was struggling to fight him too, but not only was he strong he had the advantage of a pre-emptive strike. Immediately others piled on. Someone jumped on his back and had an arm around his neck, someone else was trying to pry Helen loose. Either we were such wimps or he was too drunk to feel any pain. We couldn't put a dent in him. Far from violent the tussle took on the benign zaniness of silent comedy – torn shirts, bulging eyes and grimaces. More guys joined in and gradually the whole scrum was pushed, pulled, and dragged to the head of the stairs. And even there he wouldn't let go. Then Hiroshi, Rauschenberg's diminutive Japanese cook came running up with an iron skillet as big as himself and began to beat

Chamberlain over the head with it. He also whacked the hand that was holding my hair and at last he let go. A couple more heavy cracks to his head and finally Chamberlain's fighting spirit gave out. He slid down the stairs feet first and slumped at the bottom.

There was a general 'Hah! Take that!' from the head of the stairs and we all went back to dance with a sense of triumph.

It had little effect on Chamberlain. A few days later I walked by him in his usual spot at the end of bar at Max's Kansas City, there wasn't a flicker of recognition. Man of iron. I kept that picture of him as a rugged steel worker turned sculptor for many years until a friend told me he had actually been a hairdresser before becoming a sculptor.

Spring came and I could finally pull the plastic from the windows and look out at the Hudson River. The great ocean liners were back, returning from their winter cruises. Day after day they sailed into the harbor with their retinue of tugboats. Rauschenberg had gone back to Florida. And I found myself thinking of Newman's polished black Oxfords and his old world monocle. The bigger stories were the war and the women's movement, but quietly the view of men was changing too. The Stonewall Riot had a huge impact. The classic tough guy had lost favor with the young. A broader more complex picture of sexuality was evolving, though bigotry certainly wasn't dead just dormant.

My loft was livable by this time, though the term livable would be met with derision by later loft snobs. For the artist taking a raw space, cleaning out the crap, and making it useable as soon as possible was the idea. Rudimentary kitchens and bathrooms, knocked together out of spit and two by fours with home-made plumbing were the norm for artist's lofts. Exposed brick and beams and everything else, along with street found furniture was

pretty standard even for the more successful. There were one or two with money, of course, who converted their lofts into magazine color plates: dividing walls, hidden lighting, built in cabinets, deluxe kitchens and bathrooms, but they were generally frowned on as the bourgeoisie dilettantes.

Bill Wegman was moving into a space once used by an electrician's school, and the walls were covered in slate blackboards. He gave me one for a kitchen table. Sol LeWitt was breaking up an old sculpture and gave me the bases to make a huge worktable. Bailey, my on again off again girlfriend, gave me her pots and pans. She had decided to move on, to go live in Paris.

With the warmer weather I found I had more neighbors than I knew, not many but more than I'd thought. Artists of all kinds close by. We'd meet at the cheese piles on the loading docks, sorting through the boxes of Saint André, Camembert or Brie. When the market trucks left at midday the streets were quiet again. Quiet enough to hear Trefilch out there singing.

Send me photographs and souvenirs.

I stood and listened, even he was moving on.

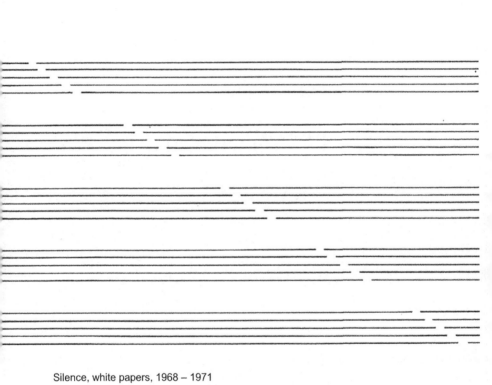

Silence, white papers, 1968 – 1971

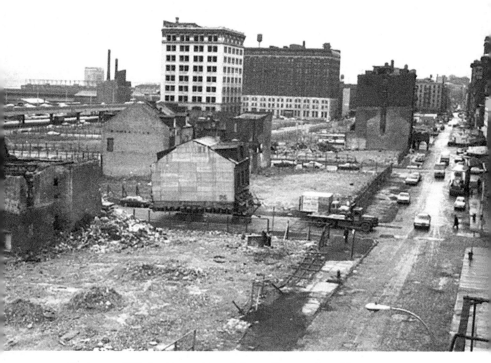

Moving an old Federal house through the northern section of the
razed Washinton Market to save and recondition it. Greenwich
and Harrison streets, 1971.

Bargoyle

Beattie was short for Beatrice, she said. Said it with a mocking tone, like Beatrice was far too fancy a name to be tagged with. She didn't like pretension, she said, didn't like formalities. I liked her right away. We met at the Metropolitan Museum of Art, in front of "La Princesse de Broglie," Ingre's portrait of a woman with porcelain skin and a luminous blue dress. I spent a lot of time in museums absorbing the history of art. They were also great places to meet women. You knew right away you had something in common. The Met had just opened and the galleries were still deserted and silent. I was sitting alone on one of the benches absorbing the painting. The smell of a light summer rain came off my clothes, the smell of polish came off the floor. The portrait intrigued me, I'd never gone for that kind classical perfection, it left me cold, but I had to admit this was a stunning picture.

Faint footsteps entered the gallery, stopping and starting gradually approaching across the hardwood floor. I didn't look. Then a young woman came between the Princess and me.

Her back to me she moved closer to study the painting. She wore a simple light cotton dress still damp from the rain, the auburn hair that fell in great abundance down her back still glistened. The leather of her sandals had turned dark from the puddles, and the straps were digging into her ankles. She stepped to one side and read the lengthy wall label. Now I could see both women and couldn't decide whom to look at. I could smell her dampness when she backed away from the picture closer to me. She turned, glancing up and down the gallery, and then at me.

"We're all alone," she said with a sly smile and a wink.

It was true, not a soul in sight, not even a guard. The situation was ripe with possibilities.

"D'you like the picture?" I said.

She turned and gazed at it. "It's very rich," she said.

"Quality-wise?" I said.

"Money-wise," she said. "Look at the jewelry and that lace."

"And that dress, it glows."

"It feels delicious ... incredible." she smiled. "Nice to be a princess."

"Rich enough to have her portrait painted."

"It's sumptuous," she said turning to face me. I saw then that she hadn't winked at all, it was a tic or some mild affliction that caused her eye to close like that. "Yes," she said, reading my thought. "I get that all the time."

We spent the rest of the day together, Beattie and I, and the night, discovering that we lived only blocks apart. She was a dancer, modern dance, the kind that throw themselves about with erotic muscular grace and little clothing. We agreed to meet on Thursday.

With most things functional in the loft: toilet flushing, gas flowing, juice in the outlets, water heater hardly leaking, I was able to pull out the notebooks I'd made at Mia's and before. They covered a wide range of ideas, sketches in words, from hiccups to art of the fugue. I wanted to put each one as a notation on a single page, an index card, so they had to be brief and simple. Like poetry but not poetry. The thought was that the synergy of ideas knocking into one another, like bumper cars, would create a whole much larger than the parts. The unifying element was language. Like poetry but definitely not poetry.

I wanted to play with language the way I had played with the materials I found on the streets – leaning, rolling, scattering, and quickly found that syntax was the gravity of language. You could lean something just so far before gravity brought it down. You could twist language just so far before syntax turned it into nonsense. The interdependence of words leaning on one another, the sentence vector, the linear way meaning is gathered as each word proposes, or limits, what the next word may be intrigued me. I took Chomsky at his word that our ability to do this was innate. I read other linguists and anthropologists, like Benjamin Lee Whorf, who told me that since the Hopi Indians had no words for past, present, or future they did not conceptualize time in the way non-Hopi speakers did. This too was amazing. Meaning, like Wittgenstein before him, that language had a profound effect on thought and reason. Then, naturally, other professional linguists wrote that this was total bullshit. I wasn't qualified to tell. I tried to

follow their arguments but they kept throwing my mind against the wall like thoughtless boys bouncing a rubber ball.

Still, there was language I knew, we all know, and that inate gift we are all given, our built-in gravity. "The house", but not "house the" "This" is not the same as "This?" "Come 'ere." implied things that "Come here," did not. There were puns, double-entendres, tautologies, solipsisms, oxymorons, zeugmas – a side of language I could play with to make the cards. I played with numbers too, and I do mean played. I'm no mathematician. Blackboards covered in chalky calculations with Greek symbols and square roots to the power of n leave me as gobsmacked as the galaxies. I mean simple numbers, numbers we use every day.

I had printed these little ideas, sketches, on white cards, hundreds of each one, and set them out on my worktable. I spent my days collating them into sets of seventy-one (it was nineteen seventy-one), and putting them into little boxes. The ultimate idea was to thumb through the cards stimulating whatever thoughts they provoked - interpreting, associating, deducing – all the good stuff.

Thursday, I went out to meet Beattie at Barnabas Rex, a local bar, part way between us – from there, maybe, Chinatown or Little Italy for dinner. My mood heading out the door couldn't have been better.

In nineteen seventy-one the Bowery still had Bowery bums, flop houses and cheap saloons and drunks passed out on the sidewalk. Regular people didn't go to bars like that. Neighborhoods had bars of their own, bars with neighborhood tone and local knowledge. There was no shortage of bars downtown, cheap or fancy. Dark quiet bars where you wouldn't be disturbed. Or like Teddy's, frequented by the likes of Elizabeth Taylor and Richard Burton. Bars where you'd go if you'd had a hard day, and saloons where

you went if you were having a hard life.

Barnabas Rex was a hole in the wall. Small and dark with a pool table taking most of the floor space and providing much of the light. To the newcomer Barnabas might have been one of those Bowery bars, it had the gritty feel of a derelicts' saloon. A Bowery stink about it. There was a little sawdust on the floor, a ball game on the big TV, an edgy woman dancing by herself at the juke-box, and pool players. Always pool players. They never stopped; poking customers with their cues as play went on while the bar grew crowded. It didn't take many to fill the place and it often got so jammed you could barely move. Youth was the attraction, most everyone in their twenties. Late nights there was dancing to the loud jukebox, jostling and squirming around one another, el-bows in the face, rubbing bodies, spilling drinks, and still the pool game went on. Stalking the table, chalking their cues, the players seemed oblivious to the rest of us.

"Hey, d'y'mind, I got a shot here."

I made my way around the clicking balls to the bar where I found a spot downwind of Dick Campbell's convictions. I hesitated; he was the local gargoyle, a fixture at the bar – a bargoyle, angry, opinionated, pain in the ass. There was a buffer between us, some guy in a suit staring into a whiskey sour, looking out of place. Campbell was already dissecting the day's news for a captive for-bearing bartender. Most nights he was here early, drinking his way through *The Daily News* and *The New York Post* before emerg-ing as the local rant man.

"The liturgy was better before!" Campbell insisted, glaring into the barman's puzzled face. "They should go back to the Latin mass. Vatican ... whadda those assholes know?

"Ah, you're right there, Dick." The bartender, an aging hipster with long strands of hair draped across his balding head, nodded at Campbell like he cared.

"Frauds!" Campbell growled.

"That's it, Dick." The bartender looked at me over the Whiskey Sour's shoulder and winked. "What'll it be?"

"Gimme a draught."

I glanced at the clock – a little after eight. I hoped Beattie wasn't the type who kept you waiting just to mess with you. The place was still pretty empty. A few regulars at the bar, the pool players, Terry, a young Army sergeant, watching them - clean cut and excessively polite, drinking Coca-Cola and completely gay and completely tortured.

"You Catholic?" I turned to find Campbell looking directly at me. What happened? The Whiskey Sour had vanished leaving nothing between us. "Big C."

"Apostate," I said, trying to be civil but avoid engagement.

"Yeah?" he looked me over like he'd never seen me before, though he had, many times. "I was never in the church m'self. It's all bullshit, but they should never have changed the mass."

The Stones' "Brown Sugar" suddenly blasted through the bar and the woman at the juke went into a stiff, herky-jerky dance that looked more painful than fun.

"Look at that!" The television caught Campbell's eye. "Struck out! He couldn't hit that goddamn ball if it were nailed to his bat."

The bartender chose the wrong moment to bring my beer. "Yanks

just bought this loser, right. What'd they pay for him?" He roared over the rampaging Stones.

"Not my fuckin' fault," the bartender yelled back. "I'm a Mets fan."

"Mets, shit!" Campbell swiveled back to me. "Mister fuckin' Mediocre! What they pay for him?"

"No idea," I shrugged.

His capacity for outrage was endless. Did he really care or was it all about getting attention?

"You think you're special, right?" He was leaning toward me, his big face only inches away, his watery blues eyes widening.

"Huh?" The tone didn't strike me as belligerent and I was in a mood light enough not to feel besieged. "Of course," I grinned, suddenly the music stopped, and I found myself shouting, "Extra special."

"Well of course you do! You're an artist. You have to think you're special." See, he did know me. He turned to the bartender who was sneaking a drink for himself. "What's the point of doing it if you think you're not as good as the next guy? None of us sets out to be mediocre. But that's what most people are."

"Speak for yerself, Dick." The bartender grinned at me and took off, refreshed and pleased with himself. The woman by the juke kept up her herky-jerky dance without the music. Now it looked like a medical condition. I reached for my beer trying to find an exit line.

"Unquestionable talent ... there's a few," Campbell went on. "Any field, you name it ... go on, name a field. See!" He didn't wait for an answer. "Even people who hate 'em agree they've got talent ... But the vast majority are drones, worker bees, replaceable by the next

guy who walks through the door."

I looked at the door in hope.

"Am I right? Or am I right?" He tapped the bar with his finger.

"Well, It wouldn't be special if everyone had it," I said.

"Damn right. We all like to think we're great. Convince ourselves that we haven't wasted our lives." Then Campbell leaned in on me, a hand on my arm to make his point personal. "But the truth is, my friend. Most of us are just not that good." He pulled back staring at me. What had I done to deserve this? "Don't mean you, of course." Though I suspect he did. Me and everyone else he laid those watery blue eyes on. "Know what I'm talking about?"

"Talent," I said.

I might have said horticulture from the way looked at me. Was I stupid or what?

"Authenticity! Core, my friend, substance." He downed his drink in a gulp. "It's the culture." Tucking a thumb into the belt of his blue jeans where his belly rounded out his work-shirt to a Humpty Dumpty bulge. "The culture doesn't want you to think for yourself."

But horticulture was in my head now:

"You know that Parker line on horticulture?"

"Charlie Parker?"

"Huh? No, Dorothy ... When someone asked her to use the word in a sentence?"

"Oh. Yeah, yeah. How'd that go again?"

"'You can lead a whore to culture but you can't make her ...'"

"Drink!" Campbell blurted, overeager to show he knew the line.

"No, '*think*.' 'But you can't make her *think*.'"

"Just what I said. See, the culture doesn't want you thinking."

"Tears of A Clown" came flooding from the jukebox. In my head I juggled: You can lead a whore, Can you lead a whore, A whore can lead you. Campbell glared at the barman who quickly lowered the sound.

"Hey!" The herky-jerky dancer was pissed.

A middle-aged painter, twenty years too late to join his heroes the Abstract Expressionists, Campbell was considered passé by the art world. He had turned the rejection into honor. In his mind it gave him gravitas, made him genuine, significant. It was all justification and denial, and then justifying the denial.

The clock over the cash register read eight-forty. I glanced around the room. Redhead Charley had come in and replaced someone at the end of the bar. The bartender, bent over his little sink, looked up at me from the glasses he was washing, and chuckled sympathetically.

"Event driven – Pavlovian dogs." Campbell suddenly gave out a bark that froze the room. "Events!" thumb back into the belt. "News, events, one piss-assed thing after another. They date. Cheap novels are driven by external events, literature is driven by internal events. They stay fresh precisely because they are not about dated events. You ever read Dickens? 'Fog up the river, fog down the river, fog on the Essex marshes,' it's all in there. Read Dickens."

The bartender bobbed up in front of us, his thumb sticking up, his

forefinger straight out to make a pistol. He pointed at Campbell's empty glass, and made a popping sound with his mouth. He liked to think of it as his style.

"Go again?"

"Yeah. Look at Pollock, de Kooning." Campbell spoke hesitantly of his canon. "By god those guys had to fight to get a foothold, struggle to establish an identity. Titans, man. Fucking Titans. They didn't step out of school with a bag of tricks and a business plan."

He saw himself in their romantic old shoes without laces.

"Yeah. It was different then," I said. "The culture was stuck on European art. Paris. Most young artists still struggle."

"With what? Their trust funds?" he scoffed. "You only need a couple of people, a coupla co-conspirators: a Daddy Warbucks collector, maybe, a dealer. They'll get your name out all over the place."

"Oh, yeah?" My turn to scoff. "Piece of cake. So, how come I'm still struggling?"

"Gotta get this shot, guys." A lanky pool player pushed between us adjusting his pony-tail. He bent over the table, making us stand like a couple of stiffs watching his elbow with a spider web tattoo wagging in our faces. "Corner pocket," he called. We stood in silence as the balls cracked and thumped off the cushions.

"Imagine," said Campbell as soon as the ball rattled in to the pocket. "Imagine you're a writer ... you've got to appeal to thousands of readers just to cover the cost of printing. One collector ... one!" He emphasized with a forefinger shot up in my face. "One ... can sustain an artist's whole career. How much more thatched can a cottage industry get?"

"Hotcha gotcha, guys?" The bartender was back with his darting pistol fingers jabbing at our glasses.

"Nah ...' I glanced at the clock, 8.55 – still no sign of Beattie.

"Give him another. My tab," said Campbell.

The bartender whipped away my unfinished beer before I could object. The bar was filling up. The smell of stale beer and cigarettes rounded out by the odor of bodies. It was a rich brew that didn't quit. It clung to the dark wood and the chipped Formica, soaked into the brick and mortar. The next morning you could smell it in your hair and on your clothes.

9.10 p.m.

Campbell watched the cue ball slide across the baize with backspin. "You got a dealer?" he asked in a surreptitious whisper, like inquiring after a social disease.

"Nah."

"Bunch of parasites." He sighed with relief; it cheered him up.

All the weight he carried in issues and torments. All the rejections and petty insults, real or imagined. His attempts to survive, save himself, ate at him every day. He couldn't forget, move on, they taunted him at every turn, breaking out like sweat.

"Dealers!" Campbell snapped at the word like a dog at a fly. "Parasites living off the talent of the artist and the ignorance of the collector." He stuck his thumb back in the belt to his jeans and stewed, gathering a head of steam for a coming eruption. "And ... and, if you ask them, they're the ones who created Abstract Expressionism, Pop Art. Fuck! If it wasn't for them Picasso'd be a truck driver. Vermeer'd be selling fucking hot dogs!"

Don't get him going, everyone said, but here he was – going. I glanced at the other patrons talking, laughing, drinking and smoking. She was an hour late. What do I do, act nonchalant, like I don't care?

"And they don't show up," said Campbell.

"What?"

"Dealers. They build up your expectations, then cancel. I've had dealers fall asleep in my studio, talk non-stop about their husband's infidelity, or stand there and tell me how good someone else is. They'll show up just to crap all over you."

It was painful to hear but every artist had some nightmare dealer story. I glanced at the door again, then the clock.

9.18 p.m. and I was beginning to feel rejected myself.

"They're not all bad." I tried to stay in the conversation to stop myself from brooding. "Castelli's a class act - all that old world charm and elegance. Dick Bellamy has a great reputation."

"Yeah, yeah. Everyone loves Dick, I know." It gave him pause to reflect on the eccentric Dick Bellamy.

"Talent for dealers is simple." He barreled on. "If you sell you're good. If you don't you're not. How do they justify their flops? Easy: I gave him a chance and he didn't come through. They're shopkeepers and you're just the box of cereal. Quality? Quality? Would they know the difference? Is my foot in your ass? They don't know meaning, they know money. Quality? You want more meaning? I'll double the price, how's that for quality?"

The room was noisy now, full of motion, crowded with animated talkers. I looked about at the faces, many I knew from the neigh-

borhood. Elizabeth Murray, Richard Serra, Susan Rothenberg. It was nine-thirty-five - still no Beattie.

"Gotta make a call," I muttered to Campbell, and pushed my way to the phone.

I had no idea what I'd say if she answered, or what I'd feel if she didn't. Pressing the phone to my ear I listened to it ringing above the din in the bar. I felt my mood change, my optimism sink with each ring. I'd been stood up, that was clear. Why? I thought we had fun. I thought we got along. I thought it was "sumptuous." Was she just stringing me along the whole time? My hurt pride immediately started to invent excuses – maybe she went to the wrong bar, maybe she'd still show up full of apologies.

I squeezed my way back to the bar feeling baffled and irritated. The crowd was getting lively, having fun – except for the pool players who doggedly played on, increasingly pissed. Being rejected made me warm to Campbell, what life had done to him. He sensed my disappointment. His smile turned warm and friendly. I felt comforted by that thumb dipping back into his belt, found myself agreeing with his take on dealers. How difficult it is to manage our frailties, and then to have others with insecurities of their own reinforcing our worst fears. Campbell had been overwhelmed. Whatever talent he had was starved and neglected rather than nourished. Others with similar talent had flourished, others with less talent had thrived. It was hard to see why. It was hard not to feel bad for him.

"Let me get this one," I said in my mood of conciliation, and waved at the bartender. There were many calls for his attention now, hands in the air, bills waving, empty glasses thrust across the bar. In time he got to us, bobbing along, his pistol fingers shooting at our glasses.

"Go agen, genlmen?"

When he returned with the refills I pushed a bill toward him from my little pile on the bar. Campbell watched him snatch the bill and groaned.

"Money." He sighed again. "It's all fucking money. The future of art is capitalism," he said. "Idealism died with the sixties."

10.10 p.m.

"I remember this one collector coming to my studio," he said. "He was the head of one of those big, international financial conglomerates. Mega bucks. Personable enough, polite, all the manners of privilege, private schools. And real quick, oh yeah, real quick to assume he was in charge. Might have been my studio, my art, that I'd sunk years into ... decades of belief, frustration, anxiety ... life. Life itself. But it was his fucking money.

"He barely looked at the pictures; didn't give a shit. What he wanted to know was had my gallery given me a long-term commitment. Who was buying my work? Where would I have my next show? Which museums were interested? Which critics were on my side? He wasn't the slightest bit interested in the art; it was just another product, shoes, plastic containers, office supplies. He didn't want art, he wanted a business plan. It's not the examined life they're after, it's the examined bank account. He was talking investment."

I was only half listening Campbell's plangent cries of the future.. I'd turned my back to the bar and was watching the crowd in the room. There was dancing now, bodies wriggling and squirming to the blaring juke. The pool players were pissed; fucking dancers setting their drinks on the table messing with their game.

"Hey! Hey! We're playin' here."

"And we're dancin' here!"

And they laughed. Gyrating bodies were flowing over players crouched to make their shots. Other nights it was comical to watch but tonight my mood had soured.

10.30

Fuck it.

"Forget it; She ain't gonna show," said Campbell.

He was amused. I was in no mood to be teased. He was enjoying my rejection.

"You young guys think painting is dead. There's more to being modern than not painting pictures, you know. You think you can replace sensations of art with ideas, forget it. Art exists because of the human condition - the need to express. The art market exists because of the human condition – acquisition. Used to be the artists who decided what was art. Money followed art. Not any more, now the rich decide. Art follows the money."

Now he was annoying me. He was irritating. She was thoughtless. And he was amused; delighted by my discomfort. Who does she think she is? Treating people like shit. And that damn thumb of his, can't he keep it out of his pants?

"Dealers! Easy to stand on the sidelines finding fault... "

It's not like we had a fight or anything. It's just a nasty feeling that she picked me up at the museum to entertain herself. I could smell the smell of rain on her dress and felt used.

"Ah, fuck it," I said.

And started pushing my way out of Barnabus Rex. Behind me I heard the barman.

"Something wrong? What's up with him?"

"Pussy whipped," said Campbell.

Facing page
I am Here, 1971, print or book. An early form of GPS. 54 sheets of graph paper laid out in the same format as the graph paper. Each black square indicates its position in relation to the whole

133

Identical twins in the palindrome 8mm film, Emit-T-time, 1970

The hand of unemployment

Of course the palindrome. If there is one thing that words always do it is go forward – beginning to end. Only the palindrome offers an alternative. Under the influence of Borges' stories on the distortions of time, I wondered, was it possible to make a movie palindrome? In one of my classes at SVA I had a set of identical twins, two attractive, raven haired young women from New Jersey. With such a pair, to mirror each other, a little non-verbal movie palindrome might work. I knew nothing of filmmaking, but devised a script of intricate moves, like dance steps, and the twins agreed to participate. By little movie I mean really amateur – Super-eight, short and silent. We shot it, in one take, in my loft. Dressed identically, they sat facing each other across a table laid out with teapot, cups, plates and cookie dish in asymmetrical order. Then in a series of carefully choreographed moves they made simple gestures: taking cookies, moving tea cups, leaning on this elbow, stretching that leg. Until finally they were the mirror image of where they began. And not just beginning and end. At any point it was possible to find the corresponding mirror image just

like a palindrome. The movie run forward or backward appeared the same. Madam I'm Adam.

Soon the school year ended and so did my job. They assumed I knew. I didn't. Bud Schuler, head of the program, was philosophical, bending his apologetic old face toward me.

"We're seasonal workers, son." It was deep and breathy, the way he said it, kind of Hollywood biblical. "The harvest's over."

So he was part-time, too. I pursed my lips letting the news sink in. He rolled a do it yourself cigarette trying to conceal his discomfort. We stood apart from the small crowd at a reception for a show of his drawings at the Mayfair Gallery. He was surprised by my surprise. It was awkward.

"I thought you knew."

"No...no." Of course I should have known, and would have if I'd given it any thought.

His wife came up and led him away to face his admirers. He gave me a sympathetic glance as I backed away. So that was it. Out of work.

The Mayfair was one of those exclusive boutique galleries uptown on Madison Avenue – blue chip customers and gold frame art. Very posh. I looked around at the gathering of Upper-East-Side money, older and more elegantly dressed than anything I was used to; men in tailored suits, women with frosted hair and heirloom jewelry. Downtown openings weren't at all fancy, just the artist's friends hanging out, young people in blue jeans. Up here denim made them flinch. It's what cowboys wear. And artists like cowboys were best seen in the movies.

Bummed out and out of place, all I could think of was getting out

of there. I was heading for the door when she blocked my way, refilling the glass I'd forgotten I was holding.

"You look like you need this." She was young and voluptuous with tumescent lips of cherry red

"I was about to..."

"Don't go." She flashed her dark eyes with long artificial lashes and put her lips to my ear. "I'll be back."

Her perfume and warm breath were seductive. It had been years since I'd spoken to a woman in makeup. The women I knew were frontline feminists who'd scoff at the very idea. She was exotic, a fashion photo right out of a glossy magazine: shiny hair, painted nails, mascara eyes and glowing lips. A Madison Avenue creation men had learned to drool on, artificial as hell and a real fantasy. We skipped the getting to know you part – she would've smiled and said she liked things like this, and I would've said I like some of that, and we'd've thrown it back and forth pretending to be real interested in bullshit we couldn't care less about just so we could get to the next bit, which was the bit we both wanted, so we went straight for the carnal delight. Instant lust; we were already having sex, hot and heavy, though we'd never touched.

She moved about the room filling glasses, smiling, deftly teasing the older men whose eyes clung to her ass when she moved away. We exchanged lascivious glances; a curl of the lip, a batting of lashes. It was a game full of yearning, anticipation, the crowd just scenery in our foreplay. Her name was Susanna, she was the receptionist at the gallery. Eventually the party wound down, and the bone thin owner led the last guests away to some chic restaurant leaving Susanna to lock up. And so we did.

I applied to the Professional Placement Office in midtown as a

start toward finding work. I got a postcard from Bailey in Paris. She'd met someone and they were moving to Amsterdam. New pots and pans. It was the last I heard of her. Now there was Susanna. Oh, Susanna. Our friendship was entirely sensual, exclusively physical, we had little else in common. For the unemployed it was nourishment enough. She cared nothing for the art in the gallery, it was just money, her main preoccupation was having fun. I marveled at the simplicity, envying her shameless sensuality, her unabashed hedonism, it was a great sales pitch for the unexamined life.

Her cramped Upper-West-Side apartment was knee-deep in discarded clothes, perfumed candles everywhere, and the only book in sight held the bathroom window ajar. Her world was either or: what was fabulous and what was not. In the endless search of gratification she constantly toyed with her body, painting this, shaving that, clipping and decorating, clothing and baring.

In one corner of her bedroom several canvases, draped with underwear, leaned against the wall next to one of those wooden paint boxes they sell in art stores. I assumed they were hers, but when I asked the answer was "ech!" and a dismissive flick of the wrist.

For two weeks we gorged our libidos, exhausted our bodies trying everything in every conceivable way until our flesh became numb to the touch. Then it was over. When does lust die? Nothing happened, no fight, no argument, no cruel words – just something missing. Emptiness. Growing silences. We couldn't keep a conversation alive for more than two minutes. In the middle of Chinese take-out I got up and turned one of the paintings around. It was a nude. Her. I turned the others too. They were all her, all nudes, done in an amateurish, art school style. I looked at her for some word.

"I model for some old guy," she said it like it was the dullest thing in the world. "Clem Greenberg. You know him?"

"Clement Greenberg? The critic?"

"Maybe, I think he said he was. You've heard of him?"

"If it's the same guy."

Years earlier, as a visiting student, I stood in the crowded MOMA courtyard café, holding a cup of coffee, looking for somewhere to sit. I'd been dithering there for a minute when two old guys pointed at the empty chairs at their table. I thanked them and sat. They gave me a friendly nod and went on talking.

"If he thinks the world's gonna beat a path out to his door, he's mistaken." The more animated of the two was a sharp dresser, suit and tie, neatly groomed and fast talking with an edge to his voice.

"Well ... It's the country."

The other guy toyed with the paper sugar packs beside his coffee. Soft spoken, his rumpled air of distraction, lumpy sweater, bulbous shoes and tousled hair round a balding head, was forgiving.

"He's gone." The hard-edged guy brought his hand down on the table with a chop. "Goodbye, Clifford Still. Dumb move."

After a while the sharp guy realized I was just sitting there listening to their conversation. He turned to me.

"So. What do think of the show?"

I don't remember what the show was, but he was intimidating, assertive and abrasive but not unfriendly. He gave me his opinion and then introduced himself.

"I'm Clement Greenberg. This is Mark Rothko."

Rothko, wow. This sweet old guy? He was exactly how youth sees old age. Disheveled, heavy set, balding, thick glasses, and so gentle, even bemused. Compared to Greenberg his mood was thoughtful almost brooding. What a great painter. I gushed my youthful enthusiasm and he smiled.

"Ah, yeah. Some people tell me I'm a good painter, other people tell me I'm a bad painter." He rolled the sugar packet between his fingers. "I don't know anymore, I just paint."

It was unsettling to hear someone that good, that accomplished, show such doubt. I had no idea, of course, of the pain he was going through, his health, his personal life. My youth only saw someone gifted and celebrated, I could not imagine his unhappiness. Between the two of them, Greenberg and Rothko, they made a list of the best private collections where I could see Abstract Expressionist work. Then Rothko wrote a brief note of introduction. Sitting on the bed at Susanna's I wondered whatever became of that note. Now Rothko was dead. It was only a few months since he had killed himself. I looked down at the clumsy paintings of Susanna, were they really Greenberg? What was he thinking? Was he trying to make art or were they just an excuse to get close to Susanna's naked flesh?

I looked at her on the other side of the bed staring out the window.

"You all right?"

"It's over, don't you think." she said with bored distraction.

"I guess," I said.

There was no ill feeling. We were sated. Lust had run its course.

I left and sauntered, hands in pockets, down Broadway thinking

of aging into sadness: Rothko's gloom and Greenberg's lingering desires. The setting sun was throwing intense shadows along the cross streets. The fading day, Sunday evening and the city becalmed. There were people about, and traffic, but the sound was muted and distant. The deep shadows gave the buildings that Edward Hopper quality of moody introspection.

Distracted I'd wandered from Broadway and walked into The Deuce without thinking. Every city has its seedy spot, its open wound where everything festers and toxins thrive. Some become famous – Seven Dials, in Dickens' London, Five Points in Civil War New York. In 1970 The Deuce – the street name for that raunchy strip of Forty-second Street between Seventh and Eighth avenues – was a Halloween of porn, whores, pimps, parolees, and other miscreants out to take the air, and anything else they could get. I kept to the edge of the sidewalk, skirting the three-card-monte tables, and the doorway markets of sex and drugs. I kept my focus where I was walking, picking my way around the puddles of fresh puke.

BAM!

What the fuck?

I came to rolling in the gutter. Both hands still tangled in my pockets. I'd blacked out briefly. I struggled to free my hand, no idea what happened.

Those nearest were looking at me, then swiveling their heads to follow the fleeing figure half a block away. A young black hooker, her face ravaged by addiction, had enough compassion still to step forward and see if I was okay. She read the confusion on my face.

"He hit you." I started to ask why but felt the pain in my jaw. I put my hand to my face and felt the warm sticky flow of blood. "Here."

She dropped a couple of paper napkins on me, those small squares the street vendors hand you with your hot dog. She decided I would live and melted back into the shadows. When she did the rest of the crowd lost interest. I held my hand to my face to staunch the wound. The blood spilled through my fingers and down my arm. I felt dizzy, shocked at the amount of blood, yet my first thought was relief. It was not a knife or gun. Some idlers were still staring, blank, disinterested looks. Without my assailant I was just another demented, blood-splattered wretch, street trash in a messy society.

I struggled to my feet, aware now of the blood soaking my shirt. I walked out into the street through the daze and the traffic, and hailed a cab. Hands in pockets, who sees life's assailants?

"Where to, Bub?"

"South of Houston."

Moving and Turning, ink on paper, 1971

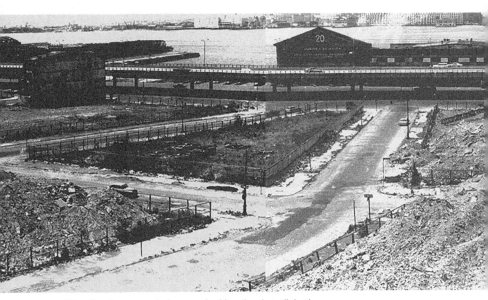

The view from my window overlooking the demolished
Washington Market, 1970. The empty lots, the Westside Highway, the piers, the
Hudson River and New Jersey in thebackground. The area is now called Tribeca.

145

Outline of North America, a book. The Village Voice Continuity gave me the idea of following the coastline of North America, page to page, in a little book. It gave the outline of the continent a disjointed, almost comic, appearance.

Granted

Out of the underworld of Port Authority the bus surfaced in Hell's Kitchen and headed upstate through intermittent showers. I hated leaving the city; rural landscapes with rustic barns held no appeal for me. Urban grit, grating egos and libertine thought was more my speed. Separation anxiety came and went like the weather: it rained and quit, shined and quit. I watched the open fields bow by. It rained again. After five numbing hours we arrived somewhere in the middle of nowhere. I had won a grant.

How

Earlier, on a spring evening, I'd been home alone, nursing the split lip I'd been given on forty-second street. With my good eye, the other was dark blue and swollen shut, I was looking through Lawrence Sterne's Tristram Shandy. It's a zany mixture of irreverence, erudition, and the comically bawdy – the Monty Python of the

eighteenth century. Supposedly about the life of Tristram Shandy, it is anything but.

The phone rang ...

The heart of the book is its endless digressions

I picked it up – no one there.

....... disparate ideas scrambling together in a wildly inventive form said it was okay to be good and silly. Sterne's whimsical digressions – on knots, button-holes, noses, fortifications and fornication fed my fascination with chaos and the scattered fragments of reality. The narrative, like buckshot from a blunderbuss, goes everywhere at once, the text peppered with typographical dingbats in a plot line more like scribble.

The phone rang again Dead again.

Someone, besides Lawrence Sterne, was messing with my head.

I gazed at the newspaper spread out across the floor. The Village Voice. Every newspaper starts major stories on the front page and continues them inside the paper, it's standard. But the Village Voice at that time took continuity to new levels. Nothing ever seemed to appear whole and complete on one page. A story about the Baader-Meinhoff gang might start on page twenty-three, next to a story about dog turds on the sidewalks, then jump to page thirty-nine between ads for shampoos and afros, then onto page fifty-two running next to a feminist outcry against pornography. The whole paper was a big puzzle of stories. I had bought two copies, to get both sides of each page, and laid it out as large rectangle on the floor, holding it together in a with tape. Then, with color markers, I followed the progress of each story as it flowed throughout the paper, surfacing here and there, the story

reemerging in new surroundings, like a mountain brook turning into a woodland stream, then becoming broader through the suburbs, and churning into a polluted city river and on out to sea. The larger picture of all the stories criss-crossing the paper, and one another, was very colorful.

I turned from the paper, staring blankly at the window, and was startled by the sudden appearance, and disappearance, of an angry face. Somebody was on the fire escape. This was a desolate part of the city and I was alone in the building. Before I could move the face appeared again and this time I recognized it – Jack Mayberry. Why was he on my fire escape? I opened the fire door and he ducked by me without meeting my eye, head butting forward, shoulders taught, more than a whiff of booze about him.

"Where is she?" he demanded.

"Who?" Surprised, I forgot my lip. A sharp pain reminded me.

"You know who. Where is she!"

His anger filled the space, eyes darting, body fraught with menace, clenching and unclenching his fists. I was already pummeled by the mugging and wasn't up for a prizefight. Jack wasn't a particularly big man but his smallness was very condensed, like an iron bar. An angry iron bar.

"Where the fuck is she?"

By now even he could see through his rage that there were few places to hide. The loft was one large space, all white, with little furniture. He moved quickly to push my one armchair aside, and then, comically, to look under the bed. Finding nothing made him even madder, he flung open the bathroom door and disappeared inside for a moment. When he came out:

"You mean Rene?" I honked out the side of my mouth.

"Of course, who'd you think?"

He looked around, frustrated. There was nowhere else to hide in the Spartan loft.

"Why would she ffff be here?" My punched-out mouth made my voice unpredictable, full of air and squeaks.

"She's been seeing you. Don't deny it, Rick."

"Rick? fffff. I'm not Rick."

Jack Mayberry was a good artist with a quick inventive mind and early success, but his inquisitive nature had worked against him. As soon as he completed one kind of art he'd switch direction, trying something new. It is not a career move the art market likes. At forty-one he'd switched directions with wives and married Rene who was twenty-two. His mistake was easy to see. Rene was close to my age and constantly out and about, a social butterfly. I didn't know Rick but I'd heard the stories. Probably the same rumors he'd heard. Now Jack found himself in an awkward spot. He adjusted his glasses, meeting my eye for the first time.

"What happened to your face?" He finally noticed. The black eye, though less painful than the split lip, was more dramatic.

"Didn't fffff see him ffff coming," I said. I sounded like a kazoo.

He nodded, without a smile, and looked at the book on the chair where I'd been sitting.

"Tristram Shandy. What's that?"

"... it's ffffunny."

He nodded again, looking down at the Voice pages glued together on the floor. I could see his eyes following the connections I'd made, and expected him to say something. He didn't. He glanced about loft once more to be sure, then left the way he came without word.

The grant I got, that summer, was neither large nor particularly prestigious. Part of the deal, they told me, was that I had to teach for a few days at a school of their choosing. They chose Franklin Pierce Memorial College somewhere upstate. No one knew exactly where, or what I was supposed to teach. When the bus pulled away in a toxic cloud it left me amid trees and open country, on my side of the road, and a straight-backed woman waiting on tiptoe on the other.

"Yoo-hoo." She waved with a show of bright teeth.

Behind her lay Franklin Pierce Memorial College amid acres of neatly clipped lawn. What might have been contemporary design when it opened now looked like cheap fabrication turned shoddy.

"Veronica Pantry. Welcome." She pumped my hand when I crossed the road. "Welcome. I run this summer program."

In her forties with tightly permed and lacquered hair, she was the America I'd only seen in movies: a *Life* magazine 'gal', a finned-tailed auto, a Doris Day in Cinemascope; so wholesome, brimming with health, and so clean she could be soap. The tan muscles of her arms were toned for a cross-court volley or a chip shot out of the bunker. Veronica was a bolt of vigor.

"A grant's a wonderful thing," she positively hummed. "Wonderful."

The college was marvelous, too, she said. The students fabulous,

and the grass, the grass in between was perhaps the best thing of all. "Kentucky blue grass," she dropped to a crouch and ran a hand through the blades, "with a little clover."

She stood up and said: "Yes."

"Yes?" I said.

And she said, "Yes."

Abruptly, her muscular right arm shot out, and up on the balls of her white tennis shoes she said:

"Yes ... Shall we?"

Everything so positive. She struck out, arms swinging, across the lawn. I grabbed my bag and, wondering at the curvature of time that had folded our universes together, fell in behind.

The night of his fire-escape escapade Jack Mayberry took his red face off around the bars in search of Rene. He found nothing but drank more trying to erase the embarrassment, and went home, kicking trash cans. Having recently been a minimalist his place was empty of most things including his bride. But her closet was there, stuffed with every outlandish fashion she could find to spend money on. What a fool he'd been. It was obvious now she cared nothing for him or his art, only following the whims and flirtations of youth. She had turned him into the pantalooned fool staring at the empty bed.

The next morning a businesslike Veronica Pantry was in the cafeteria with a caraway seed muffin and a clipboard full of papers.

"They're old but very sweet." She assigned my class. "Just get them to squirrel a little watercolor paint around. Keep them happy."

Five hours on a bus to squirrel watercolors? The seniors didn't need me. They were happy enough without this boy from the city who obviously knew less about it than they did? *Tristram Shandy* did not apply. I tried to fake it but sage old granny hands soon brushed aside my suggestions. They had been doing this for decades, water coloring and chatting. I was superfluous and relieved when Veronica Pantry asked if I'd do something extra.

"Hello there." Her voice surprised me as I crossed the lawn.

She was crouched beside the mower checking the height of the blades while the grounds keeper, in the driver's seat, retained a forced smile. She jumped up brushing phantom dust from a fancy summer dress.

"Off you go." She waved him away; her eyes alive behind flyaway glasses covered with tiny glass beads, she followed his course paying close attention to the cut of his swath.

It was early afternoon yet she wore lipstick and a pleasant perfume. Her get-up was so smart and crisp that when she led me to her station wagon I assumed we were going somewhere fancy. She turned the car off campus, heading out for open country.

"How was the class?"

"Fine."

I glanced at the road signs we passed along the way: Willow Hollow, Creek Edge, Indian Quarry. Everywhere modern obsolescence hid out in nature: auto wrecks filled Willow Hollow, the Creek was dammed with bald tires and Indian Quarry was the end of the line for dead refrigerators.

"So what kind of class is this?"

"Oh ... kids, rudimentary." She waved off the question and countered with one about my resume, a brief stint of substitute teaching at Harrisburg Maximum Security.

"A Federal penitentiary?"

"Yeah."

"Gangsters and killers? she said. It sounded as old fashioned as corsets and bonnets the way she said it.

"Brutes."

I looked over at her. She was still mulling over the gangsters, her tongue between her lips. "Brutes," she said again in a vacant whisper.

After a twenty-minute ride she swung the car off the road into a dirt drive that led into a camp of old Quonset huts. She seemed familiar with the place. There were seven or eight huts, beaten, lopsided, patched with tarpaper and grouped in no particular design around a central dirt square. She stopped the car and cut the motor. There were picnic tables, old and broken with crippled benches. A string of Christmas lights hung between the few pathetic trees. I had seen places like this before in the barrios of Central America, ghettos of poverty and desperation. It looked deserted.

"Here we are," she said.

"Looks like a migrant camp."

"It is."

It was quiet. Deadly silent. The ground around the tables shimmered in the sunlight. The slammed car doors were like gunshots. A lone figure, roused by the sound, appeared across the square and walked toward us. The sparkling ground I could see now was a million bottle caps trodden and crushed into the dirt. They formed a dense pattern around the tables and as far as an easy toss would take them. They winked in the glare of the sun. Veronica Pantry had moved quickly to greet the man and they spoke quietly before she gestured to me.

He was in his fifties hard as a hammer and weathered. I recognized the mean veneer as language of the penitentiary. Pantry introduced him as Mr. Rabb, the camp boss. I nodded but made no attempt to shake the thorny hand he didn't offer. I didn't like him. I didn't like the fistfuls of hair sprouting from his ears and nose, he looked nasty enough to be his own guard dog.

"He's a teacher."

Pantry told him. That impressed him no end. He turned and spat clean through that one, sending a missile of tobacco juice sizzling onto the bottle caps. I looked at what he'd done, grateful he had bothered to turn. The stalled conversation was taken over by flies.

"They're in Chalet eight, in back," said Rabb and walked off.

"This way."

Again I was tagging after Veronica Pantry who was already marching her stiff backed march across the square. I noticed she had replaced her tennis shoes with fancier heels to complement her outfit.

"You'll spend time with the children first," she called back over her shoulder in her edgy sing-song voice. "This way."

I caught up with her on the narrow path alongside the hut where the faint sound of television grew louder as we approached the door of Quonset eight. She paused for an instant, giving a sharp rap on the old Coca Cola sign that made up part of the door, and pushed it open. Inside, in the dim flickering light, half a dozen ragged children lay sprawled across a bare mattress watching an old black and white television sputtering in the corner. They paid no attention to us, only glanced and carried on watching the snowy screen. Then one of them seemed to remember Veronica Pantry and nudged his friend. The memory moved from child to child and they all stared.

"Hello, children," said Pantry with cloying sweetness as she strode over to the TV and shut it off. Immediately the place fell into darkness.

"Oh...oh."

During the pause I could hear muffled shuffling and unclear mut-

tering. Then the room was filled with dim, dusty light. Pantry was pulling an old rag from a grime-covered window; once again the children's faces emerged from the gloom. She left the window through a cloud of dust, suppressing coughs and slapping her hands.

"This is," she continued unfazed, "your new teacher, he's going to teach you all to read."

"What?" I looked her straight in the face, her bright eyes no longer visible through her dust-covered glasses, her skin coated with a coarse veneer of grime. "Are you kidding?"

I slumped into the only chair in the room and looked at the kids. Immediately the smallest, naked except for mud, at least I hoped it was mud, and a ragged T-shirt came over and crawled into my lap. The children stared, their faces full of detached curiosity. Not one of them smiled or moved. They just sat and watched. I looked about the room for a book. A book! What book. There was no book, or magazine or a newspaper or even a discarded candy wrapper. Nothing, the room was so bare the dust Veronica Pantry had disturbed had nowhere to settle but the floor.

"So where are the books?" I looked at Pantry.

"Burnt," she said without explanation and slipped back to the doorway. "I'll check back with you in an hour or so." She marched off before I could speak.

I looked at the children. The tallest was already missing.

"Let's go outside," I said.

They followed dutifully in silence and respectfully squatted in the dirt outside the door. Another one disappeared in transit. I didn't see the defection, just heard the sprinting footsteps on the dirt.

I was down to four now, three squatting and one in my arms. I looked at their stoic faces, one black, one white, two Latinos, into their unblinking gaze.

"What're your names?"

They stared.

"Do you know the alphabet ... ABC's?"

They stared. They watched without emotion, the same way they had been watching the TV. What is this? Change the channel. I stood up looking for a stick, or something, to mark the ground. I moved a few paces back and forth before finding what I wanted. When I turned back I'd lost another two. Only the smallest remained, a boy about six years old. He wasn't watching me, he was watching the stick with fear on his face. I tried to calm him, speaking gently.

"Do you know what this is? I drew an A in the dirt with the stick.

I smiled. The boy sprang up and took off in a cloud of dust. The child in my arms wanted out too and struggled to be free. I set her on the ground and she ran off after her friend.

I watched the tiny runner til she disappeared around the corner then tossed the stick. There were no birds, no animals, no voices, no distant cars, there was no sound beyond the buzzing of a fly that began to pester me. I brushed it away. When the fly was gone it was quiet, totally soundless, as it had been when we first arrived. I held out a hand against the corrugated iron of the Quonset hut and felt the heat radiating like a furnace. The heat was sucking all sound from the air. The silence was sucking the life out of me. I kicked the dusty ground and idled back along the path to the square.

A migrant worker's camp, fruit tramps, it was medieval – Hieronymus Bosch at the end of the award winning Twentieth Century. Lost people cut off from society, from their own time, except for that television. What did they think when they watched TV? How can they comprehend it, let alone relate to it? I stood in the square looking at the heat rising off the distant fields. They are out there working now breaking their backs.

Where was Pantry? The car hadn't moved. I walked over to it, tapped it to break the silence, it was hotter than the Quonset hut. Digging a bottle cap from the dirt I casually kicked it across the empty square, following it until another movement caught my eye. I turned in time to catch sight of one of the kids running. He ran behind a trailer home I hadn't noticed before. It was newer than everything else and stood off by itself looking semi official.

It wasn't that new or fancy it was just a trailer sitting in the dirt, but compared to the Quonset huts it was architecture. I trod easy as I approached it, thinking to surprise the kids in a game. In stealth I hugged the side of the trailer until I could peer around the corner. The children, all six of them, were standing on the hood of an old Buick staring in at the trailer window, the same passive stare as before. As I watched I heard the sound, the sound that had attracted them. I stood on my toes and peered in through another window. All I could see was part of a giggling female's leg and a man's well-worn boot.

I strolled down the dirt drive to the gate where I sat down in the lush grass of the roadside bank. So close to the vegetation I could hear the insects, a barely audible tender drone. I lay back on the bank, my head in the long grass, wondering what kind of half-assed bureaucratic notion sprung someone like me on these poor bastards.

The letter telling me I had won the grant bore the letterhead of New York State. Nelson Rockefeller, governor. Nelson 'Hiya fella' Rockefeller, who later, rumor said, made his exit aboard his voluptuous young secretary in a Veronica Pantry mode of indiscretion. After informing me I'd won a grant the letter went on to list the names of the jury. The list was short, I recognized the names, and prominent among them was Jack Mayberry. It didn't take a moment to see that my grant was to appease his embarrassment.

The drone of two trucks coming from the west stirred me from my thoughts. Old beat-up flat beds filled with people turned past me into the camp and stopped. I watched them unload in silence, barely a voice among them. They settled everywhere like falling dust, on the makeshift benches, at the broken picnic tables, propped against the shacks, squatting under the trees. Worn people. Like a medieval battlefield, exhausted bodies deformed by labor, defeated and drained of joy. Rabb was setting up a table. He was selling bottled beer out of a tin tub that probably had ice in it. The drinkers had no money. He marked their beers on a tab so they felt no pain in the purchase. Only at the end of season would they find they owed as much as they'd earned.

The bottle caps began to fly from the tables skipping and rolling across the square. Clinking glass got louder with the occasional laugh; the volume slowly rising. Mosquitoes began to buzz and bite. Hurricane lamps were being lit against the dying light. Stepping through the crowd Veronica Pantry appeared ridiculous striding toward me. Her make-up refreshed, her clothes spic and span, her hair re-lacquered, her minty white teeth gleaming through the gloom.

"Hello, hello," she called. "This way. Let's go,"

Jack Mayberry got up from the kitchen table a little unsteady. Four a.m. and Rene still not home.

"Fuck it!"

Some years before when sales were good he'd bought twenty acres up in Maine – a country place with woods and streams. He'd bought fishing rods and a shotgun to complete the picture. The gun was still in its box in the closet, he knew just where. He went to get it. He wasn't a violent man and he resented the urge to be physical, but the urge was too demanding. He took a box of shells and walked across the loft to Rene's closet. It was big, walk-in size, and it was full. Racks of hangars bearing the finest silks and cotton and cashmere by every famous couturier there was. They didn't last. Dainty to begin with, in a few loud and manic minutes they became shredded rags. The police might be banging at his door but at least he felt avenged and justly tranquil.

My village Voice piece ended in tatters too. Newsprint is not a stable medium and within months the paper turned yellow. Not long after that it became brittle and quickly began to disintegrate.

Two of several sculptures made for Sol LeWitt

Out and about

I woke. Alone. I knew right away she'd left while I slept. Said she would. How bleak to wake without her. The bed empty of her smell, her warm nudging ass, her grumping moans, her grudging grunts. Sitting up, her small perky breasts alert to the cool air, heat escaping the sheets, stale breath escaping mouths...eyes cringing at the day. I stared at the overhead beams expecting to hear the door. She always abused the bathroom door. Wham, slam, hard against intrusion as if I was about to burst in, catch her, steal her secrets. I leave it open ... making a point. Close that door. Why? Too much? So male. In love with my own farts and parts. She kept it hidden. Prudish? Where's the toothpaste? Discreet? All buried inside. You'd never know till it all came rushing out, angry accusations. You did, you know you did. Where's the toothpaste? Well, you never said. Where's the toothpaste? Did she take the fucking toothpaste?

I dressed. Same thing every day: work-shirt, blue jeans, work-boots. Wait ... no. No coffee? What? She took the coffee too? What

the fuck. Why would she take the coffee? Petty satisfaction. She took what she could, nothing of value to take. What did she leave? Hair in the drain, a pile of used tissues, empty spaces, holes where she'd been, depressions of absence, empty closet, cleaned out drawers, vacated bed. What else could she take? ... she took what she could.

I had been sanding floors for money. The job was finished, the floors oiled and drying. I had to return the rented machine then the day was my own. I had a social call at two o'clock was all. I picked up the sander – an edging model built like a fireplug and weighed as much. I looked at the empty loft closing the door. Something missing.

No harsh words in the end only silent seething. Averted eyes. Understood, understated, it hadn't worked out. There should have been harsh words ... vicious zingers, words you could later regret with pride, tears, plate smashing, something ... at least something. And no love. The end of no love ... it was just the end of the road. Parting pleasantries, fork in the path farewells, nice knowing you, you'll love it there, give me your number, keep in touch – no we won't.

Outside on the street my neighbor, Richard, was loading his old pickup. We had originally met in the California desert it was simple coincidence that we were now neighbors. He faltered across the sidewalk under the weight of some cargo as big as himself, his shaggy afro shaking with the exertion. At the curb, by the fireplug, trash bags leaned on quite a pile of paper – enormous sheets, roughly tossed and spilling over the pavement. I could see they were drawings. He grunted, dumping the load by his truck, and turned, his work-shirt twisted from the effort, and saw me.

"Hey. How's it goin'?"

"I must go on, I can't go on," sagging at the knees, exaggerating the weight of the sander in my arms. "I'll go on."

He grinned. It was a line everyone knew whether they'd read Beckett or not.

"I saw him once in a café in Paris." Richard came over, eyes brightening, he liked his memory. "I wanted to speak to him, but...you know...he's Samuel Beckett, right. But I can't take my eyes off him. Then he starts to leave. He walks right by me. I blurt out, 'Call that going?' He turns to me, looks me in the eye, and says, 'Good. How's it going yourself?'"

My turn to laugh.

"You sanding today?"

"Returning it." I said. "You working?"

"Yeah." He glanced back at the pile of drawings settling at the curb. "Cleaning out."

"Later."

"Yeah."

Turning uptown, I glanced around in hope of a cab knowing full well they never ventured to this part of town – abandoned, inconvenient to all stores and transportation. Across the street, in the empty lot, a hobo threw a wooden palette on to his fire.

It was April's idea to move in. Trying on my life for size, the artist's life. She knew little about art and cared less. I had been alone for a few months and was ripe for intimacy. How long was it after the hard rain, the April shower? Two, three weeks before she arrived with a suitcase and a box she had found on the street coming

over. A cheese box ... was it attraction or convenience – nowhere else to stay? Presented that box like an heirloom. I'm helping out, she says. Hah! What she said when she cleaned up the place, I'm helping out. And half my stuff disappeared. What happened to my razor?

"Hi there." A voice from nowhere.

Welcome to empty intimacy, the phobias, earwax and armpits. All the shit and rank breath of relationships, all the weakness and fear...

"Hiya honey." The voice came again.

"What!" I stopped and turned. "Who's that?"

A disembodied head. A woman's dusty face, bright-eyed with a halo of pink curlers stuck out from the big green dumpster. More Beckett? No other life on the street save me. Damn this sander's heavy.

"Lend a hand, Honey. Take this chair."

Clare-Withica a local kook. Middle-aged, full of southern charm and sociability, she smiled over the lip of the dumpster. I tried her accent in my head, chai-yer ... A chai-yer for Clay-yer. She disappeared as I set down the sander on the loading dock. I heard her rummaging about inside the dumpster. She reappeared hoisting a solid wooden office chair up onto the side for me to take.

"Thank you, Darlin'. Put it with the other stuff."

Everyone was bound to help Clare-Withica, everyone her friend – though she gave no hint of recognition. In a world of her own. Obediently I took the chair.

"So kind of you. That's it ... with that stool and the basket." I put the chair with her scavenged heap.

"Slim pickin's hy-er."

She added more grime to her brow with the back of her wrist, scanning the dumpster. Was it hy-yer or hay-er? I grabbed the side of the dumpster and pulled myself up.

"You want a day-esk?" She pointed. It was half buried under musty junk. "Nice ole roll-top. My daddy had one just like it."

"Nah. I gotta a desk."

"These boxes are gude. Cheese boxes. Use 'em for all kind thangs ... no, I thank I'll keep those." All the soft cheeses imported from Europe, Camembert, Mascarpone, Saint Andre, Brie, came packed in strong plywood boxes made in Finland. The importers in the area would throw them out and they quickly became a staple of loft furnishings. "There's strang hy-er. You need strang, Honey?"

I had all the strang I needed. She'd drag it all away. Her loft was a dumpster in itself, they said, jammed with old furniture, file cabinets, broken typewriters, even boxes of old toast. I picked up the sander.

Still it wore away. Was I complicit? Yes I was. You want to move in? Come live with me and be my love. Be nice, someone there to talk to. She liked sex – in the beginning. That was good – in the beginning. Briskly loved and slowly neglected. It wore away, a sedimentary affair, imperceptible wear. No larval eruptions, no volcanoes or tectonic shifts. It wore away. Drip, drip. Was I so wrapped in myself? Drip. April being April wasn't there. Drip. An only child of mid-west auto parts in retail, over the counter brake

liners. It was her mother she hated. How do you hate your mother? Turned out just like her. She unpacked her suitcase, laid out her unhappiness, mouth fixed in that down at the corners scowl. No aim, no idea what to do with her life, no desire. Funny, years later, decades later, I would catch sight of her, someplace, smiling, an exaggerated celebrity smile flashing about a million teeth. Was she that happy? I wondered. Heartless April is the cruelest girl. The women's movement gave her no peace, prodding her to stand up, be a woman, do something, be someone. She didn't know who to be, she didn't know how, she didn't know what. Bone dry and empty and smart enough to know it. April showers. The cruelest month. Was I just ripe for the time while they bombed Hanoi, shouted at the pigs, and listened to Neil Young?

Oh. What the fuck am I talking about? Put put put past the roasting house. Smell that coffee. The aroma sweeping out my head. I loved the roasting house. I'd pick some up on the way back. Putter on, putter on.

I stopped at the Square Diner of men and metal. An old railroad car with pressed tin walls and formica tables. A place for watery coffee beside a short order fare: eggs with home fries, toast, nothing fancy. The place was full; a row of broad backs fenced off the counter.

"Yeah?"

The counterman-cook caught sight of me over their heads. He coughed, chopped it into the pile of hash sizzling on the griddle, and smacked down his spatula.

"Yeah?" He glared at me, spreading grease from his hands to his apron.

"Coffee to go."

"That it?"

His nose hairs fluttered in the blow of his world-weary snort. He was old he was Greek. The waiters were young and Greek – mustachioed studs parading their manhood, Mediterranean virility stuffed in pants bulging with tightly cupped balls. They strutted hard-ons along with piping-hot plates, throwing shoulders, flexing muscles, showing forests of chest hair through too-tight unbuttoned shirts. They traded insults with their alpha male customers by way of compensation. Snappy pre-emptive come-backs to diminish attacks on their service role. Their customers wore manhood as easy as the sweat in their undershirts. Porters, handlers, truckers, comfortable with their heavy, calloused hands, their tired bristled faces spider veined and creased by work and drink. Cops, from the local precinct, bulging from uniforms that clanked with the hardware of enforcement.

"Errrrrr." My eyes raced over options I knew already. Not much tempting on the blackboard, mostly meat that came with brown gravy - meat loaf, pot roast, pork chops.

"C'mon, Shirley Temple."

The counterman's ridicule of my curls drew a snort from the nearest cop. One waiter punched another in the biceps to underscore it.

"Gimme, a sesame bagel to go."

"Schmeer?"

"Yeah."

Outside I sat on a loading dock and ate my breakfast. Arden crossed the street with a couple of her kids. Another sculptor doubling as a plumber, a bag of tools on her shoulder, two toddling assistants.

April didn't want kids ... never said why. Didn't have those urges – any urges, no desires to nest, no need of a mate, no wish to share. Stop. Stop right there. There had to be some good! She was there a while ... Yes, yes there was something good. She was good at what? – music, yes, knew a good song when she heard it. Did I mention sex? I did. What else made her happy? She was smart, clever, liked puzzles, thought like an accountant - good at tax forms. No imagination though, nothing creative. Was she kind? ... she was not unkind. Thoughtful? She was not thoughtless. She was generalities – no definition, no solid form, nothing you could put your finger on. She was not bad she was not evil. She was just there without being there. A sucking black hole in want of a life. She took mine. Nothing too heavy, slip right into her bag. I was glad of the sander's weight ... it gave me substance by inference. How could you live with someone who is good at forms? Come live with me and do my taxes.

The sander was the weight of a dead horse by the time I reached Zelf Rental. Maybe there was a time when the gold letters shone brightly on the gnawed and battered doors to the machine shop. Now the name was coated with dirt and partially obliterated. Inside the power drills and lathes ground away in oppressive gloom, relieved, here and there, by dim flickering fluorescents. The big shop had a uniform grayness, decades of machine oil grime and metal filings coated everything.

Under a naked bulb, behind a veil of cigarette smoke, mister and misses Zelf watched me close the door. They stood side by side at the counter, silent, motionless, an American Gothic tableau. Zelf towered over his wife – her home made copper colored wig at his elbow. I set the sander on the steel counter. A smile, as artificial as the wig, spread over features shriveled by cigarettes, age, and oil.

"Did we smooth things out?" said mister Zelf with a sly yellow grin.

The machine was a toy in his enormous bony hands. He looked it over, waiting while I registered his joke. How many times had he said that? Who was this character he had invented for himself – some debonair wit from black and white Hollywood? I smiled. Encouraged he smirked:

"Now you can polish it off."

He played his role with cheerful self-mockery, keenly aware of the ridiculous do-it-yourself toupee askew on his head (same color as her wig), and the repairs to his glasses made with excessive use of black electrical tape. Regardless, he was the suave orchestra leader at the Flamingo Lounge introducing his torch singer, a thirties radio host bringing out the girl who'll break your heart with her ukulele. How long had they performed this routine on their battered steel stage? He inclined his head toward Mrs. Zelf and with a fair impersonation of W.C. Fields:

"And the reckoning ... my little Chickadee?"

A precautionary hand rose with the movement of his head, anticipating hairpiece failure, but nothing happened. The hand floated for a moment, unsure how to proceed, then reached for the cigarette burning in the ashtray.

Mrs. Zelf, gray and impassive, pounded the old adding machine, like a child mindlessly banging a spoon on the table.

"There you are, mister Zelf, my love" she tore the receipt from the machine and handed it to him.

"Why thank you, my Chicka – dee, with all my heart."

They kept up their vaudeville of courtly manners while I paid my

bill. Old timers, aged in grime, parodying a world of grace. Who was fooling whom? Their sense of the ridiculous was themselves.

Outside I felt life return to my hands. The sidewalks were warming, one or two people about. There were no cafes or restaurants, no big stores. SOuth of HOuston, way down to City Hall, was mom and pop territory, husband and wife teams. Zelf and Chickadee, family outfits - the Baehm Paper dwarfs, the puny Donut man and his gargantuan wife. Arty and Joan at the Tower Cafeteria. The Hassidic Jew with the photocopy shop and his wife who would never look at the customers.

I stopped. On the sidewalk in front of me was an arm and a leg. Plastic limbs from a child's doll, garish pink resembling no human skin, and deformed in their manufacture. A few steps further and there were more, heaps, a cascade of arms, legs, bodies and heads, spilling out across the sidewalk. Infants torn limb from limb, arms and legs horribly disfigured, heads that were missing eyes or hair. I crouched and picked up a one-eyed severed head. It had the same artificial, copper colored, hair as Chickadee and Zelf. Could it be?

Rejects from the toy company. Rejects. In my wounded state the thought was appalling. Unhappiness said she took my life, she didn't. She rejected it. Threw it back. Not a keeper. No interest in what I did. Hated my world. She disparaged my friends, thought all artists pretentious, egomaniacal, self-centered narcissists. I became indignant right there on the sidewalk, a severed head in my hand. So what ... there's room in this world for egotistical narcissists. Even necessity. Who else? Who else would make things no one needs and feel accomplished?

She tried on my life, looked in the mirror, side to side, up and down, how's it look in the back? - the point of view, the attitude,

the likes and dislikes – and cast it off. You have anything in a pastel?

I walked up Greene, sidling between the big gaseous trucks jamming the street. They crowded the steel loading docks, ass in, like rows of old soldiers hunkered over the latrines. The air was choked with black diesel. On the docks thick-bellied men with pale skin, rolled white shirtsleeves, suspenders and yarmulkes met the trucks. They cursed and yelled in Yiddish over the din and fumes of the idling engines, picking through the fat bales of rags.

At the door of 112 Greene Street I set the Cyclops head on the wide sill of the windows before going in. Inside the smell of the street gave way to pot smoke. The huge empty space was like a gutted store. Electric cables dangled through the cracked plaster walls, here and there, where old machines had been ripped out. A row of fluted columns ran down the middle supporting a tin covered ceiling twenty feet over-head. The broad unswept floor under-foot was busted through in spots. No attempt had been made to fix it up. In a rectangle of sunlight from the windows Jeffrey Lew sat crossed legged in the dust on the floor. He was young, with a mass of luxuriant black hair hanging to his shoulders, and a face made happy by what he was smoking.

"Hey. How you doin'?"

Gordon Matta-Clark, squatted against one of the fluted columns, his body a coil of tense energy. He turned to say hi. His dark eyes lively, his wolfish grin spreading ear to ear.

"Yeah? How's that?"

In the middle of the space Alan Saret was dragging a big shaggy bundle of chicken wire from spot to spot. The wire was twisted, anarchic, and flopped side to side, disintegrating as he dragged it.

"Yeah. It's good," said Matta-Clark.

"Looks good," Jeffrey Lew laughed. "Looks like Dylan's afro."

They were setting up a show. 112 Greene belonged to Jeffrey Lew. Who, at twenty-one, had found the money to buy the building. He generously let friends use the ground floor as a gallery. Later he built a recording studio in the basement.

Alan stepped back from his sculpture. Jeffrey got up off the floor. A fresh joint appeared and we hung out by the columns. Amidst the deep inhaling and exhaling, bullshit and laughter, the vagaries of the day were forgotten for a while.

I picked up the severed head on the way out. A totem, perhaps it had meaning. My hand closed on its deformed features as I walked. I had not thought about April for an hour, maybe two - this was progress. I was aware of not missing her. I enjoyed not missing her. I was enjoying the absence of absence. This was fine sophistry and I had no idea what I was going on about. It must be art.

I took Mulberry Street, because I liked the name, to Little Italy where I liked the smells; the bakeries, the coffee shops, the deli's. At Hester I turned east toward the Bowery where all things turned Chinese. Red carcasses of Peking ducks hung in the gallows of shop windows. Sol LeWitt lived east of the Bowery.

Sol looked surprised when he opened his heavy metal door, though we'd agreed to meet. It was just his manner, shy, unassuming, a stay at home guy who didn't care for the bars or openings. He'd send a postcard if he wanted to stay in touch.

"C'mon in."

He was a friendly, avuncular figure on the edge of success. Already well known to other artists, within a few years he would

174

achieve international recognition. His place was small compared to the giant SoHo lofts. An old rundown, lower east side building: cramped, iron gates over the street windows, low ceilings, a wood stove. It was easy to imagine an overcrowded sweatshop of dressmakers stitching calico, or milliners braiding straw hats; their eyes straining under oil lamps.

The front room, overlooking the street, was his workplace. A long table ran the length of the wall under the windows. He had a drawing board angled on it, with his pens and pencils laid out neatly beside it. The stove, its chimney disappearing into the blackened wall, sat in the corner with a lot of old wood.

"I used to carry bags of coal up those stairs when I was your age."

He wasn't old, early forties, with a solid, barrel-chested build. Two of his sculptures sat in the middle of the room. But the biggest thing in there was a double bed. I knew he lived with his girlfriend, Mimi, but there was no sign of her, no imprint anywhere. He threw my pea coat across the bed and we went back to the kitchen-hallway.

"This breaking up your day?" I was deferential, him being older and successful.

"My day's over," he said. "You want an espresso? Sit down." He gestured to the table in the back room.

"I was in the Quartermaster Corps when I served in Korea." He stayed at the kitchen counter to fix the coffee. "We had to get up at five every morning. I never got over it."

The back room was crowded but not cluttered – three tables, a couch, numerous chairs, and several bookcases. For a minimalist, Sol had a lot of stuff. But organized.

"I have my routine. Up at five. Read the papers and breakfast. Work until lunchtime."

He had established a modernist presence in the old crumbling building.

"Afternoons I read, take care of business, visits."

Books packed the shelves, art books and exhibition catalogues neatly stacked on the tables. And music, a big collection of albums and a growing collection of tapes – all labeled, catalogued and organized. He was fastidious with a structured schedule and a disciplined life. He brought in the coffee and we sat at the round table by a window that looked out on to a brick wall.

The room was an homage, of sorts, to the European styles of the Bauhaus and De Stijl. Tables and chairs aligned and squared. Much of the furniture had been built by him, with his signature spare rectangular frame designs, painted white. The only sign of his new-found success were the expensive Rietveld and van der Rohe chairs he had. The first things on his wish list – more beautiful to look at than sit in.

I've never met anyone more dedicated to art. Its history, its making, the people who made it. He lived totally immersed in it. He was easy to talk to. His reluctance to hold court, to dominate the conversation, made him singular in the art business, almost enigmatic.

"What's it called again?"

We were talking of books we liked.

"*Tristram Shandy*," I said, telling him of my current favorite. A classic innovative novel that played wildly with the form. Dr. Johnson said, "Nothing odd will do long. *Tristram Shandy* did not

last." But he was wrong, it is still in print, admired by many: Joyce, Woolf, Foster Wallace. Decades later Sol reminded me of the conversation. "Johnson was right," he said. "It is too weird."

"You ever read the Beckett novel *Molloy*?" he said. "The section with the sucking stones?"

"Oh, yes." This really was my Beckett day.

Molloy, on a beach, has sixteen pebbles arranged equally in four pockets. His ritual is to suck each stone in turn. Determined never to suck a stone out of order, he transfers the pebbles from pocket to pocket with mathematical precision to ensure their exact circulation.

How perfect. The orderly nature of the room was the same: methodical, precise, respectful. His art was a love for systems, organizing, algorithms. The underlying structure, the core is what he liked.

"Of course the outcome's important. I don't know what it's going to look like," he said. "I want it to be a surprise."

His love of music made me think his systems were annotations, like musical compositions. They could be played in one room or another, drawn one way or another.

"Yeah. True ... same piece of music, canon or fugue, can be played on a church organ, or by a jazz band. The nature of the wall, where it is, effects the drawing. Context changes the work."

"Where'd you find the Muybridge prints?" He had several framed around walls.

"Second hand book shop on Third." He was proud of his find. "They're the original prints he published."

The prints showed the progression, step by step, of a woman running, a man jumping, a ball thrown – each frame, like a movie frame, leading to the next. They were just like his art, rational systems at work. Pollock said: 'Every good painter paints what he is.'

I was intrigued by Muybridge the man, about the intersection of art and life. Muybridge lived in turmoil yet his art was meticulous. A photography pioneer he practically invented the movies with his Zoescope. Still he had time to pursue and shoot and his wife's lover in great passion. And in old age, died while making a pond in the shape of the great lakes. Yet his art was more like science, precise and detached. Picasso felt: 'Painting is just another way of keeping a diary.' I like that. Painting his love affairs – whether he liked them that day. Today – sausage fingers, flying tits, eyeball in the corner pocket.

Sol preferred the separation; life lived on another plane. Contemplative and measured, no crazy outbursts. So, here we were being who we were. A hedgehog and a fox. Yet we shared a deep appreciation for the pleasures of an examined life. He liked the bare bones of abstract structures. I liked flesh on the bone, to see the interweaving in the tapestry. I also liked mixed metaphors.

As I was leaving he asked how I was surviving. I told him I'd just finished a sanding job. I'd find something new. He paused.

"Could you make something like that?"

He pointed to one of his complicated sculptures, made up of opened frame cubes, on the table. I hesitated. The craftsmanship was excellent. I needed the work, but wasn't confident I had the skill. By now I felt sure that Sol's orderly life style was not simply self-imposed discipline but the very thing that kept him running. I guessed anything out of order would give him fits. I wasn't sure

1. WORK SURFACE
2. CHAIR
3. SCULPTURE (BLACK)
4. SCULPTURE (BLACK)
5. UNUSED WOOD
6. BED
7. WOOD STOVE
8. SHELVES
9. SLIDING PARTITION
10. REFRIGERATOR
11. STOVE
12. TOILET
13. SINK
14. SHOWER
15. BOOKCASE
16. ROUND TABLE (4 CHAIRS)
17. HEATER
18. T.V.
19. LEATHER CHAIR
20. 3 LEGGED STOOL
21. BLACK LEATHER SEATS
22. RECORDS
23. RIETVELD CHAIR
24 RIETVELD (RECLINING CHAIR)
25. COUCH
26. TABLE
27 TABLE
28 DESK
29 CHAIR
30. BOOKCASES.

Sol LeWitt's loft. Friend's places drawn from memory on a series
of postcards, 1972

I was up to snuff, but it looked like more fun than sanding floors.

"I dunno ... it's well done."

"Why not try one? See how it goes." He was then and always remained very generous.

I walked back by way of Canal Street with his drawing of what he wanted in my pocket. In the right mood art is up-lifting, spiritually gratifying, inspiring. In the wrong mood it's what my mother called codswallop. I stopped at Pearl River, the Chinese department store, to buy a tube of gingseng snow lotus toothpaste. As I perused the shelves, drifting about the store, I came across boxes

of jig-saw puzzles., each one with a different scene. Taken by the complexity of the little pieces that fit together to make the picture I wondered if they were truly different. Was it possible they used the same little pieces with different pictures? I bought two puzzles with the same dimensions but different pictures.

Outside other stores had their stuff out on the sidewalk, flea market style, on tables and benches, in boxes and barrels. What they sold was anything someone else had thrown out. The street bristled with hawkers and gawkers, handymen, and the curious and the inconvenienced.

"How much for this coil of old wire?"

"Two dollars."

"Two bucks? It's all rusted, useless."

"It's worth three."

"I'll give you a dollar."

"Sold."

I poured over obscure tools, engine parts, old radio valves. One minute fully engrossed in all manner of things: the test tubes, magnets – and equally full of curiosity for art and culture. The next minute my working class upbringing would mock me for all the pretension. Nothing but left footed shoetrees, meaningless rubbish, useless things of inexplicable origin. Dental tools – would I drill my own teeth? Cubism, Symbolism – would they put food in your mouth? What use was it all? Was it a pretext for avoiding life or life itself?

At one of the stalls I found Clare-Withica, transformed, without curlers, her hair set into a 1950's permanent. She lunged at me

without recognition, a broad smile on her face, she set a hand on my arm.

"You, sir. Take a look at these chai-yers, and tell me you've seen anything finer, at that price."

I paused looking at the chairs I'd helped her retrieve from the dumpster.

"You cay-n't, can you?"

I walked away, walked home. I pulled the severed head from my pocket. Its one eye blankly staring was all the help I needed to toss it into the corner trashcan. She was gone. Get over it. I reverted to homilies for comfort – plenty more fish in the sea. I embraced the spring evening. The sun hung low over the Hudson River. As usual my street was deserted. I stopped on the loading dock outside my door. The pile of drawings lay undisturbed, by the hydrant, sprawling into the gutter. I went over to take a look. They were huge sheets with fierce, black attacks on the paper. Big ragged shapes. And scrawled alongside in the same dark mood were cries of despair, graffiti of loss and love gone wrong, howls of regret and promise. A love affair had come to an end. The suffering had landed in the gutter. Call that going?

I felt moved standing there in the empty street. We all deal with unhappiness in our own way. Struggling with need and revenge, fault and desire. I went upstairs. Maybe I'd put the puzzles together, maybe not. I had nothing else to do. I had the place to myself.

I did puzzles, side by side; old movie stars, Jean Harlow in one, Clark Gable the other. Then for the test I selected an edge piece, at random, from Clark, and tried to find its match on Jean. Sure enough, there it was, the manufacturer had turned the picture a few degrees before stamping it out. I winkled out the piece from

Jean and replaced it with the piece from Clark. Perfect fit; it exposed the pattern. By swapping alternating pieces between puzzles it made two Cubist looking pictures with Harlow and Gable enmeshed in both. Looking at one, Jean Harlow was clear until you began to sense another presence, then Gable became clear and Harlow faded. Fragmented and indistinct, like the overlapping dialogue in an Altman movie. You might be missing something of the photographic clarity, but it was livelier, your mind filled the gaps with new sensations, and thoughts, and ignored what it didn't want to see. It was sort of like my day.

One of Sol LeWitt's postcards. Staying in touch.

Can't say, ink and white paint on photographs

Puzzling: Jean Harlow and Clark Gable, 1972

Feathering the nest

After a few drinks Ruth Kligman could get good and bawdy. All dressed up like that, diamonds and pearls, cocktail dress, you weren't expecting comically loud and raunchy. She was parading her sex life, comparing herself to the fastest gun in the West. "All the young artists want to fuck me because they all want to fuck the woman who fucked Jackson Pollock." She laughed a lush round laugh through a donut of ruby red lipstick. After it was over these boys became tiresome. "All they want to talk about is how good Jackson was ... I always tell 'em, with a little squeeze, 'Don't worry, honey, you'll improve!'"

We stood in a circle of louche talk at a Castelli gallery reception. An assortment of artists and friends, and friends of friends and people who'd wandered in off the street. We soaked up Leo's wine listening to lewd Ruth, whose role in the art world seemed to go no further than having a good time. And why not?

A tug at my sleeve peeled me away from the laughter. The tugger was a small man with an earnest face. His wrinkled raincoat

(though the day was fair) was thrown open to show an old fashioned sweater-vest; maroon - just like the one my dad wore. The rest of him was the same generation: old-time shirt and tie, short back and sides style of haircut. He smiled, chipmunk cheeked.

"Hi, I'm Herb Vogel." He stuck out his hand.

As I took it he rose up on his toes, puffing out his chest, his voice getting bigger, his gestures broader. I glanced down at the shoes on his tiny feet, they were made for comfort not style and battered to a Bosch-like deformity. The knees of his gray flannel pants were baggy and rounded with wear. On the street he would pass unnoticed, but here amid the uniformity of youth and blue jeans, he was odd, something different. Probably why he seemed so nervous. I'd heard of the Vogels. Not a lot. I'd heard they were collectors.

"This is Dorothy, my wife."

He barely gave her a glance as she joined us; she was even smaller, more tense, more doll-like than he was. Her wardrobe was also of a generation that called it a wardrobe: women in hats and gloves and nylons with seams. She smiled sweetly but didn't speak. Herb was the jittery talker, unable to keep still. She stood gripping her purse with both hands eyes wide open behind large owlish glasses. I'd heard that Herb was a mailman, which would account for the beat-up shoes, and that Dorothy was a librarian. Later, when I was told that vogel was German for bird I was pleased. So fitting, they were just that, sparrows on a wire hopping from one foot to the other.

Collectors though, that was a matter of opinion. There was the idealized version: sixties sentiments of anti-establishment, anti-capitalism, anti-war, and anti-materialism. Artists, especially struggling artists like myself, endorsed the idea of this couple collecting art even though they lived on a worker's paycheck.

Struggling collectors – it was a nice twist, very appealing. The less charitable thought they were a pain in the ass. The family pet who won't stop pestering for treats.

Behind me blowsy Ruth had them in stitches, rolling in the aisles. I wanted to hear but Herb had my hand and wasn't about to let go. He had heard a lot about me, he said, from this one and that one, he said, he was impressed by what they said, he said, and would love to make a studio visit. He and Dorothy liked nothing better than to find young emerging talent. Of course, everything he said was hyperbole and calculated to flatter. And the flattered become fools.

Why would they want to spend their hard earned paychecks on art? Wasn't collecting an indulgence for the rich? What was in it for them? It wasn't social climbing, they didn't appear to socialize, nor did they try to be the artist's friend or adopt the life-style. It had to be a hell of a sacrifice – one look at their clothes. And these were not pretty pictures they were after. This was fairly obscure, elitist stuff; art at the end of Modernism. They must really love it.

With no experience of collectors I still thought that people bought art because they liked it, believed in it, were seeking the philosophical rewards of the examined life. Fat chance! I'd yet to learn that collectors had all kinds of motives and methods for what they did. It had never occurred to me to think about it from their point of view.

At the other extreme of income inequality I'd met Rolf Handka, heir to a Swiss pharmaceutical fortune. He invited me to view his collection. We stood in the drawing room of his Park Avenue duplex (he also had a castle near Lake Geneva) where the walls of the large tasteful room were hung like the Museum of Modern Art; a Leger here, a Lichtenstein there, a fair sized Stella, a brass Judd

relief, and a small Pollock. Little more than thirty, Handka still had the slightly cherubic look of an adolescent, with puffy, bee-stung lips, and floppy blonde hair falling over one eye. He spoke impeccable English with the accent of expensive private schools. He handed me a glass of wine and set the bottle down next to the skinny Giacometti bronze on the coffee table. I guessed he was the son they didn't want running the company. He was explaining why he was a Communist. Maybe that's why.

"You're wondering ... I can see ..." He watched as my eyes took in the room. "With all this, why would I be a Marxist?"

"Yeah."

"Simple. I believe it because I want everyone to have this, to be able to live the way I do."

Yes. Well, he would say that wouldn't he? I stood, peanuts in one hand a glass of red in the other, admiring his collection. The size of the Pollock struck me as unusual, I'd never seen one that small before.

"That's a Premier Grand Cru you're drinking," he chided me in that superior tone. "Don't swill it. It's not for washing down peanuts."

The Vogel visit came a week later with ill-concealed irritation. On the way down to open the street door I found the last bulb had gone in the stairwell. As I led them up through the dark I could hear nasty cracks behind me and apologized for the lack of light. But in the studio it was obvious the hostilities were not about me or the lights. Something was up: glares flashed back and forth, eye-rolling and behind the hand sniping were intercut with the occasional "Phah!" It seems they got lost, took the wrong train, and were bitching it out in a marital spat. Herb was hopeless at

hiding his irascible streak, while Dorothy took a daintier route through gritted teeth. I tried show them the kind of work I was doing, which was "conceptual" and mainly little books.

"You see, instead of drawing a circle, or making one out of metal, this is about inside and outside based on the anthropology terms – endogamy and exogamy ..." I said.

"I told you we should have changed at 14th Street," Herb spat behind my back.

"Marrying inside the group or outside ..." I went on showing them a page from my book.

'Im from 'ere, her from there

"'im is a solecism – inside the social group, her is not – it's outside."

"It wouldn't have mattered if you'd have been on time," Dorothy hissed back.

They didn't stop. Maybe I shouldn't have mentioned marriage, but whatever I showed them had no effect on the internecine war. Herb didn't give a shit about the ideas, only interested in what he could get for his hundred bucks; the five twenties burning a hole in his pocket. He kept picking up bits of paper from the table. Like a tag sale.

"How about this? This a drawing? How about that?"

We were at an impasse. Frustrated by the distractions, by the lack of interest, I couldn't decided if Herb's style was nervousness or rapaciousness. But what was obvious was that my art was not connecting. Somewhere between conception and presentation I was

losing the audience. And blaming the audienceis the easiest road to denial. Whatever merit was in the work was not engaging them. It was something to think about. I ended up giving them copies of my little books. Later, I learned from other artists that the visit was pretty much business as usual. It was not the uplifting experience I'd hoped for, it was more like a fire sale.

The rich are no better, just different. They want bargains too. Not because they can't afford it but because it makes them feel special. They got the insider price, the friend's price. Friend? Is it possible to be friends with the rich? You can try but the money's always in the way. They feel you're only interested in the money, and they're right. Without it they'd be just like anyone else.

The next time I saw Herb Vogel was at a Guggenheim Museum reception. The ground floor, beneath the great spiraling ramp, was packed. He pressed his way through the crowd casing the joint. When he saw me his manner took on a kind of swagger.

"Hey, hey. How you doing?" We were old chums now. We'd been through the dark together.

After clumsy greetings he invited me to see their collection. "Come for dessert, Wednesday at six. Okay?"

After our awkward studio visit I was curious to see what they had bought from other artists.

"Okay, sure. Thank you."

"Don't be late."

Once I accepted he hesitated. His manner changing again. He hovered, wavering up and down again on his toes, unsure of himself.

"You know Rauschenberg, don't you?"

"So does everyone in this room."

"I mean you're close."

"Close? Not at all. Friendly, he's friendly with everyone."

Herb's question was not casual, I sensed an ulterior motive.

"Could you er ... get him to ..."

"Well," I stopped him short. "He's standing right over there talking to Claes Oldenburg. Why not go ask him yourself?"

"Oh. Oh, yeah. Right ... right. Of course."

Rising on his toes he reluctantly moved a step or two that direction.

"See you Wednesday," I said.

"Don't be late," he said.

After a few more steps he veered off and disappeared into the crowd.

A monumental task he'd set himself - to build a collection of contemporary art with little or no money. And from what I could tell, it was art he didn't particularly like or relate to. He had put aside pride and ran around tugging sleeves, asking favors. But how else could he do it? He didn't have anything else.

On Wednesday, a few minutes after six, I arrived at the Vogel's door – a modest two room apartment in an ordinary uptown block. The atmosphere was already brittle and awkward. Tricia Abbott, a photographer I knew slightly had just arrived with a friend. Tricia's a wide-eyed woman with a huge afro and a slight,

very appealing, speech impediment. Her friend Polly said nothing. The cause of the tension was obvious, Herb didn't disguise it – Polly was not expected or invited. A sixties girl, Tricia hadn't given a second thought to bringing a friend along. But the Vogels couldn't handle it. Still trying too hard, shooting off anxious flares, neither one of them knew how to put their guests at ease. Their nervousness infected everything, made the simplest gesture – "have a seat" – fraught with trepidation.

Dorothy, clearly wishing the whole thing wasn't happening, stood pressing her hands together with white-knuckle force, while Herb grew increasingly excited. He intended to show every single art work – and there were a lot of them. Framed and unframed they covered the walls, floor to ceiling, hung on doors, the sides of closets, propped on shelves. They were all very small yet it was hard to imagine, if they bought anything else, where they would put it. Herb recited the artist's names, most we knew, some we didn't. We nodded, following along as he grew evermore confident and excited moving from piece to piece.

So this was it. This is why they collected. Herb was no longer the mailman schlepping the daily post, the small unnoticed carrier bringing news and bills and picture postcards of foreign lands he'd never seen. Dorothy was no longer rubber stamping due dates, or slave to the Dewey Decimal. All that tugging. All that reaching up on his toes had paid off. He was transformed. He was big. And why not? Watching them you could feel their pleasure in achievement. They had found a way to work around the privileges they had been denied. I began to admire them.

There was a growing number of collectors who bought art, and had it shipped directly to storage waiting for its value to increase. The Vogels lived with their art, totally surrounded by it. You

couldn't look anywhere, save, maybe, the ceiling without seeing it. Yet they didn't seem that engaged in the whys and wherefores of the individual works. They were in touch with a bigger picture and didn't care for the details. It was enough to have it, like a souvenir of their own existence.

"Well. That's it."

Herb clapped his hands together, the tour was over. Tricia and I stepped in to congratulate them. Polly, still embarrassed to be there at all tried her best to be invisible. Then Dorothy announced dessert would be served in the kitchen.

We followed her to the kitchen table where four store-bought puddings sat in their plastic containers. We did the math in awkward silence, until Tricia said:

"Oh, no. Not for me. Thank you."

And Polly, quickly:

"Me, either. I couldn't possibly."

I ate mine. No further mention of art was made. Tricia, Polly and I were back out on the street before seven. The moment we hit the sidewalk Polly exploded:

"What the fuck was that?"

Nervous tension slipped away with laughter. The release made us giddy. For a block or two we just sucked in what air 86th street had to offer. I liked Polly, I thought she was funny.

"Did they buy something of yours," Tricia said.

"No." And I realized I had not seen my little books anywhere on the tour.

It was a fair evening and we talked as we walked, of mutual friends and shows and aspirations, until we found ourselves on Park Avenue. A big Town Car swept passed us and pulled up half a block ahead. The doorman stepped smartly out from under the awning and opened its door. Rudolph Handka, in a dinner jacket, got out followed by raunchy Ruth in cocktail dress. They quickly crossed the sidewalk into the building without looking our way.

"Isn't that whatsisname?" Tricia said.

"Yes," I smiled. "He lives there."

Puzzling:Clark Gable and Jean Harlow, 1972

Nowhere, 1972 Page from an atlas blacked out. One of many map
drawings over the years

The river that runs both ways

"I don't get it." said Polly.

"Silence," I said. "Different silences."

Pinned to the wall, I had laid out the sheet music to a Bach fugue, and colored in the various parts where each instrument did not play. Clarinets not playing - yellow, trumpets not playing – red, and so on. It was similar to the Village Voice amusement I had made earlier.

"Different silences?" Poly studied it with furrowed brow. We'd been seeing each for a few months, since that evening at the Vo-gel's. She stepped back and flatly announced: "Well, that's dumb."

"Knew you'd like it," I said.

"But who's gonna get it?" She was not enthralled by my art. "Why can't you draw a face or something?"

Her words were an eerie echo of what I had asked my hedgehog friend, Jim, years ago. But I had asked him that question to find

out why we did what we did. That is not what she meant.

"You mean, just to please people?" I said.

"And that's bad?" She said. "Warhol paints people, and makes a lot of money doing it."

"Yeah. Well, he's into that celebrity culture; he loves the superficial."

"He's good at it."

"It's authentic. It's who he is!"

"And you're so deep-dish," she laughed. "What a crock!"

We left the loft. A summer's day. The war still killing in Vietnam, Nixon off to China, George's *Concert for Bangladesh*," another summer for dirty red band-anas and Polly sang "Me and Bobby McGee" as we walked through the remnants of the old Washington Market.

"I think different silences is a nice idea," I said. "Sorta like John Cage."

"How you gonna sell silence?"

"Never thought."

"Hah! You need to get some better ideas. Silence. Hahahaha!"

At West Street we came on the wide-open expanse of the Hudson River. The bright sun threw a glare on the water. Across the street two sculptors friends were standing on the riverbank, Bill Bollinger and Peter Gourfain. Seeing us Peter waved his hand in grand arcing gesture over the breadth of the river and shouted:

"'riverrun, past Eve and Adam's, from swerve of shore to bend of bay.'"

"What'd he say?" said Polly.

We crossed to join them.

"The cycle of life!" Peter kept up the roar as if we were still a block away. A flinty talker he was all skittering hands and flying elbows. Bill raised his head and said quietly:

"The Indians called it the river that runs both ways," then he looked down at his well-scuffed boots. His taste ran more to Popular Mechanics. Peter drew another circle in the air.

"'brings us by a commodius vicus of recirculation back to Howth Castle and Environs.'"

"What're you talking about?" Polly looked at him like he was crazy.

"*Finnegans Wake*," I said.

"Oooh," she groaned. "More bullshit!"

Bill snorted.

"Bullshit?" Peter taken aback. "*Finnegans Wake?*"

Polly looked out at the skeleton of a pier, only its bleached pylons sticking out of the water like the ribcage of some giant dinosaur. "It looked like gibberish to me," she said.

"Hah!" Bill grinned, took his hands from his pockets and tucked them under his armpits.

"Gibberish?" Peter looked from Polly to me, and back. "Joyce was playing with language," He worked his hands in earnest, kneading the words. "Pushing, pulling, creating poetry in accord with the meaning." He squeezed and stretched the words. "When the sense is dancing the words dance." He stopped and marveled at the thought.

Bill reached down for the pebbles at our feet.

"It's not about something," I said. "It is something."

Bill swung back and hurled a stone out into the river.

"Blah blah blah," said Polly, and in a mealy-mouthed whine she mimicked: "It's the flatness thing. The no illusion, thing. Yadda, yadda, yadda. It's not a painting of a map it is a map. Hah!" She scoffed as if ridicule proved her point. "You guys over-intellectualize every piece of crap. It's just art, boys. It is what it is."

"And that's the point," I said.

And Bill threw another stone.

"Have you read it?" Polly demanded as we walked away.

"Just parts," I admitted. "It's very dense."

"Aha! See! See." Polly laughed as she teased, her bullshit detector flashing wildly. "Why even talk about it?"

I envied her certainty. Her quick mind never idled in speculation. She knew what she knew, and if it proved wrong she spat it out like yesterday's gum. Working at a newspaper doing the Listings: every movie, play, every concert, every restaurant from A to Z, she was an index of popular culture. As a posture, mostly comic, she claimed to know nothing of anything that happened before her sixteenth birthday. If it didn't happen while she was around then fuck it!

"Just talk," I said. "Throwing things around."

"Yeah? And what's with Bill throwing the stones?"

"He's making a point," I said. "Action not words."

"Jeeesh!" She practically skipped with delight and began again ... *and we sang every song that Bobby knew* ... singing as we walked "You read something into every little thing." She interrupted herself. "Give it a rest. Your head's gonna explode!"

Passing the Erie & Lackawana sheds we were forced under the dank armpit of the elevated West Side Highway for a stretch. Pigeons flew out of the sunless recesses they shared with small colonies of bats.

"Bill's like you," I said. "Hates anything intellectual,"

"You guys." She shook her head. "So insecure."

Back in the sun a chain link fence staggered alongside the road, sprawling and broken. We climbed over it to the Marble pier. We had come out this afternoon to find a small tabletop for her apartment.

The wharf was desolate. The old corrugated iron warehouse ripped like a paper lantern. Decayed and rusted, chunks of the roof hung from crumbling girders, the big doors fallen in, the windows smashed. The remains of an office, with heavy wooden chairs bowled over, missing arms and legs, stood open to the weather, anything worthwhile already stolen.

"Your whole art world is nothing but over-sized egos making absurd claims for trivial crap," she said.

"Boy," I watched her pick up an old stock certificate from the floor. "You've got a bug up your ass today."

"Keeping you honest, my boy." She let it fall to the floor where it settled amid the detritus. Useless stocks, bonds, silver certificates. The marble owners had walked out leaving everything to fate.

"I don't slag pop culture. I like a lot of it."

"S'what everyone likes."

I picked a small china inkwell from the rubble and turned it in my hand.

"It's popular cuz everyone likes it," she said.

Dipping pens and inky fingered scriveners had sat right here, the sound of lapping water beneath their feet.

"I'm not allowed to like unpopular things?"

I set the inkwell on what was left of the old roll-top desk, smashed by vandals, and stuck a finger into a bullet hole where I could still see the slug.

"Well, if you think it makes you important," she said.

"It's not about that." I snapped. "It just opens your eyes to something different ... surprises because you never saw it like that before. Popular entertainment's not really about anything other than making you feel good. It's comfort food."

"Gawd. You're such a snob, an intellectual snob!" she laughed. "I mean, who gives anyone *Zero Degree Writing* for their birthday?"

"That again," I said. "It's a nice little book."

"Zero Degree fun. Jesus."

"I bought you the boots too!"

"With my money."

"I'll pay you back."

"Yeah, sure." She grinned a triumphant grin and stuck out a leg to

show off the boot. I followed the curve of her long tan leg from sturdy work boot to contradictory miniskirt. She read my thought coming closer.

"Let's do it on the marble," she said.

"Outside?"

"It's very popular."

"Tyranny of the majority," I muttered.

Beyond the warehouse the pier stretched out into the river the broad planks pitted and worn by work and time. The gleaming new Trade Center towered above us, still unfinished. Across the river Ellis Island and The Pennsylvania Railroad Terminus sat low on the water, further out the Statue of Liberty stared out to sea. We called it the Marble pier because it was full of imported marble, masses of it; a deserted grave-less cemetery of long crooked aisles stacked high with great slabs; haphazard rows of cut and polished blocks and convenient hidden nooks. We found a large polished slab warmed to perfection by the sun. All this, the wharfs, the piers, the marble and the scriveners inkwell was buried under landfill by the end of the seventies. Stuyvesant High School, Teardrop Park and Rockefeller Park took their place.

After, we wandered through the landscape of marble chunks and slabs that thieves had tried to steal before discovering the immense weight of the stone. Beyond the marble we could see a tugboat moored at the far end of the pier. We wandered toward it, the buzz of traffic back on the West Side Highway growing distant. There was a woman on the tugboat, leaning on the rail, talking to a man on the pier. She waved as we approached. The man turned to look.

"Hi," she said, "looking for a tabletop?"

"Yeah, like everyone else. Huh?"

"Ah ha!" The man put his hand to his head, perplexed, as if asked for something he'd forgotten. His disheveled clothes, hung about him a limp insoluble problem. He adjusted the heavy black-framed glasses on his boyish face. "That's a tough one, yes, that's a tough one. Too bad, all the small stuff's gone. Too bad."

"I know you." The woman was looking at me. "You know Kieth and Arden, right?"

"Oh, sure. Are you Captain Pam? They talk about Captain Pam and her tugboat."

Captain Pam had the look of a Huckleberry Finn. Her khaki shorts smeared with black oil, her tee shirt ripped, her bare legs squarely planted in clunky unlaced work boots. Whatever else she was, she was not vain. She must've been working on the engine, her arms glistening black to her elbows with oil.

"D'you know Dick?" said Captain Pam. "Dick Bellamy."

I was surprised. Dick Bellamy was a storied figure in the art world. He'd had a gallery in mid-town called the Green Gallery in the early sixties that had introduced a lot of young artists – James Rosenquist, Donald Judd, Robert Morris, Claes Oldenburg, Mark di Suvero and more. He was Mooney Peebles, star of the Beat film Pull My Daisy with Ginsberg, Corso and Kirouac. Why was he on the pier?

"Ah, yes, well." He took off the heavy rimmed glasses, ran a hand through his hair, leaving a lot of it standing on end, and held up the palms of his hands to suggest this was a question he hadn't considered. "Beautiful day, you know. Looking at the marble, maybe, like you."

Right away I could see why he was so well liked, he was eccentric, an original.

The tug sat low in the water. As we talked it pulled at its mooring, heaving against hawsers, thick as a man's arm, fetching moans from the wooden pylons.

"You want to look around?" Captain Pam beckoned us aboard.

The buffers around the sides, fenders of old rubber tires and coiled rope, whined and squeaked as we climbed onto the boat.

"This what you're working on?" Bellamy stood looking down at the wrenches neatly laid out on a grease-covered towel in the engine room.

"Yeah. I'm done," Captain Pam cleaned the oil from her skin with the remains of an old tee shirt. Under the smudges she appeared to be in her late twenties, a womanly body without feminine gestures.

"These original?" Polly ran a hand over the old brass fittings in the oak paneled galley.

"Yeah." Captain Pam squatted in front of the small refrigerator. "I've got beer." She had the voice of an aging mobster.

She handed out bottles of Ballantine ale.

"Let's go for a ride," she said climbing the steps to the wheelhouse. "It's a beautiful day."

Polly followed her to watch. Bellamy and I lifted the holding ropes as she urged the tug against the pier churning the polluted waters beneath. We jumped aboard as the tug pulled away and settled in the stern as the wake spread out across the glassy surface of the water. A listless, sunny, Sunday afternoon, we were the only

boat moving on the river, heading south toward the mouth of the harbor.

"Do you like the Hudson River School?" Bellamy said after a while.

The 19th century school had painted huge, obsessively detailed landscapes of the Hudson Valley – every leaf on every tree.

"You know what they believed," he went on. "They believed an accurate depiction of the landscape revealed the presence of God. No brushstrokes to betray the hand of man."

"More pious than romantic," I said. "Are you a religious man?"

"Spiritual. No omnipotent god, no." he said. "No. I struggle with Buddhism."

"Struggle?"

"I struggle with most things," he grinned. "I try to find the self, find equilibrium, but the self is always changing, like the water. Sometimes rain, sometimes river, sometimes dew."

It sounded like Joyce again. Finnegan.

"I tried, I could never read it," he said.

"I like the hand of man," I said, "the imperfection, the discoloration."

We stood in silence with our imperfections. Neither of us knowing where to go with the conversation, we just looked at the river. Then he walked away, without a word, to the center of the deck and lay down on his back and closed his eyes. Was he searching for his equilibrium?

I joined the women in the wheelhouse. We had sailed out by Gov-

ernors Island and Staten Island toward the Verrazano Bridge. Captain Pam at the helm, one hand casually draped on the wheel the other round the neck of her Ballantine beer. Polly and I stood in the doorways on either side of her watching Manhattan recede into the waves.

"You were an artist?" said Polly. "Before this?"

"Yeah," she said. "But you've gotta live."

"You quit?"

"I liked this better. I wanted something real. You know what I mean? Concrete ... coil that rope, tow this barge, fix that rail. I worked a lot of years on other people's tugs. City Island, Hoboken, Brooklyn. Ran the galleys. Then I heard about this," she rapped the boat with her knuckles. "Good price, prime condition. I got a little something when my mom died." She took a swig of her beer. "Real things."

"Like Bill," I glanced at Polly.

"Dah, the stones," she said.

I listened to the women talk; fluid, animated, funny, taking pleasure in "real things." I looked out at water flowing by. Was Polly right, was I an intellectual snob? I lived the same soda pop culture everyday but didn't love it the way she did; totally immersed, like Warhol, so high on the surface she couldn't spare a moment to reflect. Trying to be like her would be foolish. But it was true, I was often chasing my own tail around an ivory tower. For years I had buried myself in intellectual pursuits ignoring my whimsical self. So serious, trying to avoid vulnerability by knowing more, being overly analytical. Was I turning into Mr. Casaubon? Holy crap. Which was me? Where was my fox? I liked the wall, I liked

207

the ladder, but most of all I liked the leaning.

We sailed under the Verrazano-Narrows Bridge into the lower bay, past Coney Island heading to the brink of the Atlantic Ocean between Sandy Hook and Far Rockaway. Bellamy appeared below us in the bow of the tug shuttling quickly from one side to the other scratching his head. He looked from the ocean up to Captain Pam in the wheelhouse.

"Where's the ship channel?" he called. "You know, the deep part the ocean liners use."

"The Ambrose Channel? We're in it. It's right here between Sandy Hook and Breezy Point over there."

Bellamy's head swiveled back and forth searching the water. "So where's the famous shallow spot?"

"Romer Shoal? It's over there toward Sandy Hook. How'd you know about that?"

"I read a book, *Bottom of the Harbor* by Joseph Mitchell. He says there's a spot only four feet deep around here. Some guy wanted to stand there wearing a top hat to greet the ocean liners as they came in. Can we go there?"

"What for?"

"I just want to try it. Stand in the ocean." Bellamy was laughing with joy. "I want to see if it's real."

"I can't go near it, Dick. It's too shallow. I don't want to get stuck."

Bellamy was disappointed he couldn't stand in the ocean and wave. He resigned himself to just looking, and after sitting a while taking in the spectacle of the Atlantic Ocean. Pam brought the

tug around and we circled back into the upper harbor. We sailed round the back of the Statue of Liberty and into the Morris canal a narrow inlet on the Jersey side with weed covered banks; right across the Hudson from Battery Park but mostly hidden by trees and scrub.

Sailboats, tugs, and barges, were moored in the tranquil waters, creaking and nudging pleasure boats, Coast Guard cruisers, even rowboats. Along the banks the grass grew tall and thick around the skeletons of dead boats, abandoned tackle, and old pumps like a rural junkyard. Huge steel rib cages lay broken and silent, strewn like carnage – rust orange, rust red, dead. A few people worked on their boats quietly painting, repairing sails, coiling hawsers. They waved to Pam as we settled into her berth.

Bellamy and I stood watching a man in a single scull. He was heading off toward Manhattan, gliding in silence, serene and elegant in the heat of the late afternoon. His body dipped between his knees and pulled with easy, unhurried grace. He wore a white singlet, and a red bandana round his head.

"Thomas Eakins," I said.

"Yeah," said Bellamy. "John Biglin in a Single Scull. Great painting."

I sat on the capstan and watched Bellamy make sweeping gestures with his arm. I thought he was casting an imaginary line into the canal then I realized it was a tennis stroke.

"Is that your backhand?"

"My Rosewall slice."

He repeated the gesture, getting low with a bend to his knees. I noticed he was wearing odd shoes, alike enough that you might not tell, but definitely different.

Author's sketch of Dick Bellamy

"Hey! Guys. Hey!"

Captain Pam and Polly had already left the boat and were on shore in the long grass, silhouetted by the sinking sun. They beckoned. We followed, picking our way through abandoned rudders and engine parts, wading through brambles, and bushes until we found them at a big old-fashioned yacht. It was luxurious, elegant beyond anything else moored in the Canal, the kind of boat you'd expect to see in Monte Carlo or Palm Beach. They were already on board sitting in lounge chairs on the sun deck.

"This is Captain Shirley." Pam introduced us. A big blonde with

tattooed biceps stood up from her lounge chair and towered over us. She held out her hand and greeted us with a solid grip.

"Captain Shirley runs this yacht for a big corporation," she said.

"Used to," said Shirley. "They've had a lawsuit against me ever since I became a woman."

"Trying to get rid of her," said Pam.

The light was slowly fading and the mosquitoes had come out in force. Captain Shirley lit a joint. We sat around smoking, talking, punctuating our words with sharp slaps to bare skin. Polly took off her work boots and spread her toes on the warm deck. Bellamy was entranced by Captain Shirley, an oddity that eclipsed his own. He couldn't take his eyes off her. Shirley didn't think she was odd. She was nothing like the amphetamine drag queens who strutted and squealed in the Meat Market. She was gentle, almost motherly, in her fussing concern, though her body had the strength to rip us all apart in seconds.

I leaned back in the canvas chair and took in the twilight sky. We couldn't see Manhattan from the canal but its glow formed a bright dome on the horizon. Above it the night sky was so clear, even the stars could be seen. I drifted. The boat creaked against its mooring, the mosquitoes buzzed, the water lapped.

Polly was talking real estate to Bellamy. He sat cross-legged on the deck clutching his knees. "I had a six-room apartment back then," he said. "On the Lower East Side. Twenty-six dollars a month. Can you imagine? Six rooms."

When we climbed back into the tug the mood was almost melancholy, no one talked. We slid over the dark waters of the inlet, out toward the river. Around the bend and suddenly out of the dark of

night the whole shimmering skyline of Manhattan radiated from the glistening black water. Elated, a shudder of excitement passed between us, awe at the massive show of energy and power.

Captain Pam cut the motor as we reached the middle of the Hudson River, and everything became silent, sliding like silk on skin until we simply swayed in the water. Nothing else moved. On the Jersey side the floodlit Statue of Liberty, the great Colgate clock glowing red, the Pennsylvania Railroad Terminal and Ellis island. On the New York side the Trade towers dominated the scores of glittering skyscrapers. The whole city was alight.

I leaned over the stern fender looking down into the water.

"Looks clean," said Polly.

"High tide," said Pam.

"This is salt water?" I leaned further over trying to dip a hand into the water.

"Sure," said Captain Pam. "Sea water, way up, way past Manhattan, past the Tappan-zee bridge, way up," she said. "It's the river that runs both ways."

"Great metaphor," I began ...

and might have known Polly's mischievous streak would not be able to resist the temptation. I was well under water while I imagined the gleeful look on her face as she pushed me in. She was laughing when I surfaced. The others looked down at me, unsure how I'd take it.

"It's wonderful," I said. "C'mon in."

No one hesitated. They quickly stripped off and plunged into the water. It was clean. For six or eight inches at the surface it was

as warm as the night air, then it cooled toward the depths. For a while we drifted and floated on our backs, lost to the spectacle around us. An infectious joy took hold of us, for once these shining monoliths weren't symbols of greed or power, it was a gaudy amusement park of unimagined brilliance. We began to laugh.

Particular Instant. Four 16 x 20 inch photographs: Ball hitting wall
1/125 of a second. Lightening 1/250 of a second. Water squirting
1/500 of a second. Lightbulb smashing 1/100 of a second

Ubu owls

"Clocks was my idea. Time. He stole it."

"Terry? Time? You sure?"

"Who else?"

"Time? " Jenny let go a harsh breath of smoke and dropped the roach on her plate. "I dunno. Ideas, y'know, in the like air. Stealin' time? Oooph."

"He didn't steal time. He stole my clock idea." Our attempts to reason only made Frank more pissed. "He's in my studio two months ago. He saw my 'Time Warp'. Clocks lined up ... Exact same thing he's showing in that gallery!"

"Keeping time?" Susan giggled.

"Stealin' time ..." Jenny snorted a smirk, "wipers slapping time." and turned the wine jug pretending to read the label. A way to hide, a way to move on, or drift off. Her lips moving as she silently



read. Her own art was made with felt and rubber, thick marine cables in coils of sexual explicitness - which she denied. She probably didn't care for Frank's Time Warp.

"Very funny. Now it's gonna look like I'm copying him! Fucking snake." Frank glared at the table, his shoulders hunched defensively.

Frank used to be funny. Not now. Not even tragically funny – tragically funny he'd mock himself, we could laugh in his face. Not now. What to say. Awkward. We sat in Susan's cavernous, unfinished loft, mostly empty, mostly incomplete. The walls half painted. The unhung bedroom door leaned against the wall, the bathroom sink sat on the floor among the books awaiting shelves. The film she was making still on hold too. Susan found it hard to finish things. Everything in embryo, as if completion would bring unbearable finality.

Remnants of an impromptu, improvised spaghetti dinner lay on the table, an orange glow all that was left on the plates. I watched the movement of Jenny's soft full lips. Was she as sexual as her art implied, or was it all sublimation? We sat and smoked, no one moved to clear the dishes. Whether we liked Time Warps or not, we empathetized with Frank. Ideas didn't come easy, they are you, your tiny nugget of self, your identity. Someone going through your pockets, pilfering your mind, was not funny.

"I mean ... Time ..." Susan choked off the gurgle of a nervous laugh.

"People thinking alike," I tried to be off-hand.

"Consciously stealing, I dunno," said Susan. "Even unconsciously."

"Bullshit! Ambition'll make so called 'friends' do despicable things." Frank did the two finger quotation marks around "friends" then

snatched a cigarette from my pack of Marlboros and tore off the filter. "He stole ..." He lit the shredded end with my Zippo... "Asshole!"

"I thought you quit." Susan reached for one too. She quit every day.

"Swimming around ..." Jenny pulled another joint from her pocket. "Not like he stole your hat ... see it on his head."

"Whaddya mean? That's exactly what I can see. My idea. My clocks in the gallery plain as day!"

A violent crash, a howl and thumping footsteps suddenly came from above. We all looked at the ceiling. The exposed raw beams offered little barrier to the noise. The floorboards above were the ceiling below. Every sound right there at the table. We looked at Susan. She rolled her eyes in resignation.

"Ubu," she laughed.

"Who-bu?" Jenny was laughing too but didn't know why.

"You mean Judy Jello?" I said. "She lives here? Upstairs?"

"Yeah." Owl hooting came through the ceiling. "That's her," said Susan.

Judy Jello was known in the neighborhood, a performance artist in love with the idea of life as art. A fierce devotee of the French eccentric Alfred Jarry she saw her life-art, like him, as an uninterrupted stream of dream and waking consciousness, no light between fantasy and reality.

"She has an owl?" Jenny blinked.

"It's plastic, like her," said Susan. "She does the hooting."

"Know what I hate? I hate ferrets!" Jenny inhaled her fresh joint. "You ever hear a ferret? Sound like running a stick along railings, tika, tika, tika, tika. "

What was it with these French eccentrics and animals? Nerval with a lobster on a leash, Huysmans a jewel encrusted tortoise, Roussel a hairless cat, Jarry an owl – an avatar? alter ego? pretender? Inventing a persona for yourself, squeezing the last drop from the tube? Picasso had been fascinated with Jarry too, and proud that his owl was a descendant of the owl that lived with Jarry. Judy made no secret of her obsession – Pataphysics – Jarry's science of imaginary solutions, was painted on the bicycle she rode around the neighborhood. Susan called her Ubu – after his famous creation: Ubu Roi – a figure of excess, a bloated expression of all suppressed infantile urges and fantasy.

She liked that. Judy fervently aped Jarry's explosive id. Yet, in person, the inescapable truth about Judy (formally Winter) Jello, despite the envy green hair and gender skewed costumes, was her ordinariness – why Susan called her plastic. Her eccentricity was as sadly inauthentic and sugary as the name she'd given herself. Compared to contemporary eccentrics like Howard Hughes or Glen Gould she had the soul of a magazine housewife with a feather duster. Her only real oddity was her relentless desire to be odd.

"Ah come on, come on," shouted a voice upstairs. The owl voice hooted loudly. The shouting voice: "Merde pour vous!, merde pour vous!"

"When my Dali drawing was stolen," Susan raised her voice over the din from above, "I knew who it was but couldn't prove it."

"You had a Dali drawing?" I said.

Susan Brockman while filming Sub Rosa in 1973

Unlike Judy Jello, who spent her hours courting shock and surprise, with little success, weird things happened to Susan without effort. She was a friend, never a lover, though she was woman of rare passivity whose beauty made all kinds of men desire her. Her looks made odd things happen to her that didn't happen to other people. She stood, a bystander, an idle onlooker, watching her life unfold, surprised by events as much as anyone else. Puzzled by her life.

"Years ago," she said. "Right after I broke up with Bill." As a very young woman she'd lived with Bill de Kooning for several years. "Must be eight, nine years now. I was at some fancy dinner party; Salvador Dali was the special guest."

"I hate his work," said Frank. "Total pretense!"

"Melting clocks," said Jenny. "What a ferret."

"Not my clocks," said Frank. "Mine were totally different. Totally!"

"Yeah," Susan said. "I thought he was a jerk, to be honest, but he's Salvador Dali. He asked me, out loud, in front of everyone, if I would pose for him. What could I say? He was Salvador Dali."

"Completely different idea," said Frank.

Upstairs doors slammed and bare feet beat back and forth across the loft, interspersed with incomprehensible shouts and hoots.

"What happened?" I said.

"He wanted me to sit on an egg, naked except for a pair of red rubber gloves, while he drew me from behind. Surreal right? – Salvador Dali. I didn't think much about it till I was sitting there on the egg then I could hear him panting. He was jerking off behind me."

"Ha! He didn't draw?"

"Like you said, pretense - a few quick squiggles – he signed it. I didn't care for it but I had it framed and hung it on the wall. It disappeared while I was seeing Dick Campbell."

The televised voice of Johnny Carson came through the ceiling doing his opening monologue to the accompaniment of forceful moans.

I looked at Susan not knowing which was more surprising, that she dated Dick Campbell or that he stole the drawing. Before I could speak:

"Campbell, really? That drunk." said Jenny. "He's so wasted."

"Very briefly. We were young. He used to be hot."

"You think he stole it?" I said.

"Of course he did. Denied it, naturally. It ended the friendship."

Things happened to Susan that didn't happen to other people. Upstairs the unmistakable moaning and pounding went into overdrive as Johnny introduced his first guest, Don Rickles.

"Sounds like Don's a real turn on," said Frank looking up.

"You'd think," Susan grinned. "But it's all for our benefit. She's alone up there."

I read deep into the night listening to heavy rains pound the roof. The Maltese Falcon kept me awake – more stealing and deceiving. In my own work I felt increasingly like a detective pursuing leads that led nowhere. I was the deceiver and the deceived.

By the time I woke the over-night rain had stopped and a bright sun was breaking through on the old market. The heavy downpour had hosed off the streets revealing the dray-horse world of

fading signs and ghostly hand painted ads for liniment and hair tonics, setting loose ancient smells trapped deep within the cobblestones, smells of coffee and cheese and horseshit.

At West Broadway and Thomas I pulled open the heavy glass door of the Towers Cafeteria.

"You didn't see him!" Joan, the cashier, sat in the box she called her pulpit by the door, snapping at Arty, her husband, sitting nearby. "Another minute he would have had his hand up my skirt."

"You wish," said Arty.

"Good Morning." She greeted me then turned back to Arty. "This my new leather skirt too."

"Get over yourself."

"Did you see him?" She pounced on me.

"Who?"

"You're in your box, love." Arty made another entry in his neat ledger without looking up. "How could he touch you?" He shook his head. Dumb bitch. Buttoned up Arty with button-down shirt and bow tie doing the accounts; Joan his flighty, bawdy kite on a string, with bright red lipstick, dyed hair and sweep-away glasses – the owners of Towers Cafeteria.

"Don't gimme that dumb bitch look," said Joan.

The big cafeteria was almost empty, the morning rush had passed an hour ago. Over by the big windows I could see Dick Campbell slouched over the day's paper. He didn't look up. I felt a surge of animosity toward him on Susan's behalf. He probably justified stealing the drawing: his need greater than hers. She didn't like it anyway. I slid a plastic tray passed the pans on the steam table,

piling my plate with eggs and bacon and toast. The counter man punched my ticket as I moved along. I took my breakfast to a table near Arty to get a look at their newspapers.

"Late this morning." Joan looked up from her crossword.

"Overslept," I said.

"No Polly?" she said. "Haven't seen her in a while. You two break up?"

"It didn't work out," I said.

She shook her head sympathetically, and judging it was not the time to discuss it moved on. "Who was a leader in 1917? ... five letters."

"Wilson," said Arty without hesitation.

"That's six letters, dummy!" Joan rolled her eyes then looked at me.

"Lenin, maybe?"

"Nah," she scowled at her crossword. "Won't work."

"That other commie," said Arty. "Stalin."

"Some bookkeeper."

She was still working the puzzle when I paid my check. She took the bills and made change. She asked about my day - mother hen to the growing number of young artists in the neighborhood; she passed advice and gossip from her pulpit. It provided a caring axis, like family, and like family she had no interest in art.

"Susan was in earlier," she said.

"Brockman?"

"No, Rothenberg. And Dick Campbell."

"He's still here," I said.

"No."

"Yeah. Over by the window."

"No, he's not." She came out of her little box not believing me. "He left hours ago."

She put a hand on my arm as she went around me to get a better view across the cafeteria. I could see now that Dick was in the same position as he'd been when I first came in, the paper in front of him, a pen in his hand.

After a moment Joan said: "Is he all right?" her voice was hesitant. "Arty, go take a look at Dick."

Behind him, through the window, people passed by on the sidewalk. One or two gave a casual glance inside with no sign of interest. Arty made his way between the empty tables. We watched as he touched Dick's cheek with the back of his hand, then he waved his fingers in front of Dick's eyes. He turned back to us and shook his head.

"Oh, shit," said Joan.

"He was doing the crossword," said Arty.

Dick Campbell died on display in the window for all to see and no one noticed. Like his life. By fifty-four he'd already given his body several lifetimes of abuse. His routine was not complicated, painting and drinking. He had no family to speak of only a bag of conflicted emotions – his beliefs one thing, his desires another. His pictures well meaning but.

MEMORIAL

Joan insisted, from her bully pulpit, we all attend Dick's memorial. It was set for a blistering August afternoon in lower Manhattan, out on an empty lot by the river, near the newly completed Trade Towers. Since the city planners moved the produce market to the Bronx these vacant lots, once the hub that fed the city, were now nothing but fenced off rubble and weeds waiting developers. Not even the cops bothered going there except to park their cruisers and sleep.

I joined the small group pushing through a hole in the chain link fence into the tall weeds on the far side. The heat was unrelenting; the sun too high over the new Trade Center towers to cast any shadow of relief. Out on the lot there were twenty-five, maybe thirty people milling round the leaping flames of a bonfire.

"A fire? Holy shit." Judy Jello in a "Madhatter" top hat like the one Leon Russell wore in concerts – led the way, always performing, trailing clouds of patchouli oil off her long sinuous body. "Here's Johnny," came to mind for some reason. "They've gotta be kidding," she said. "It must be ninety out here."

The heat of the fire seared as soon as we made the clearing. So intense it was pushing people away. A Viking pyre fueled by kids dragging in wooden palettes, cheese boxes, and crates scavenged from the neighborhood. They seemed oblivious to its heat. A makeshift table of saw-horses and a palette held wine and paper cups and the snacks provided by Joan. Beside it a garbage can full of beers in melting ice. I took one.

Small knots of people stood around the lot like a garden party. I knew the younger artists from the neighborhood, but apart from Mooney Peebles I didn't know Campbell's middle-aged cronies.

They had that Ab Ex look, a fifties "Beat" look of the Village, a kind of Kerouac, working guy, style of uniform that seemed dated compared to our uniforms of nonconformity. We sported shoulder length hair and beards or Zapata mustaches; the women wore their hair long and loose, their flouncy dresses the same. A couple of magnanimous bums, who lived in the next lot, after drinking all they could hold, felt compelled to stagger about greeting people as self appointed hosts.

"Atchoo! Goddamnit!" Rachel sneezed so hard it doubled her over and made her hair jump at every bark.

"You're missing the point." Frank, walking at her side, was insistent.

"Atchoo!" she sniffled, eyes streaming. "I don't think he stole your time, Frank. Ideas are in the air like this damn ... Atchoo! Goddamnit!" She headed for the fence.

"Wait." Frank pursued her.

"Dick was trapped in that gap between the way life is, and the way he thought it ought to be," said Keith.

"That beer's gone straight through me." Jenny, studiously rolling her cannabis, spoke to no one in particular. "I really gotta pee."

"He was a minor talent," said Ed, a bearded Ab Ex - er. "His pain was that he knew it."

"They need to express too," said Mary. "Much as any major talent."

"Maybe more," said Ed. "Maybe more."

A racket from the table turned our heads. A great bear of a man covered in coarse hair, stood banging a bottle for attention. We

straggled in closer, refilling wine cups, taking fresh beers, before sprawling on the ground about the dying fire. Now the kids were out of palettes it was only smoldering ashes. I was surprised to see Beattie there, hanging out with Judy Jello, who was getting loud and showy, already crocked, and having trouble with her top hat and lowering herself to the ground without spilling her drink.

"I'm all right." She waved off any help, falling more than sitting. "We all here for the Resurrection?"

Judy needed the attention.

"Hi."

Susan's breathy whisper followed her hand reaching for my pack of cigarettes. She dropped down beside me,

"Hey, didn't expect to see you here."

"Oh, you know," she said. "Give the people what they want."

An old joke. I laughed, nodding toward the speaker. "Who's this guy?"

"Wordy Moynihan," she said.

"Wardy?"

"Wordy ... Word. A joke name. He rarely speaks. At least this'll be short. I hardly recognized him without the paint. He 's usually covered in it. One of those 'at one with the paint' Ab Ex ers. Dives in and rolls around in it."

"You got an opener?" The guy next to me held up a beer can.

"No. Over there, in the green shirt."

"This ain't a stiff affair." Wordy Moynihan started up at the table,

then realized his unwitting pun and guffawed. "I jus wanna thank ... yeah ... fer...er comin' to pay our, y'know, to a man, we all... er .. yeah, Dick Campbell."

Wordy Moynihan paused, glazed over, looking out toward the Statue of Liberty and pulled on his beer. A minute passed with only the crackling fire breaking the silence.

"That it?" I whispered to Susan. She shrugged.

"Hello ... " Judy Jello called out. "We're waiting."

"You're losing us, Wordy. " a male voice reminded.

Moynihan's weathered face checked back in, gleaming and sweating from the heat of the fire and the sun. He tried again.

"Well ... Dick could be, well ... a dick ... let's face it." He relaxed, relieved to get that off his chest. "A real fuckin' pain . . . but that was Dick . . . he saw some changes, man. A rebel! Weren't afraid of shit."

I barely listened, more taken the the faces around me. Most were artists, most of them older, poets and dancers, men and women who had been in the vanguard, now replaced by younger ambitions. A passing generation, once young and eager, flush with energy and ideas. Be different, make something new, surprise us all. Did they get what they came for, did they have anything to give? Was there any real talent flopped down around the fire, or were we all victims of our own delusions condemned to die, like Campbell, in plain sight, unnoticed, soon to be forgotten. Our work headed for the landfill?

"What's the can for?" Susan whispered to me.

"Huh? What can? Oh ... "

On the makeshift table the wine jugs had been replaced by a paint can: Benjamin Moore's eggshell peach, oil based, one gallon. We weren't the only ones curious. Several heads nodded toward the can, eyes narrowed, brows clenched. Voices murmured. Tina leaned forward:

"What is it?"

"What's with the can?" Judy hissed.

Wordy Moynihan kept on over the whispers, laughing, sputtering over words, his vocabulary shot:

"Fuck, man. I mean, fuck."

"What's in the can?" said Ed, too loud to be ignored.

"Says, eggshell peach," said Poppy up front.

"Fuckin' idealist, man. Couldn't stand the commercial shit." Wordy Moynihan lowered his voice to a growl of sincerity, "Dick Campbell said fuck the system."

"Dick was too dumb to even know there was a system," said a male voice behind me.

"Dumb Dick." another male agreed. "This beer's like bathwater."

Jello hooted: "What's in the can, Wordy?"

"It's Dick! Who'd'ya think fer chrissakes." Wordy Moynihan wiped the foam from his mustache.

"Wha?"

"Ashes, man. The fuck!" he said, not prepared for the hoots of laughter. "What's the matter with you? He was a painter. D'ya'expect, some fancy-assed middle-class piece of shit brass urn? We thought

it was appropriate. What the fuck!"

"Not eggshell Peach. That's real Decorator shit. Why'd you pick that color?"

"Jesus! Everyone's a fuckin' critic." Wordy Moynihan pounded the table with his bottle. "All right. All right. Who's got something to say?"

Speaker after speaker got up and told stories and the afternoon grew long. The wine had gone and most of the people too, Joan and Arty, the older folk, others had fallen asleep. The kids and the flies the only ones with energy. Some guy called Izzy Something up at the table started telling the Dali story. I looked at Susan.

"Who's this guy?"

"No idea," she was clearly surprised.

Izzy sniggered. "... sit on an egg ... naked."

Heads came up around the dying fire. An appreciative laugh rippled through the group. Susan shrugged her amazement.

Izzy, barely able to contain himself: "So, Dick swipes the goddamn drawing and sells it. Ha ha ha!"

"That asshole!" Jello jumped up screaming. "I knew it was him. The bastard!"

Susan looked at me in astonishment. The world was acting out on its own. Her life of incomplete acts, unfinished thoughts, abandoned words, was taken over. – someone finishing her sentences.

"Judy, Judy, Judy." Wordy Moynihan tried to calm her.

"Fuck you!" she snapped, stomping through the dying fire toward

the table. "He had no right!"

"You asshole!" Wordy Moynihan yelled into Izzy's astonished face.

"Whazz going on?" Puzzled sleepers awoke from their stupors.

"She knows it was yours, right?" I said to Susan.

"No idea," she said.

"She's stealing your past," I said.

"Stealing my past?" Susan blinked.

"C'mon, Judy He's dead." Wordy Moynihan pleaded.

"I still don't trust him." Judy, her "Madhatter" top hat clamped down about her ears, glanced into the paint can as she grabbed it. For once the look on her face transcended the ordinary. For once she found an inner demon. Her Jarry moment. Her Ubu Roi.

"Judy, Judy." Wordy Moynihan begged. "You know what he was like."

"Better off dead!" And defiant she raised the can over the dying fire. "Ash-holes to ashes." she laughed and dumped the remains of Dick Campbell in a dusty cloud.

"Wow!" Susan blinked.

"Aw, shit!" said Wordy.

Loyal friends scrambled to their feet, scoring the ashes with toe-caps, grabbing sticks, separating painter from charcoal knots of palettes and cheese crates. Campbell blew about, a thought here, a flash of anger there, a frivolous laugh blowing, ashes blowing.

"Go home, Judy." Wordy grabbed Jello. "Go home!"

The futility was obvious, and friends gave up scouring and raking ... abandoning ... quitters. Dick Campbell would have taken it personally. No one comes through. That's right, walk away!

Judy Jello wriggled in Moynihan's arms, tossing the can into the fire with a triumphant,

"Merde pour vous, ash-hole!"

I stood with Susan watching the stragglers disperse, leaving the remains of Dick to die once more in plain sight along with the fire. She was silent, her face somber and still.

"You okay?"

"I feel ..." she paused watching the ashes begin to blow over the empty lot. "I feel ... like Alice." She stood sifting the events in silence. "Imaginary, rabbit hole, solutions ..." she started and stopped. Let it go. Her face broke into a grin.

"Exit pursued by bear?"

11	38	23	58	7	42	27	54
22	59	10	39	26	55	6	43
37	12	57	24	41	8	53	28
60	21	40	9	56	25	44	5
13	36	61	20	45	4	29	52
64	17	34	15	32	49	2	47
35	14	19	62	3	46	51	30
18	63	16	33	50	31	48	1

APPARENTLY NO MOTIVE

U.S.A. 1929

page (15 x 8) **120**

"Has he ever run across anything which might have some connection with it? Is it probable? Is it possible ... even barely possible ?"

The Maltese Falcon Dasheil Hammett
(Vintage edition)

DETECTIVE, 1972. A small book creating mysteries out of speculation. As the mind dwells on the endless permutations of maybe this, could be that, it builds a web of suspicion that creates something out of nothing.

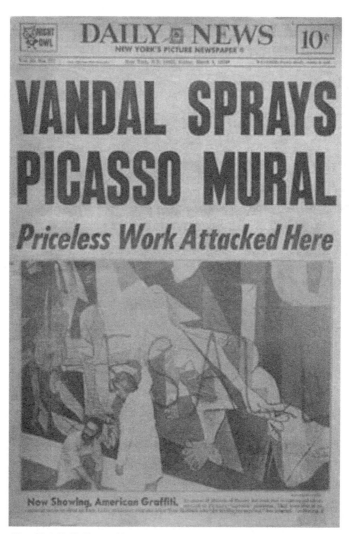

New York Daily News, March 1, 1974

Guernica

April 26th 1937 was a warm clear day in Guernica, a small town in the Basque region of Spain. It was a Monday, market day, and the town was crowded with farmers from the surrounding hills. The air was full of the usual sounds, market sounds, ordinary, expected sounds, when something different was heard: the low drone of approaching aircraft. More than one plane. Many.

Twenty-eight bombers of the Luftwaffen Condor Legion came up over the hills flying formation. Alongside were twenty Messerschmitt fighters filling the sky, heading straight for the tiny town. The people watched, intrigued. Then suddenly bombs began to drop and the people ran. For three hours the huge bombers maneuvered back and forth overhead dropping more than a hundred thousand pounds of high explosives on Guernica. The ancient town crumbled under the barrage. Buildings old and new, wood and stone were reduced to rubble. Those who could fled from the firestorm running away, panicked and terrified, through the narrow streets and lanes. The Messerschmitts, agile predators,

dropped from the sky, chasing them spraying bullets from their machine guns, cutting them down as they ran, then wheeling away to turn and repeat the cycle. For three hours they bombed and strafed the burning town and then they left. Left like it was time to knock off work, time to go home. They left unmolested. They left devastation.

The fires burned for three days. When they could the town's people counted sixteen hundred civilians dead or wounded. It was the first time in warfare that bombing had been used specifically against civilians. Later Wolfram von Richthoven who had led the raid sent word to Hitler that "the concentrated attack on Guernica was a great success."

When news of the massacre at Guernica reached Paris, outraged friends of Picasso urged him to make a gesture of protest. Horrified but indecisive he declined. He was not a political painter. But when they showed him stark black and white photographs of the tragedy he changed his mind.

The attack had been made on behalf of Generalissimo Franco leader of the right wing Falange party who were fighting to take control of Spain. Franco wanted to break the spirit of the fiercely independent Basques who had sided with the Republic in the Spanish civil war. Within two years the Second World War gripped all of Europe. In Nazi occupied Paris, a German SS officer confronted Picasso with a reproduction of the painting, demanding: "Did you do this?" Picasso famously replied: "No. You did."

NEW YORK

When I first met Tony Shafrazi people called him Shaz. That was London in the 1960's where we were both young artists. He had been a plaster-under-the-fingernails sculpture student who went on to make shiny minimalist slabs, and become a fan of Frank Zappa and all cool West Coast fashions. A likeable guy. Out of the studio he was a snappy dresser, a dandy in luminous shirts with oversized collars and dark blazers with pocket handkerchiefs. Sporting an over-sized cigar he'd give out charming, befuddled theories on all things hip and edgy. Every fleeting sensation whip-sawed his attention one way or another in his boundless search for direction and role models.

Ethnically Armenian, he was born in Iran. Someone in his family must have knocked off the last a and n in his name that usually signify an Armenian. For a while he shared the studio downstairs from me on the east side of London, and he would tell me stories about his Savile Row tailor. Independently, we both moved to New York which is where I saw him a year or so later. He was transformed. He had adopted the coveralls, the beard and long hair of the sculptor Carl Andre, his new mentor. He looked like a shaggy Karl Marx.

In the early seventies he called me to see if I wanted to work on a loft with him. Construction work is what he meant. He must have known I was broke, I usually was. Like a lot of young artists I was juggling the time to make art with the means to stay alive. The loft we were to work on belonged to the sculptor Hannah Wilke. She was a striking, narcissistic woman in her thirties with deep dark eyes and the finely drawn features of the sensual Singer Sargent portrait Madame X. She made her art out clay, or Plasticine, or something like that, which she rolled and twisted and prodded into life-size vagina forms.

The raw space to be converted was a very large SoHo loft. The former tenant, in the rag-picking trade, had left a Dickensian reek of old clothes that permeated the floorboards and the brick walls. Shaz and I went over the plans with the architect. The space was to be divided into kitchen, bathroom, bedrooms and studio - an elegant place. He had dropped the Karl Marx get up by this time and was between personas. He looked pretty much like any other young guy walking around SoHo. We decided to keep time sheets for the job and split the money according to the hours we put in. Jobs like that always start with a lot of heavy lifting – bringing in the lumber, hefting sheetrock up several flights of stairs – it's killer work. Framing the walls goes very fast. You cut all the wooden studs to the same length and lay the frame out on the floor. Standing on the lumber as you nail it keeps everything in place and when the frame is tight it is easily raised and moved into position. It's physically demanding work but satisfying. Several walls can go up in the course of a day giving a real sense of achievement.

We talked as we worked – between the scream of the saw and pounding hammers. The usual talk, about the new movies, Nicholson's split nose in *China Town*, the electronic surveillance in Coppola's *The Conversation*. We talked about Robert Smithson, our mutual friend, who had been killed in plane crash over the site of one of his earthworks down in Texas the previous summer. He was another of those role models that Shaz looked up to. We talked about the news: Nixon was deeply mired in Watergate. Haldeman, Erlichman and Mitchell were just indicted. The Symbionese army had kidnapped Patty Hearst. And Hank Aaron was gearing up for a shot at Ruth's home run record.

Hannah showed up from time to time to see the work. She was an easy boss, she didn't complain, she just needed a place to perform. She would swan about cackling over how fabulous everything was

going to be, her excitement full of unexpected hoots and squeals. We liked her visits, she was more comic relief than anything. When the skeletal walls were up Jim, the electrician, arrived, he was an abstract painter. Then Yoshi, the plumber, came. He was a Japanese composer of electronic music. They began drilling and hacking holes through the frames we'd put up. Nobody on the job, save the architect, was a real professional. We were all doing what we could to get by.

Once the walls were sheet-rocked, it was all nailing back then no screw-guns, and the taping was done the pace of visible progress slowed. After the hard physical work of framing and drywall we could relax and make it a little easier on ourselves. Up until that time Shaz had put in the long hours and worked hard. Now he started slacking off, showing up later and later each day. When the phone was finally installed it was a temptation he couldn't leave alone. He talked for hours on the phone as I hammered and sawed and grew steadily more querulous.

The conversation remained animated only now instead of art, or movies, he always brought the subject back to rebels and revolutionaries. That video of Patty Hearst in the bank with the machine gun was on TV all the time, and the papers were full of The Symbionese Liberation Army. The Soledad Brothers, Kent State, The Black Panthers, The Weathermen, even the death of Ché Guevera were all still recent events. And given Shaz's tendency to get carried away with the romance of the heroic rebel it didn't seem out of place. He admired the outlaw, the miscreant, the dark charismatic figure defying the rules and jabbing the establishment in the eye. Given today's technology he would've spent his time in some conspiracy chatroom scheming with wild eyed cohorts spouting cock-eyed theories, myths and half-truths that said far more about his need for attention than any reformation of society.

As it was he would fawn approvingly over grainy pictures of resistant felons or protesters in the New York Post or Daily News.

Increasingly as the job wound down there were days when Shaz wouldn't come in until near quitting time. Working alone one afternoon I got a whiff of that nasty chemical smell that aerosol spray puts in air. I walked from to room. He was there. I had not heard him come in, and I couldn't see him anywhere, but I could see his coat. Then I heard that distinctive clicking of the little metal ball being shaken in a paint can. It was coming from behind the wall. Through a crawl space opened up by the electrician I found Shaz with a bunch of paint cans spraying the inside wall. He saw me watching and quickly dismissed it as tests for a project he was working on. Then he made some excuse and left.

This is part of the deal, I told myself. Shaz is flaky, he'd always been flaky. I knew that before I started. Why should I care I was getting paid for my time. He was getting paid for his. Or was he? I'd never thought to look at his time sheets. They were not secret, they were right there on a clipboard hanging from a nail by the door. I scanned the column of figures in his handwriting marking the hours he'd put in each day. There was no hint on the sheet that he'd ever missed a minute. Whatever I had put down for the day on my sheet, he'd put the same on his. I was pissed.

The next morning I was ready to confront him the moment he walked in door but, as usual, it was hours before he showed up. When he did come in I was thrown by the way he looked. His hair was gone. The day before he'd had a full head of thick black hair. Now he had a buzz-cut, the hair so short that his soccer ball head gleamed white through the remaining fuzz. He could have been a skin-head except that he seemed embarrassed by the look of it. His self-conscious grin stripped away the malevolence. I told

him I'd looked at the time sheets and right away he apologized and said he'd fix it. It's hard to fight with someone who folds right away. It didn't seem important to him somehow. The haircut carried far greater significance.

I had seen these abrupt transformations before over the years but I didn't know this new character. Now the whole day was shot, eaten away by irritations and distractions. He said he had things to do the next day and I agreed a day off would be good.

I spent the following day in the studio trying to make some art. It's not easy to get started if you've been off hammering nails for a while. I spent a lot of time sweeping the floor and staring out of the window. By late afternoon I'd got around to cleaning my desk when the phone rang. The plummy, quasi British, accent told me that it was Kynaston McShine, a curator at the Museum of Modern Art. There weren't too many people in the New York art world who spoke like that. As an artist my first thought was, Oh boy, is this my lucky day? Was he calling to include me a show? No such luck. After a few pleasantries he asked me how Shaz was doing. It was an odd question but I said he was okay – same as always. Then he told me that Shaz had just been arrested for spraying graffiti on Picasso's Guernica. In large letters he had sprayed – KILL LIES ALL – on the picture, screwing up the syntax in his haste. I was stunned.

Over the next few hours my phone was alive. Just about everyone who knew Shaz, or knew that I knew him, called. What the hell did he think he was doing? How had he managed to keep it quiet all that time? I was as much at a loss as everyone else. Mark, a filmmaker friend, called to tell me they were going to arraign him at the Centre Street Courthouse at seven that evening.

I think Carl Andre and Richard Serra posted most of the bail but

I'm not sure. Shaz was soon released into the lobby where a small group of us stood waiting. He was smiling, grinning like the puppy who has just destroyed your favorite shoes and expects to be praised. He was well pleased with himself.

Tribal instinct to defend your own made us take Shaz up to Max's Kansas City to court-martial him. The 'back' room at Max's had a big booth with a large round table where we settled to tell Shaz what an asshole he had been. On virtually any other day of that turbulent year his action would have been seen as chump change and buried by the media. But, by chance, the I.R.A. were off that day, the Watergate scandal was treading water, and nothing new was coming out of Vietnam. On a day of nothing else he was suddenly the headline on the evening news, and the front page of The New York Daily News. A fleeting sensation.

It was clear from his generic slogan of rebelion, KILL LIES ALL, garbled as it was, and the paint he used - easily removed without damage - that he had no revolutionary manifesto and no agenda of destruction. He was another streaker at a sporting event, more adolescent prank than political theater. He simply and desperately wanted to be known. To be in the public eye, to be somebody. He was that day's distorted scream of ambition that held no substance or purpose beyond a demand for attention – hollow ambition ripe for a culture of famous for being famous.

As a defense they concocted some cock and bull story of protest against the war in Vietnam and he got off with probation.

A year or so later Brad on the staff of the Leo Castelli Gallery noticed Shaz briskly walking out the door. On impulse he immediately checked the art and saw that the Flavin sculpture and the wall behind it had been sprayed with graffiti. The staff quickly convened and decided to play him at his own game. Within

minutes the sculpture was clean and the wall behind it repainted. Nothing was said. An hour later Shaz was spotted peering around the corner at the pristine sculpture looking puzzled.

Shaz disappeared from my thoughts for several years after that. The next time I heard anything of him he had become an art dealer. He opened a gallery in Tehran, which closed as soon as the Shah was overthrown. He opened another one in SoHo, New York, and was transformed again, reborn to much the same personality as the one I had first met in the sixties: cool fashions, expensive cologne, and hip to all the latest trends. I visited his Chelsea gallery once and couldn't help noticing how many guards there were standing around ready to protect the art.

Max's Kansas City. New York. Photographer unknown.

Stains remain

There were comings and goings outside Max's. Yellow cabs lined at the curb, groups clustered about the door, the smell of weed on the heavy night air. The big black sign, L shaped with fat white letters hung above the awning, over the comings and goings and hangings out: Max's Kansas City, Steak Lobster Chick peas. In the summer of '72 it was still the place to be someone, or better still, someone else, to measure yourself, see who was who, and why they came to say, I cannot stay, I must be going.

The window framed a Chamberlain sculpture of crumpled auto parts – colorful bits of Chevys and Buicks in a mash up of anguish and culture or something like. Pull open the big glass door and loud music was in your face.

"Gor-blimey it's the Limey."

"Hey, Suzy. You're leaving?"

"Going out for a smoke." She rolled a fat joint between her fingers. "Wanna come?"

"Later," I said.

After the sulfurous yellow streetlamps Max's was red. The tablecloths were red, the napkins were red, the lights were low. The long bar was on your left and beyond it tables and booths, the kitchen, and beyond there the gender bender backroom. On the wall opposite the bar, over the jukebox, there was an artwork by Donald Judd, machine-made out of shiny brass. Something mathematical is going on there between the box like forms and the spaces in between. What it is, I couldn't say. 'What's going on?' I couldn't say. 'What's going on?' Marvin Gaye's voice swells from the jukebox filling the spaces in between and all about.

"Behind you. Comin' through."

Lithe young waitresses in black minis and tiny red aprons slid back and forth through the velvet smoke hefting trays, heavy with steaks and liquor, over the heads of the young, noisy crowd. The owner, Mickey Ruskin, stood puzzled and distracted in his charcoal pants that never reach his ankles. He was about to go... "What?"... about to go... "What?"... He had drug issues of his own.

The early diners were headed home, the graveyard shift settling in as I pushed through the crowd at the bar. Neil Williams, painter, John Chamberlain, sculptor, fixtures in their usual spot against the rail by the fender-bender opus. Like others they had traded their art with Mickey for tabs, and were busy drinking his finest liquor. Some one grasped my arm.

"Hi." Carolee Schneemann, performance artist and painter, leaned in and we embraced. "How are you?"

Carolee and I had a short but joyeous fling in London years before. She was an exceptional woman, truly free and uninhibited, even in this crowd. She introduced her date and I moved on.

Surplus Dance Theater, New York, 1964. Carolee Schneeman and Morris. Photograph: Hans Neman

"Hey, Brice. Hi David."

Those guys always sat with beautiful women. Lawrence Weiner, Hanna Darboven and Garry Owen were at a table further back, I made my way over to say hello.

"Hello, again."

A woman spoke to me as I passed. Elegant in white, middle-aged, with the look of money about her. I said "Hi", but only had eyes for the gorgeous waitress who was known to be choosy.

"Hi Ellen," I said.

She flung a red tablecloth flapping through the air. "Hi" she smoothed it down. Oh, that deviant smile it made me crazy. She never chose me. Other tables were cleared as I passed. Gnawed bones and mounds of luminous mint jelly on clattering plates stacked and whisked out of sight. Lou Reed's latest, Walk on the Wild Side, replaces Marvin Gaye on the jukebox.

"Siddown," said Lawrence, a young artist like myself. "What's new?"

Hanne Darboven, a young German artist with perfect manners, sat bolt upright between the two slouching men. Their full beards swept the table. Max's is a hairy place.

"Got an eye for Ellen, eh?" Lawrence grinned.

"Ya. We did saw you." Hanna's watery blue eyes were alive. "You do wear your heart on your coat."

"That's not his heart," laughed Garry Owen. "You gotta go lower."

Couldn't deny it, wouldn't try. I looked back toward the bar. "D'you know who that is? The woman in white, just leaving."

They craned their necks as a willowy black waitress came to our table.

"I'll take another armagnac," said Owen. "You mean the Widow?"

"Yeah. In the white," said Lawrence. "Applejack, thank you."

I took a beer. Days before the woman in white had stopped me in a gallery with the words: 'You look like my dead husband.'

"Knox?" Owen scoffed, incredulous. "Nah, you don't. Nothing like. It was pick-up line."

Typical letters from Hanna Darboven

Gary Owen was older, straddling the generations of Beat and Hippy. A painter, caught between Abstraction and Pop, he'd had success and lost it. Now he drank.

"You knew him?" said Lawrence. "What was his name ... Stanley, Stanford?"

A woman's boisterous laugh exploded at a nearby table. Gloria Bicce was a loud fixture at Max's. We glanced at her then turned to Owen.

"Yeah, Cecil, Sidney, some damn thing, but he was known as Badger," he said, pulling at his beard. The name Badger fired some dormant synapse in me while he talked, I knew the name but couldn't think why.

"I was in a Happ'nin'. You know, early sixties, down on Great Jones Street. She was in it." Gary Owen flicked a thumb toward Gloria loud. "And her, Carolee." He pointed and grinned at Carolee up front by the bar. "Lotta fun those Happ'nin's, erotic, lotta naked flesh, lotta groping." He couldn't resist a gurgling chuckle at the thought. "One night, after the show, I'm standing there buck naked, ole glory wavin' in the wind, when this babe from the audience comes up to me. Uptown money written all over her, one of them Jackie Kennedy hairdos, early thirties. I don't have to ask what she wants she's starin' right at it. Cool as you like, she invites me back to her place. 'Come as you are,' she smirks."

The silky waitress set drinks on the table while we salt and peppered his memory on our separate plates.

"She has a cab waiting when I get out," he went on. "And a guy. 'This is Badger,' she says. 'My husband.' The fuck! You kiddin' me? He's a Wall Street suit. Nixon with thinning hair, cufflinks and tie. I mean, come on, cufflinks? At a Happ'nin'? I'm thinking, What's

up with this, man, when laughing girl," another thumb at Gloria, "joins us and I see we're gonna party."

"Ach." Hanne raised her eyebrows, following along seriously like she was taking dictation. She held her cigarette poised like a syringe at the tips of her fingers.

"So, the wife pulls me into a separate cab and gives the driver a Sutton Place address."

"Fancy," said Lawrence.

"Shoulda seen it, man. Fuckin' A. Un-real, even had its own elevator. And Gloria's already on the couch ballin' the Badger.

Ballin' the Badger? Hanne's face crimped with curiosity. You could almost see the translation going on word for word. And it wasn't just the words; the whole culture left her in need of a dictionary. Her pale blue eyes searched Owen's face for clues. She was determined to get to the bottom of this. Bolt upright with the blonde hair close-cropped and the German accent you might think her some kind of ubermensch. But no, she was just tense – tight as a drum at Valley Forge.

"Ya, ya. Vas?"

The noise swelled as more drinks arrived. Janis Joplin's Ball and Chain, shook the place. A woman danced by on her way to the can. Gloria's deep-throated roar cut through it all. Her head thrown back, swinging from the arm of her bashful young man; lunging backward, laughter rippling her flesh, till one of her large pillowy breasts flopped from her open shirt.

"Escape!" screeched her friends.

In no hurry to corral the beast, howling, she crushed her flummoxed

boy into her bosom. Her honking friends fell on one another in delight.

"Zeitgeist, man," Owen watched with pleasure. "She was pretty once. Before the drugs. That hair used to be so silky." He smiled and shook his shaggy head. "Zeit-fucking-geist."

"And so ..?" Impatient Hanne. "And so?"

"So." Owen gave a whaddaya expect kind of shrug. "The 'Widow' and I got it on ... It's going great 'til Gloria wants in. She's pushing me out, taking over."

"What happened to Badger?" said Lawrence.

"Groping, groping me! Gloria's set me up, don't ya see? Imagine that, sex with Richard Nixon."

"Oooh. Too political," I cringed.

"Absolutely ... metaphorically speakin' I'd like Richard Nixon to suck my dick. But in reality it was a real turn-off."

"Watch your back. Coming through."

The tables all around were filling up. Animated talkers side by side, front to front and back to back. Carl Andre had come in with Poppy, they were standing talking to Dorothea and Richard at a nearby table. Andre had his hands pushed way down into the pockets of his blue coveralls. With matching jacket it was the uniform of the working man. Its style and its politics suited him. He never wore anything else. His large head and full beard and more than shoulder-length hair gave him the look of Walt Whitman, but his wit was more often delivered in the dead-pan drawl of W. C. Fields.

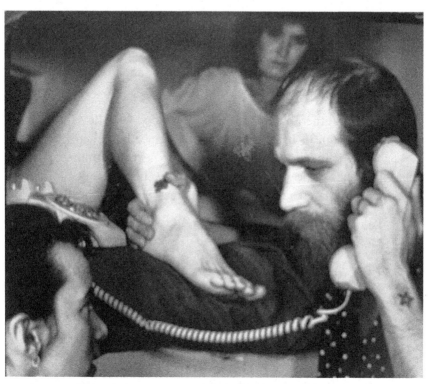

Lawrence Weiner in the announcement for his film *Passage To The North*, 1981

The willowy waitress put another armagnac in front of Owen and ducked away. The sight of it cheered him up.

"Art-Workers Against the War," Poppy told us where they had been as she sat. She and Andre were part of a politically active group that kept a close watch on the Vietnam War, organizing political theater and demonstrations. She was very young, twenty-one at most, with Scandinavian features and long blonde hair. She took a deep red pack of Pall Malls from her purse and put them on the cherry red tablecloth.

Badger. I sat there chafing my memory to find why the name was familiar. I mean Badger's a name you remember. Then I got it. Sabena Airlines, a six-hour flight seated next to a middle-aged Belgian bookseller. We'd exhausted polite chit-chat and got into Inspector Maigret mysteries by Georges Simenon the Belgian writer

"He liked the ladies, right?" I said.

"Oh, yes. Amazing womanizer."

It brought up someone he knew in the Belgian Congo. He'd been there as a young civil servant during its transition to independence. He still felt guilty, still ashamed of his country's abuse of the colony. Especially Lumumba.

"Remember Patrice Lumumba?" I said.

"Remember Lumumba doin' tha' rumba." Gary Owen drummed on the tabletop.

"Wasn't he assassinated?" said Poppy.

Firing squad, ordered by the Belgians. The bookseller, full of remorse over his country's role in it, talked of an American he knew.

A man called Badger Knox. It seemed personal, more to it than he was telling. He said Badger was everywhere – Leopoldville, Stanleyville, pulling strings, a real operator. There were factions within factions, breaking out every day, a civil war tearing the country apart. Everyone wanted their own kind of independence.

"And Badger was in the thick of it, conniving."

"Was he CIA?" said Poppy.

"Doubt it," said Owen.

"War profiteer," said Lawrence. "Another Harry Lime."

The Belgians were sending supplies down there: emergency food, medical needs, military personnel, armaments. What Badger Knox saw was planes full of cargo landing, empty planes going back. He knew the Congo was rich in coffee and copper, diamonds and cotton. But the place was in chaos, armed conflict; they can't sell or move what they have. But he can. He's on nobody's side but his own. He makes deals all over, buys for next to nothing, or just takes it, and ships back for free.

"He made his fortune."

"I shoulda fucked the crap outta him!" Garry Owen laughed.

Carl Andre pulled out a chair as he looked about stroking his beard. Did all men with beards need to pull at them? He sat down with a sigh.

"A sultry night. Not fit for man nor beast."

For a sculptor, still in his mid-thirties, he'd had a lot of success: prestigious shows at the Guggenheim and major European muse-ums – even had an entry in the Columbia Encyclopedia. He was

also a poet, widely read, verbally unpredictable and combustible. He could quickly flip from a jovial Falstaff to a bad tempered Marx.

"I'm thinking of having gills implanted." He was Falstaff tonight. "So, here we are again." Andre's gaze made another slow panorama of the room. "And again and again."

"We're 'ere because we're 'ere, because we're 'ere." I offered the ditty from the war to end all wars. Here because we didn't want to be left out.

"I cannot stay," Andre changed the tune to a Groucho Marx song, 'I came to say ... I must be going.'... So," he said calling for a wine for Poppy, a Remy Martin for himself. "Anyone else – my treat." He was always generous.[1]

"Hey, Mickey." A voice yelled the length of the bar. "A coupla queens've locked themselves in the bathroom. I gotta take a piss." Mickey Ruskin stalked, bent forward, an ostrich on the go. "What now? What the fuck?"

"Remember when the widow found Badger in bed with a guy?" said Poppy. "All the tabloid scandal."

"Why would she care," I said. "Doesn't sound like her."

"She didn't care," said Poppy. "It was the other guy who went to the tabloids."

1 The summer of 1972 was more than a dozen years before Andre's stellar career took a tragic turn. In the mid-eighties he married the Cuban artist Ana Mendieta, a feisty young woman, as opinionated as himself. They lived in a high-rise in the Village. On a balmy, late summer night, after hours of drinking and arguing, they went to bed. Not long after she fell from the window of their 34th floor apartment. He was charged with murder. What exactly happened will probably never be known. He said he woke to find she was not in bed. Then heard her cries of no, no, no. The night had turned chilly. She was a small woman and, he conjectured, she must have climbed up to close the windows and lost her balance. He was indicted (three times) and eventually acquitted. Her many friends in the art world never believed his version, and thought him guilty. Either way the life he knew was in ruins.

"He was after the money," said Andre.

"It's always the money," said Lawrence.

"A few months later he was dead," said Poppy.

"By what?" said Hanne.

"Seizure? Maybe. Heart attack? It's fuzzy now," said Poppy looking about. "D'you remember?"

We shrugged. Who knew. Time passed.

"They lost his body, I remember that." Andre giggled into his cognac.

"Lost?" said Hanne. "Where?"

"If they knew they'd have found it. They misplaced it! Shipped it out West for burial, but the airline lost it."

"That's right," said Lawrence. "They thought they found it in Bermuda ... turned out to be a large dog bound for Israel."

"The widow said the body left a stain on the sheet," said Poppy.

"Stains remain," I thought.

"Sten?"

Hanne gave us the wide eye, looking from face to face. None of us knew German. Lawrence tapped the damp ring on the tablecloth left by a sweating beer bottle:

"Like that."

"Ach, so."

"I love the faint remnants, ghosts," I said. "There's a wonderful

staircase imprinted on the wall next to a torn down building near me."

"Near the Square Diner? Yes," said Poppy. "And that barely visible faded sign for Mathew Brady's Civil War Photography Studio."

"I Like the skeletal pilings of the old piers in the Hudson," said Garry Owen worrying his glass again.

A fondness for stains and their shadowy existence drew us in. Impressions left about the city, palimpsest history imprinted in fading memories.

"Palimpsest, man? The fuck? You guys think too much," said Owen.

"Don't worry," Lawrence laughed. "We'll never accuse you of that."

Andre liked more solid stains like New England boulders as crumbs from the Ice age plate. And:

"I like the scars from Con Edison roadwork," he said. "Roads are the perfect sculpture. They're neither phallic nor intrusive."

So the fitted sheet of Sutton Place became the Shroud of Turin. The after-burn on the launch pad. I thought of Badger's ascending soul, off to Max's in sky. I only came to say, I cannot stay, I must be going.

A tag team of drag queens paraded by to the backroom with amphetamine hoots and squeals. A colorful band of silconed shape shifters – Jackie or Holly or someone else staggering on high heels. "Jackie is just speeding away, thought she was James Dean for a day" Gloria joined in with Lou Reed, very loud. You wouldn't call it singing.

"Give it a tune."

"Go fuck yourself Garry Owen!"

Our willowy waitress delivered Owen's armagnac. The narrow features of her long Ethiopian head then turned to the others.

"I'll take a Heineken," Robert Smithson appearing beside her pulling off his jacket.

"Same check?" She nodded.

"Just saw Beyond the Valley of the Dolls again," Smithson threw a pack of menthols on the table. He took the conversation before taking a seat, hovering over his thought with sly pleasure. "Totally mannerist. Complete summation of the sixties."

A year earlier Robert Smithson had finished his monumental earthwork, Spiral Jetty. Already it was the most famous sculpture in the country. Photographs of him show a serious man with a spill of lank black hair falling over aviator style glasses, his face scarred by adolescent acne. But the best picture of him is Alice Neel's portrait. In it he's young and skinny in a rumpled black buttoned up suit. One leg is hiked up across the other, his shoulders hunched, his expression one of glaring concentration. The paint is loosely, almost crabbily, laid on in colors you might find in old cans at a shipyard. She'd worked his face so much, stabbing and scraping, she left an angry mess that exposed his brooding intensity. He's leaning on your thought.

"The movie ignores all that Woodstock bullshit." He spoke to his cigarette pack as he dashed one loose and put it in his mouth. "Goes straight for the flabby white underbelly of polyester: perversity of flesh, big babes, drugs, violence, rock 'n' roll, soft-core porn."

"Ah, Bob," said Andre. "You love the very squalor of squalor."

"Reality. Everything moves toward disorganization." Smithson lit his cigarette and scowled. "Entropy."

He was the happy outlaw of discomfort. Anger at passivity was good. Something he said obviously amused John Baldessari at the next table because he leaned over and responded. Whatever it was didn't please Smithson.

"This is New York," he snapped. "We're not interested in jokey California art here!"

He could be harsh but not dull. In less than a year from this hot summer night, Smithson would go off to Amarillo, a place that likes to call itself the real Texas. He was there to scout sites for a new earthwork – the Amarillo Ramp. On July 20, 1973, he got into a small plane with a local pilot and took off to survey the area. Rumor had it that they dropped acid before take off. Who knows? He liked to live on the edge. Rumors are rumors. At some point the pilot lost control of the plane and it crashed killing them both. Robert Smithson was 35 years old.

In the mourning months following his death, his widow, Nancy Holt, came to remember him as that skinny young man in the painting. She looked around and decided I was the only one skinny enough to take his clothes.

"Can I clear these glasses? You finished with that?"

The busboys cleared. Like nurses changing bed sheets it brought a temporary quiet as they moved in and out taking glasses, changing ashtrays. Time to use the cramped bathroom where shemales hogged the mirror. A moment to look around, see who'd come or gone. Scores of artists, young and old, hung at Max's: visual artists, musicians, writers, performance, filmmakers. Some I knew, far more I didn't, either by name or by sight. All here because

we're here. Occasionally there'd be a buzz of glamour created by some celebrity, or Andy Warhol cruising the room, "Ooo. What's his name?" or de Kooning "Ech. My age – always wid de creaking and de farting." But most nights the superstar was ambition and the place itself.

"Do you have the cigarettes?" Hanne asked the busboy.

"Am not a waitress. Machine's up front, near the juke."

"Is our waitress that one?" Hanne still sat rigidly straight.

"Well. Just one more cognac," said Garry Owen, who didn't.

"She was an Abyssinian maid," I said.

"Aha ha. Yes, indeed." Andre came to life, his eyes lit up. "And on her dulcimer she played.

"In Xanadu did Kubla Kahn?" said Smithson. "Always sounded like Vegas, to me. Bugsy Segal as Kubla Kahn in the desert. All those underground caverns, measureless to man, going 'Down to a sunless sea.'"

"I won a hundred and sixty-two bucks in Vegas," says Garry Owen. "at the Sands."

"I do not like sand." Hanne was firm.

"A lifeless sea of nothingness," said Smithson. "Underground deliquescence,"

"Deli what?" said Poppy. "Deliquescence?"

"Over indulgence of chopped liver," said Andre. "It killed Badger Knox."

"Nothing killed him," said Smithson. He hunched forward, deadly

serious. "Badger Knox never died he melted away. Deliquescence means absorbing moisture from the atmosphere 'til you turn to water. Badger was a sponge. He grew paranoid when Mobutu took power in '65. Something had happened in the Congo he never talked about. He feared retribution. According to the widow Badger couldn't stop crying. Water everywhere. He liquefied. Slowly dissolved. He never died a corporeal death, he died of convenience ... melting away ... engineered the premature evaporation of his soul, and lost the body Badger on Trans World Airlines, first class. His vaporous spirit transmigrated to Texas where the dry desert air distilled it."

Smithson took a swig of his beer and savored the nonplus look on our faces.

"Dah, bullshit!" Andre roared. And we laughed.

A late, straggling dolled-out superstar went clattering through to the backroom blowing kisses. *Plucked her eyebrows on the way –* Lou Reed on the juke for the twentieth time that night – *Shaved her legs then he was a she. She said, 'Hey babe take a walk on the wild side.'*

4.00 a.m. "Is Late," said Hanne.

The bill was split and paid, mostly by Andre. The table left strewn with glasses, crumpled cigarette packs, misunderstandings, bruised egos, overflowing ashtrays and unfinished thoughts. The thinning crowd had quieted to murmurs. Even Gloria's drug fueled table was subdued.

Out into the humid air to deliquesce. Starting home with afterthoughts, what might have been said, if what was said was never said. The tired streets empty, breathing heavy, laden with stains of the day. Late-night traffic sliding through in waves. Held at the

light, everything quiet. Distant sounds...a tug horn on the river, a mending plate banging. Quiet under the sulfurous light. The world as it was becoming what it is. Me with the dyer's hand of immigration. A fox still running smell to smell among hedgehogs with firm beliefs, settled beliefs. Will I ever see what's right in front of me? The clouded mirror fogs my view. Another wave coming, taillights bobbing, bouncing plates and potholes of outrageous fortune. Inventing a life. Only the stains remain.

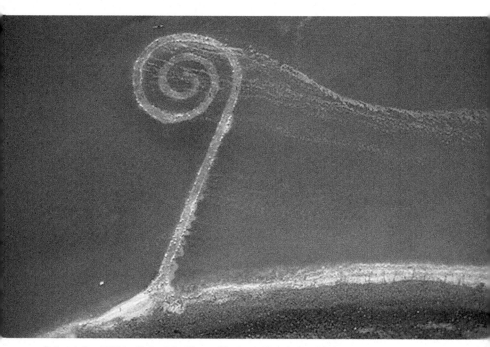

Spiral Jetty, 1972 by Robert Smithson. Photograph: robertsmithson.com

```
15 14 13 12 11 10  9  8  7  6  5  6  7  8  9 10 11 12 13 14 15
14 13 12 11 10  9  8  7  6  5  4  5  6  7  8  9 10 11 12 13 14
13 12 11 10  9  8  7  6  5  4  3  4  5  6  7  8  9 10 11 12 13
12 11 10  9  8  7  6  5  4  3  2  3  4  5  6  7  8  9 10 11 12
11 10  9  8  7  6  5  4  3  2  1  2  3  4  5  6  7  8  9 10 11
10  9  8  7  6  5  4  3  2  1  0  1  2  3  4  5  6  7  8  9 10
11 10  9  8  7  6  5  4  3  2  1  2  3  4  5  6  7  8  9 10 11
12 11 10  9  8  7  6  5  4  3  2  3  4  5  6  7  8  9 10 11 12
13 12 11 10  9  8  7  6  5  4  3  4  5  6  7  8  9 10 11 12 13
14 13 12 11 10  9  8  7  6  5  4  5  6  7  8  9 10 11 12 13 14
15 14 13 12 11 10  9  8  7  6  5  6  7  8  9 10 11 12 13 14 15
```

Perspective, white papers 1971

AFTERWORD

The youthful exuberance and vitality of the sixties flowed seamlessly into the seventies where it collided with Realpolitik. The landslide election of Richard Nixon in the fall of '72 was lethal for the Counter Culture. It threw a heavy pall of depression much like the Trump election. The reactionaries had won. Nixon's venal smirk was the wrecking ball to the anti-war movement, the Women's movement, Civil Rights, Gay Rights and everything else we cared about. The party was over. The verve was gone. The "silent – and vindictive – majority" had slammed the door in our face. Get a haircut!

It was the end of Modernism, too. Though it took a while to sink in. The line stretched back decades, succeeding movements find-

ing fertility in preceding movements. Now painting was supposedly dead, Minimalism wrung out, and Conceptual art was already being twisted and abused – the label attached to anything to make it appear more contemporary: conceptual paintings, conceptual pottery, conceptual quilts. Beyond Castelli and Sonnabend few New York galleries went near the real thing with its blunt refusal to attract money. Post World War ll America was a freshly minted consumer society that wanted things, ideas didn't cut it.

So what now? What to do? Where could we turn to defy the object and still retain the idealism we had preached for years? It was a desert of bewilderment. Like 'Godot' characters, we wandered about the empty sands in a cultural void; watching, side-eyed, for clues. How to make something stimulating, visual, engaging and thoughtful without returning to traditional art forms. Film, video and performance art became the answer for many of us, ushering in years of numb rear ends sitting on cold loft floors watching endless acts of self-indulgence. We all liked our own work, we weren't so sure about the other guy's.

As much as we liked the new media the technology was simply not there for the individual without means. Film, and its equipment, was outrageously expensive and video was still in a cumbersome, primitive, low definition stage of development. And when finished the best your film could hope for was a week's showing at the Whitney or MOMA, and then retirement to the bottom drawer to be forgotten but not gone. There was no widespread means of showing what you had done.

The lacuna of the seventies produced unforeseen developments in the art world. The effect of big money had not entirely penetrated but it was beginning. A few artists were able to find wealthy backers

to bankroll their enormous projects. It was a different approach to making art. The creative act itself seemed diminished compared to the complex and costly production values. When Robert Smithson died in a plane crash, in 1973, his widow, Nancy Holt, presented me with the expensive suit he wore to attend big money meetings. It didn't fit physically or temperamentally. I passed it on. It drew a sharp, metaphorical contrast between the quiet epiphanies of daily creativity and the awe of the spectacular presentation – the mega theme park, the stadium concert, the blockbuster show.

The galleries too, which had been predominantly elitist, owned by old money and operated as genteel clubs for the initiated, began to get very businesslike. New young dealers, like the new publishers, music entrepreneurs and sport promoters became very professional, even corporate; it was no longer about art it was about business. And with money as the arbiter values quickly changed. If it sells it's good. If not not.

What we didn't know as we scrambled about looking for feasible means of expression, was that the world was changing; the first internet message had already been transmitted. Coming soon but not soon enough were affordable computers, cameras, recorders and the means of distribution – the internet. In twenty years the digital revolution would be everywhere. In retrospect, the ideal place for Conceptual Art, everywhere and nowhere.

MH 2014

```
z y x w v u t s r q p o n m l k j i h g f e d c b a z
y x w v u t s r q p o n m l k j i h g f e d c b a z y
x w v u t s r q p o n m l k j i h g f e d c b a z y x
w v u t s r q p o n m l k j i h g f e d c b a z y x w
v u t s r q p o n m l k j i h g f e d c b a z y x w v
u t s r q p o n m l k j i h g f e d c b a z y x w v u
t s r q p o n m l k j i h g f e d c b a z y x w v u t
s r q p o n m l k j i h g f e d c b a z y x w v u t s
r q p o n m l k j i h g f e d c b a z y x w v u t s r
q p o n m l k j i h g f e d c b a z y x w v u t s r q
p o n m l k j i h g f e d c b a z y x w v u t s r q p
o n m l k j i h g f e d c b a z y x w v u t s r q p o
n m l k j i h g f e d c b a z y x w v u t s r q p o n
m l k j i h g f e d c b a z y x w v u t s r q p o n m
l k j i h g f e d c b a z y x w v u t s r q p o n m l
k j i h g f e d c b a z y x w v u t s r q p o n m l k
j i h g f e d c b a z y x w v u t s r q p o n m l k j
i h g f e d c b a z y x w v u t s r q p o n m l k j i
h g f e d c b a z y x w v u t s r q p o n m l k j i h
g f e d c b a z y x w v u t s r q p o n m l k j i h g
f e d c b a z y x w v u t s r q p o n m l k j i h g f
e d c b a z y x w v u t s r q p o n m l k j i h g f e
d c b a z y x w v u t s r q p o n m l k j i h g f e d
c b a z y x w v u t s r q p o n m l k j i h g f e d c
b a z y x w v u t s r q p o n m l k j i h g f e d c b
a z y x w v u t s r q p o n m l k j i h g f e d c b a
z y x w v u t s r q p o n m l k j i h g f e d c b a z
```

Rotating ABC's, white papers, 1968 – 1971

Made in the USA
Middletown, DE
26 August 2020